MICHAEL FREEMAN
THE PHOTOGRAPHER'S VISION

MICHAEL FREEMAN
THE PHOTOGRAPHER'S [VISION]

Understanding and Appreciating Great Photography

AMSTERDAM • BOSTON • HEIDELBERG • LONDON
NEW YORK • OXFORD • PARIS • SAN DIEGO
SAN FRANCISCO • SINGAPORE • SYDNEY • TOKYO

Focal Press is an imprint of Elsevier

ELSEVIER

Focal Press is an imprint of Elsevier Inc.
225 Wyman Street, Waltham
MA 02451, USA

This book was conceived, designed, and produced by
Ilex Press Limited. 210 High Street, Lewes, BN7 2NS, UK

Publisher: Alastair Campbell
Creative Director: Peter Bridgewater
Associate Publisher: Adam Juniper
Managing Editors: Natalia Price-Cabrera and Zara Larcombe
Editorial Assistant: Tara Gallagher
Art Director: James Hollywell
In-house designer: Kate Haynes
Design: Simon Goggin
Picture Manager: Katie Greenwood
Picture Research: Hedda and Michael Lloyd-Roennevig
Color Origination: Ivy Press Reprographics

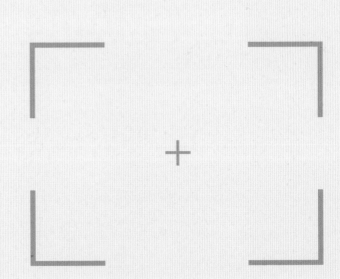

Library of Congress Control Number
A catalog record for this book is available from
the Library of Congress

ISBN: 978-0-240-81518-3

For information on all Focal Press publications
visit our website at: www.focalpress.com

Printed and bound in China
10 11 12 13 14 5 4 3 2 1

CONTENTS

INTRODUCTION **6**

I. A MOMENTARY ART **8**
What a Photograph Is...and Isn't 10
What Makes a Good Photograph 13
The Qualities of a Good Photograph 14
Does the Audience Matter? 24
How Shooting Happens 26
Global Photography 30
How to Read Photographs 34

II. UNDERSTANDING PURPOSE **38**
The Genres of Photography **40**
Landscape 40
Architecture 44
Portraiture 46
Photojournalism 50
Wildlife and nature 58
Sport 60
Still life 61
Fashion 65
Scientific 67
What For? **68**
The single print 69
The curated show 75
The single published image 77
The photo essay 78
The photo book 89
The slideshow 92
Web sites and e-books 96
Capture to Concept **98**
Modernism and Surrealism 98
Lives unlike ours 103
Polemic 106
Newsworthy 109
Exploration 110
Invention 116
Deception 118
Concept 120

III. PHOTOGRAPHERS' SKILLS **126**
Surprise Me **128**
Seeing differently 129
Unexpected contrast 131
Holding back 133
Making connections 135
The Skill to Capture **137**
Hands on 138
Perfect imperfect 140
Reaction 144
Timing 146
Intervention 152
Compositional Skills **156**
Assertive subjects 159
Knowing what works 160
Styles of composition 162
Suspicions about composition 166
Color and Not **168**
The art-crit problem with color 171
The dynamics of black and white 176
Lighting **181**

Index **186**
Picture Credits **190**
Bibliography **192**

INTRODUCTION

Photography has come a long way in recent years. This is evident in how it is practiced—which is to say digitally, covering more of life and experience than was possible or even desirable before—but maybe not so evident in how it is appreciated. Cause one is that since the 1970s photography has gradually become accepted as a fully fledged form of art. This in turn has had a domino effect, in that the kind of photography never conceived as art—the majority—is now exhibited, collected and enjoyed in much the same way as other art. Cause two is that more and more people have taken up photography seriously themselves, for creative expression rather than just for family-and-friends snapshots. This makes photography subject, as no other art form, to the "I could do that" reaction.

You would think, wouldn't you, that with photography having become so fully embraced by everyone, that we would be taught from an early age how to follow it—as a visual version of literacy? Far from it; there is not even a matching word. Although I cannot redress all of that here and now, it is worth looking at the whole spectrum of photography to show just how enriching it can be. And yet, it rarely is treated as a whole. Writing on photography tends to be partisan. Fine-art photography is usually considered in isolation, as is photojournalism, as is advertising, and so on. Personally, I don't see why this should be so, particularly now that the different genres of photography seem to be migrating. Museums now collect fashion photography, advertising uses photojournalism, landscape photography tackles social issues. Like a growing number of people, I like to think of photography as all one.

Nevertheless, an issue of identity now affects photography. It has been going on, and getting stronger, for the last three decades, and what is at stake is whether photography is rooted in capture, or in making fabulous images irrespective of whether they come from the real or from imagination. Capture is photography's natural capacity, the default if you like, with events, people, and scenes as its raw material, all happening more or less without the photographer interfering. This is the photographer as witness, as observer. Yet throughout photography's history there have been excursions into making images happen by construction, direction, creation. Tableaux telling a narrative; Surrealist experiments with process, collages, studio concoctions; still-life arrangements. Why should it be different in principle now?

What has changed has been the understanding that photography is either one thing or the other. What happened in front of the camera really happened as it seemed, or it was a different kind of photography in which things were made up. The processes of photography largely kept these two separate, with the exception of ingenious but rare attempts to alter reality. But this distinction, for many people, and perhaps already the majority, has disappeared. The two agents of change have been digital technology, naturally, but also the promotion and acceptance of concept as a valid direction for photography. There were hints of this coming from early in the twentieth century, but it was not until the 1970s that conceptual photography really got into gear.

The primacy of concept over actuality has in effect given photographers permission to make use of techniques that alter the substance of images. These techniques—digital—continue to evolve, but already they are so sophisticated as to be undetectable in skilled hands. But perhaps the most important change of all is that much of the time these techniques are not operating in the context of detection. Whether a photograph is real or not is, for many people, unimportant. What is coming to count more is whether a photograph is clever enough and attractive enough. This does not please everyone, of course, but it is the reality of contemporary photography, and it calls for explanation. Or at least it calls for an attempt to integrate photography-as-illustration with photography-as-record. This is one of my aims here, within the overall framework of the capacity to read, enjoy, and have opinions about photographs in whatever form they appear.

➤ **Pittsburg, PA ca. 1979–1980, by Lee Friedlander**

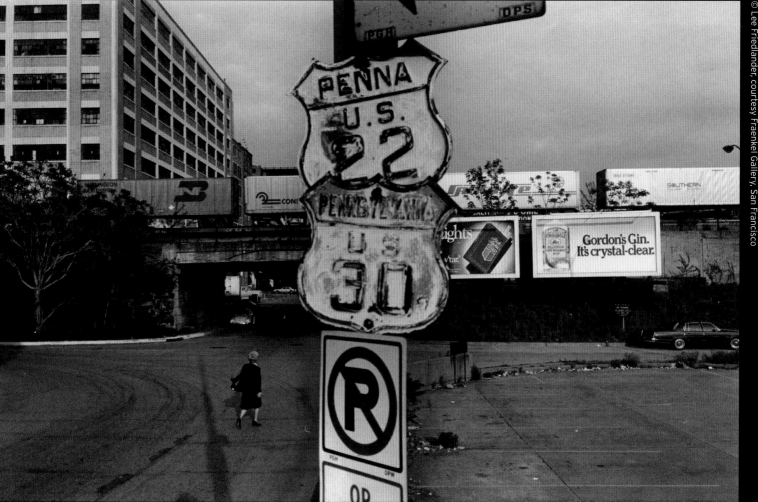

PART 1
A MOMENTARY ART

Now that digital photography can be processed and altered to make it look more like an illustration, and now that contemporary art is at liberty to use photography as a starting point rather than just an end-product, it might be useful to get clear in our minds what is unique about a photograph. And right here at the start it's worth addressing the now-familiar concern about what can be done to a photograph digitally, in post-production, to alter it. The problem for many people is that the photograph may lose its legitimacy. Another is that perhaps it in some way is no longer a photograph, but a different form of image. This is a big debate, but for the purposes of this book I take the following, possibly simplistic view: there is nothing inherently right or wrong about digitally enhancing and manipulating a photograph—just as long as no one is pretending it's not happening.

Simply put, a photograph...
Takes directly from real life
Is fast and easy
Can be taken by anyone
Has a specific look

These are the raw, obvious differences between photography and the other visual arts, but there are interesting implications when we start to dig more deeply, which reveal why photography is now by far the most popular means of creative expression worldwide.

WHAT A PHOTOGRAPH IS...AND ISN'T

TAKES DIRECTLY FROM REAL LIFE

Although the camera can be used to construct images, particularly in studio work, the great strength of photography is that the physical world around us provides the material. This elevates the importance of the subject, the event; and the reporting of this is obviously something at which photography excels. At the same time, however, this ease of capture reduces the value of accurate representation, because it has become commonplace—very different from the early view of painting, when Leonardo da Vinci wrote in his notebook that "painting is most praiseworthy which is most like the thing represented." Instead, the way in which photographers document—the style and treatment—becomes more significant.

At a deeper level, there is an inherent paradox between depicting reality and yet being something completely apart as a free-standing image. Other arts, like painting, poetry, and music, are obvious as constructs. There is no confusion in anyone's mind that a poem or a song have originated anywhere else but in the mind of their creator, and that the experience in life that they refer to has been filtered through an imagination, and that some time has been taken to do this. In this respect, photographs do create confusion. The image is, in most cases, so clearly of a real scene, object, or person, and yet it remains just an image that can be looked at quietly in completely divorced circumstances. It is of real life, and at the same time separate. This contradiction offers many possibilities for exploration, and much contemporary fine-art photography does just that, including making constructions to mimic real-life content.

FAST AND EASY

Photography can explore and capture all aspects of life—and increasingly so as the equipment improves. One example of this is the increased light sensitivity of sensors, which has made night and low-light imagery possible. We take this pretty much for granted, but it is a strong driving force behind photography's immense popularity. Little or no preparation is needed to capture an image, which means that there are many, many opportunities for creative expression. As digital cameras make this easier and more certain technically, it also focuses more and more attention on the composition and on each person's particular vision. Or at least it should, provided we don't get sidetracked by the "bright, shiny toy" component in photography. "Photography is the easiest art," wrote photographer Lisette Model, "which perhaps makes it the hardest." There is unquestionably less craftsmanship in photography in the sense of time and physical effort than there is in other visual arts, something many professionals feel defensive about. But in its place, the act of creation is extended afterwards to reviewing and selecting already-taken images. As well as editing, as this is called, the processing and printing of images is also a later and important part of the process.

CAN BE TAKEN BY ANYONE

This never happened in art before. Photography is now practiced nearly universally, and not just to record family moments, either. It's no longer a case of artists and professionals on one side, audience on the other. Digital cameras, sharing across the internet, and the decline of traditional print media have made photography available to almost everyone as a means of creative expression. Nor do these many millions of photographers feel bound by the opinions of a few. Many are perfectly happy with the opinions of their peers, as audience and photographers are usually the same people. All of this makes contemporary photography wide-ranging and complex, with different and competing standards and values. Creating good photographs does not depend on a career plan, which for all save professionals is good news. What is less good is that a large number of images tends to confuse any judgement of excellence, and the internet is awash with imagery.

"Humanism in China: A Contemporary Record of Photography" Xie Haitao/FOTOE/www.fotoe.com/image/1012b149

▲ **Scene of a building collapse, Xi'an, Shanxi, 2000, by Xie Haitao**

This is a tough first picture for the book, but it illustrates in an uncompromising way what photography does that no other art can (video excepting). It can report exactly what was in front of the camera in that place on that day in history, and at that moment. We may not always like what we see, but that is the nature of the special contract between the photographer and the viewer. Unretouched images that are captured from life were the original form of photography, and many would argue that this is its most legitimate form.

HAS A SPECIFIC LOOK

Whatever choice of paper texture and coating you make for a print, the image itself is completely without a third dimension. The frame is a window, and this sets photography apart from painting and from any kind of imagery created by hand. In many ways, this lack of physical presence makes screen display perfect, and this is increasingly how most photographs get viewed.

In terms of its look, photography begins with the viewer's expectation that the contents are "real"—taken from real life. In fact, we relate the appearance of a photograph to two things: how we ourselves see, and how we have learned to accept the look of a photograph. We are very sensitive to the naturalism and "realism" of a photograph. The further that a photographer takes the image away from this, by complicated processing or unusual post-production techniques, the less the image is photographic. This is not a criticism, just a statement of obvious fact. The basic photographic look relies on the assumption that very little has been done to the image since it was captured. Photography also has its own vocabulary of imagery, not found anywhere else. This includes such things as differential focus, a limited dynamic range, motion blur, flare artefacts, less-than-fully-saturated colors, and the possibility of rendering the image entirely in black and white.

▼ **From the series *Four Seasons in One Day*, 2007, by Laura El-Tantawy**
A warm afternoon graces central London as pedestrians cool down with ice cream cones. Differential focus, and even some slight motion blur, together with the smoothness of the tonal range, make this a very "photographic" image, despite the ways in which the photographer plays with illusion and juxtaposition. It presents itself as capture from the real world, rather than a manipulated illustration, and it's this given that allows El-Tantawy to experiment and to intrigue with her distinct way of seeing.

Laura El-Tantawy

WHAT MAKES A GOOD PHOTOGRAPH

Good may sound sloppily vague as a generalization, but it means something useful to each one of us. And, of course, it means being way above mediocre, or even ordinary. By that definition, most photographs are not particularly good. This doesn't sit well with many people these days, because everyone wants to be liked and criticism is increasingly seen as impolite and unnecessary. This is nonsense, of course, and I'm not going to indulge it here. Excellence is the result of ability, skill and (usually) hard work. And this is what makes it worth writing about: to find out what exactly goes into the best photography, and why it stands out.

Ease-of-use and ease-of-taking guarantees that there will always be a huge majority of ordinary, uninspiring photographs. Using the camera for something more than semi-automated clicking demands attention to what a photograph can be. The American photographer Walker Evans, who was notably articulate, summarized good photography as "detachment, lack of sentimentality, originality, a lot of things that sound rather empty. I know what they mean. Let's say, 'visual impact' may not mean much to anybody. I could point it out though. I mean it's a quality that something has or does not have. Coherence. Well, some things are weak, some things are strong."

We all have different ideas about what "good" exactly means in the context of photography, and this variety of opinion is important. Here, we'll explore what these meanings are, and more importantly, how photographers put them to use to make good better. I have my own ideas, naturally, and equally naturally I want to infect you with them. But in the course of assembling them here, I've drawn on a very wide range of other people's thoughts on the subject, so what follows is not just quirkily personal.

The following are the qualities that I believe define a good photograph. Within each, as we'll see, is a whole world of ideas, methods and contradictions to explore. You may object that I've not included the term "original," but that is because it's a very loaded word, to my mind to be used with extreme caution. I see it bandied about all over the Internet with little restraint, but sadly much of the time with ignorance. Unless you bend the meaning of "original" out of shape, very few creative works are. Most creative ideas, even in photography, evolve from others. True originality is rare indeed. Kant thought it a quality of genius, and I'm afraid we're not aiming quite that high. Or this, from Arthur Koestler: "The measure of an artist's originality…is the extent to which his selective emphasis deviates from the conventional norm and establishes new standards of relevance." Claiming originality is dangerous. It may just be that someone else did the same earlier, but the new claimant failed to realize it.

And as for what makes a truly great photograph, that is entirely another matter. The judgment of great transcends good and very good, and there is almost always conflict of opinion. Great usually needs to stand the test of time, as in any art, and at the start can be a lone voice. I believe a number of the photographs that we have in this book are truly great, but I'm not going to spoil the game by listing them. You will have your own opinions, and if I've done my job properly these may change by the time you've finished the book.

THE QUALITIES OF A GOOD PHOTOGRAPH

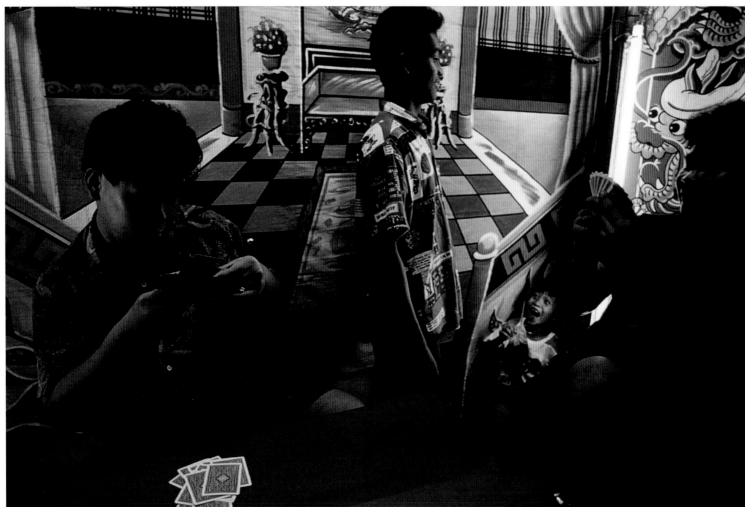

1. IS SKILLFULLY PUT TOGETHER

There is a long list of image qualities which are seen by most people to be technically and conceptually correct. They include, for example, sharp focus on the main subject, a median exposure that covers the dynamic range, a composition that most people will find generally satisfying, and even a choice of subject that seems worthwhile. These and many more are basic photographic skills, not to be lightly dismissed, and there are strong arguments for mastering them all. If the image needs them, they have to be there. But a good photograph may deliberately dismiss many of them—for a reason. There is

a big difference between messing up the focus through ignorance or by mistake, and de-focusing for deliberate effect. What counts is first knowing how composition, lighting and so on work. Photographers who master these can then play with them.

Part of this is skillful process, or you could say craftsmanship, and it tends to be at its most evident in print and display. Anything well-crafted attracts admiration just for that fact alone, and this is as true of photography as it is for any other art. Not every part of the process may show through in the final image, and it may take another photographer to appreciate

fully what went into its making, but usually and to most people there is a sense of the skill involved. Traditionalists not only hold this very high, but make it essential. More experimental photographers may subvert it. But no one serious actually ignores it.

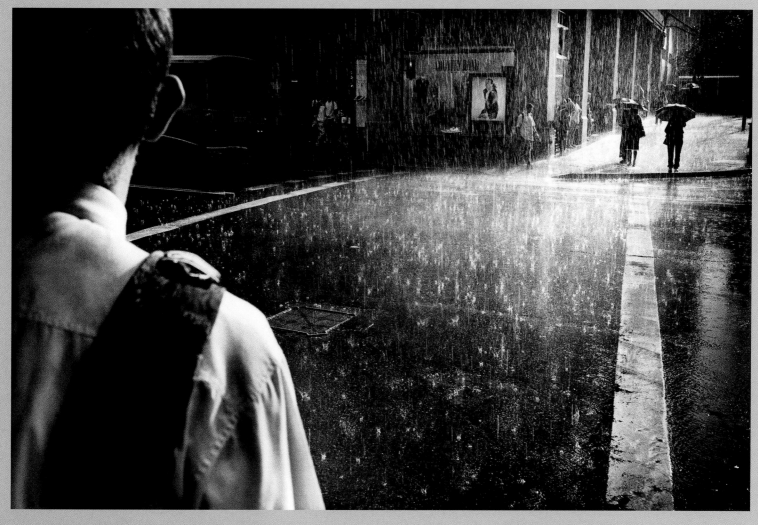

◄ **George Town, Penang, 1990,**
by Gueorgui Pinkhassov
This is a complex image that rewards a long
look. The *trompe l'oeuil* of the painted wall extends
into the image itself, and the precise framing adds
to the segmentation. The real and the illustrated
interlock. Pinkhassov writes, "The only thing that
counts is curiousity."

▲ **From his *Dream/Life* series, Sydney, 1998,**
by Trent Parke
Summer rain. A man stands huddled under awnings
on the corner of George and Market Street, his tie
thrown over his shoulder after running through
a Sydney thunderstorm. The skill in the putting
together of this image lies in Parke's sensitivity to
light—in particular, high-contrast light—and in the
framing that extends the depth between the figures,
balances them, and yet leaves the eye to rest on the
glittering, bouncing raindrops in the middle.

A MOMENTARY ART

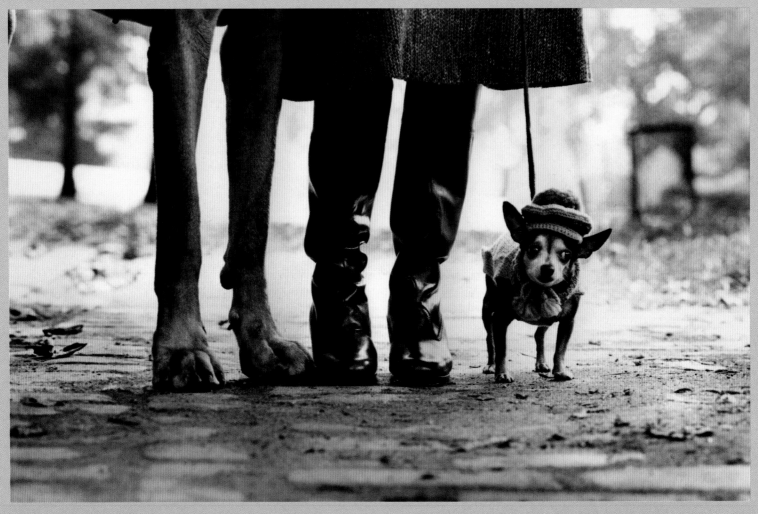

▲ **Felix, Gladys and Rover, New York, 1974,**
by Elliott Erwitt
All art needs to strike a chord with its audience.
There are many chords, and Erwitt generally chooses
humor. In particular, he likes dogs, and finds their
relationship with their human owners a rich vein to
mine. "If you're going to take pictures," Erwitt says,
"it's good to find places where you're going to have
amusing situations. A nudist camp is one, dogs are
another, beaches are another…" Also, "I have said
that dogs are people with more hair. I have said that.
I have said other stupid things. Dogs are universal,
and they don't ask for model releases, and they are
usually quite friendly."

THE PHOTOGRAPHER'S VISION

2. PROVOKES A REACTION

Above all, a good photograph is visually stimulating, and so gets an interested reaction from its audience. Maybe not from everyone, but from enough people to show that the image is engaging attention. If our immediate reaction is "I've seen it all before," then it's a failure. That may be a brutal assessment, and it may not matter at all in many kinds of commercial photography, where a packshot is a packshot, and a tropical beach resort needs to prove only that it's located on a beach with palm trees and blue skies, but if we're talking about "good," then the standards have to be higher than ordinary. Photographers want their images to be looked at, paid attention to, talked about. That is going to happen only if the image prods its audience, gives the viewer something to think about.

But for photography that aims to be in some way creative, problems begin when we try to second-guess the audience. Being too aware of how other people are likely to respond to a photograph can lead down a sterile path, towards images that are too calculated, trying too obviously to please. One of the last things I want when I show someone one of my photographs is for them to think it panders to their taste, because that makes me look like a salesman. All art has this in common, and it raises a well-worn debate about what makes a work of art—the intention of the artist or the judgment of the audience. The audience for photography wants, among other things, to see something afresh through the imaginative eyes of a particular photographer. Most people feel cheated, however, if they suspect that the photographer is simply trying to please them.

3. OFFERS MORE THAN ONE LAYER OF EXPERIENCE

A good photograph delivers to the viewer more than just the immediate, obvious image. It works on more than one level. Take, for example, an early image in this book, Romano Cagnoni's striking black-and-white of Ibo recruits in Nigeria, on page 54. The graphics are immediately powerful—a mass of shining faces and torsos connected above to a line of figures in profile. Then there is a textural richness from the printing (although the original was in color). It is also optically unusual, and we are quickly aware of an extreme compression—it was indeed shot with a very long focal length from an elevated viewpoint. Another layer in, and there is much to discover, different expressions on each face. Look, for instance, at the seemingly paler face at the far left near the back of the main group, turned away and down, mouth open. What is this young man thinking? This leads us further down into the layer of context—what is happening here? This is recruitment for soldiers during the Biafran war, and, as such, a rich historical document.

In other words, looking at a good photograph gives a layered experience. Among the arts, photography actually has a head start in this, because it contains a built-in paradox with regard to reality. A photograph is of life and also divorced from it, both at the same time. From a creative point of view, this offers good potential for any photographer who cares to make use of it. There are already two frames of reference waiting to be shown and exploited. But it needs work; it needs to recognized.

Arthur Koestler, whose 1964 book *The Act of Creation* was a deep investigation of the mechanisms of creativity, coined the word bisociative to mean working on more than one plane, which he considered central to the process, whether in science or art. In art it means juxtaposing two or more planes of perception, bringing together more than one frame of reference to produce a way of seeing, an experience, that most other people have never thought of before—and yet which strikes a chord. For example, W. Eugene Smith, working much of the time for *Life* magazine, combined hard photojournalism with a lyrical, sometimes heroic style of lighting, composition, and moment. These at the time seemed contradictory, but Smith brought them together to great effect, in images such as *Tomoko Uemura in Her Bath*, and his essays on Albert Schweitzer, a psychiatric institute in Haiti, and Pittsburgh.

Striking a chord with the viewer is fundamental. We love to discover, and we want to be stimulated. Our minds take pleasure in finding connections and noticing things that are not immediately obvious. Being too obvious in an image is a far greater sin than being obscure, because it insults everyone's intelligence. A full-frontal, baldly self-evident image that has nothing to accompany the first glance, is hardly worth our while looking at, and certainly not for enjoyment. And finally, among all these layers of experience and viewing, there is the unexpected and the unanticipated. In case all of the above gives the impression that all successful photography is well thought through from the start, many of the most stimulating photographs contain a little magic. This may be something that even the photographer was unaware of at the start. Looking through the contact sheets later—or the screen catalog nowadays with digital—the photographer may discover something about one frame that surprises, makes it special, which is the case on page 18 with Seamus Murphy's image.

That a photograph can have these different layers does not always depend on the photographer being aware of this complexity. That can come later, on viewing. But in this case, Murphy was steeped in Afghan matters, and knew the context. The graphic coincidence here is discussed later in the book, under "Making Connections" on page 135.

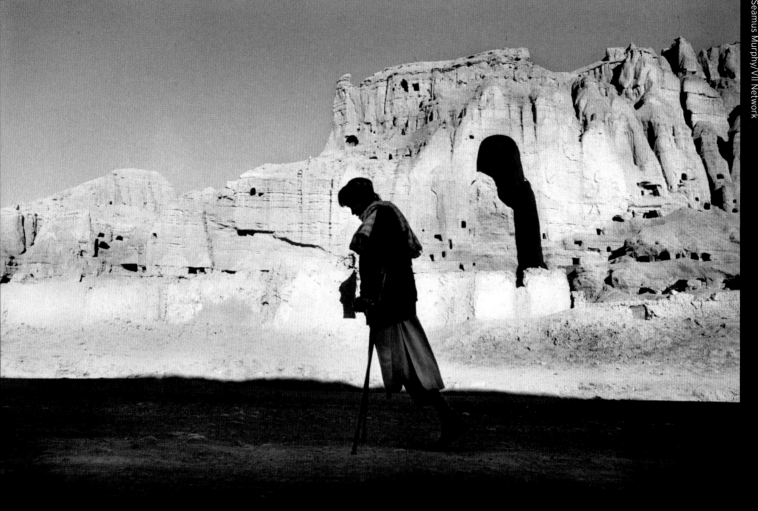

▲ **Image from *Darkness Visible* series: Bamiyan, Bamiyan Province, June 2003, by Seamus Murphy**
A powerful image that reads on different levels. There are at least three layers of experience, depending on how deeply the viewer wants to go. Not necessarily in the order of seeing, there is first, the image as showing the consequence of war, the Afghan war. The one-legged victim makes his solitary way through the harsh Afghan landscape. And then there is the striking coincidence of shape and timing. We see the correspondence between the

man, bent slightly at this point in his awkward walk, and the deep shadow in the rock behind. This is such a marvelous correspondence that the immediate thought for anyone who can imagine themselves in the position of the photographer is, how did he get that? It's clear that this is not something to stage manage. And then, in our hypothetical journey into the photograph, we look at the shadow in the rock face more closely. What happened there? It has been carved out, but it's empty. If we know something of the recent history of Afghanistan, and remember

the news reports, we realize that this is where the ancient Buddhas of Bamiyan were, before they were blasted to rubble by the Taliban in 2001. This adds another layer, of loss and intolerance. And of religious conflict. Religious intolerance destroyed the Buddhas. A war with religious undertones that began with the destruction of the Twin Towers destroyed the man's limb, and he, as the photographer explains, is a Hazara victim. The Hazara, as Shia Muslims, suffered particular tyranny under the Taliban. So, an equation of suffering.

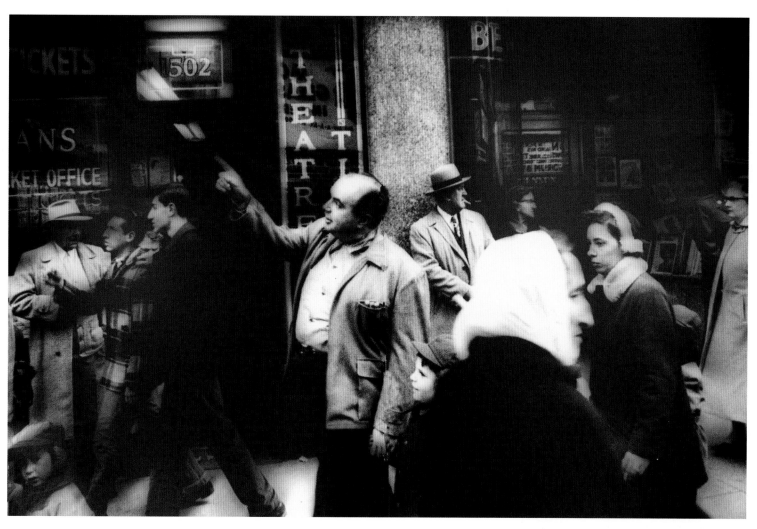

▲ **Theater Tickets, New York, 1955, by William Klein**
An image that sits squarely in the tradition of street
photography, a very specific form of photojournalism
in which the photographer walks and looks for the
unplanned moment, the coincidence of people or
actions or form, hoping for the surprise. And also
hoping to be able to recognize it quickly when it
happens, and to capture it. The man points, and this
is the moment for Klein. But equally, he is in the right
position and is able to understand and frame the
shot elegantly and simply.

4. HAS ITS CONTEXT IN PHOTOGRAPHY

A good photograph is taken with an understanding of the range of imagery already out there for public view. This is dangerous ground when it gets close to pandering to an audience, as just mentioned, but photography is so embedded in the present, and so much a part of everyone's daily visual diet, that it can't help but have a cultural context. Photography is by nature contemporary, and most people like it that way, dealing with the here and now. Nineteenth-century photography really does belong in the nineteenth century—fascinating and valuable, but not part of the present. An experienced photographer knows where his or her imagery fits into the context of others. Some photographers strive to be like others, or at least to head in the same direction. Others strive for the opposite—to distance themselves from certain others. All of them, however, realize that their work is likely to be judged in a wider context. Anyone who chooses still-life photography, for example, and believes they have something worthwhile to bring to the genre, cannot escape the legacy of figures like Outerbridge and Penn.

5. CONTAINS AN IDEA

This doesn't have to be complicated or obscure, but any real work of art has some depth of thought. In a photograph, it may be a way of composing on the surface, or perhaps a more intellectual idea deeper down. It may even surprise the photographer looking through the edit later, but there still needs to be something that catches the imagination. In fact, it is all the more important in photography, given that photographs can be made without any thought whatsoever.

But of course, there's a lot of published imagery out there that seems full of cliché—idea-less—and yet apparently successful. Where does this fit in? Success in photography, as in any other art, can come by appealing to the lowest common denominator. Many photographs that are simply successful are also seen by some as being irritatingly shallow. We don't need to upset anyone by pointing to particular examples; it's sufficient to see some of what sells as stock photography through agencies. This is not to say that a photograph like this is easy to take, as the art directors and photographers who do this for a living will rightly point out. But they tend to be compromised on ideas.

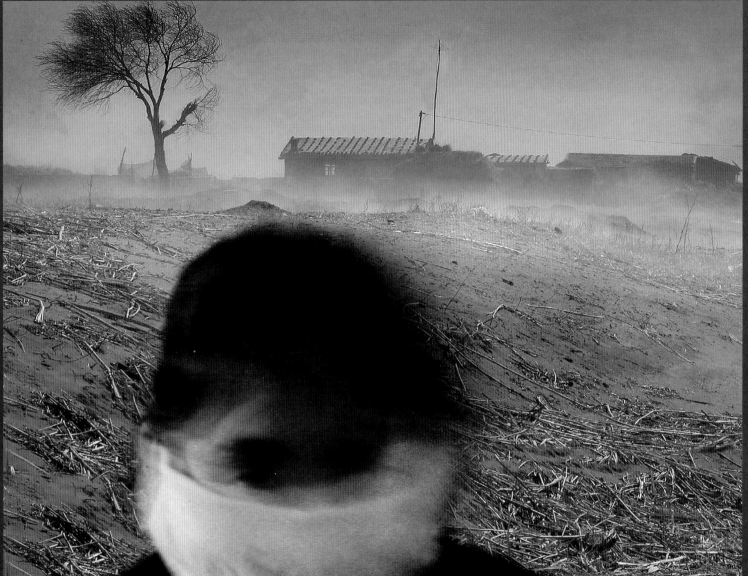

"Humanism in China: A Contemporary Record of Photography" / Liu Weiqiang

▲ **A village submerging in a sandstorm, Daqing, Heilongjiang, 2001–3, by Liu Weiqiang**

Among other things, this is an "idea" photograph, and the idea is: what does a violent sandstorm feel like? What does it do? Sandstorms are actually beyond most people's experience, but are strikingly unpleasant. Here we see, and partly feel, everything we need to know. There are the low clouds of sand raging across the landscape, which is bleak and ravaged. The woman's mask is pure documentary, but the motion blur gives us the buffeting. And her face is in our face, too close for comfort, which is very much what being out in a sandstorm feels like.

6. DOESN'T IMITATE

There is a long-held view that each art should concentrate on what it does best, and not try to imitate others. The influential American art critic Clement Greenberg, for instance, wrote that "the unique and proper area of competence of each art" lay within what "was unique in the nature of its medium." It should not borrow from others, and in this way would "purify" itself. He was writing about Modernist painting, but the same applies perfectly to photography. So, a good photograph does not attempt to mimic other art forms, at least not without irony. Rather, it explores and exploits its own medium, and this means having a clear idea of what photography is good at. The German writer and critic Siegfried Kracauer wrote, "Generally speaking, photographs stand a chance of being beautiful to the extent that they comply with the photographic approach…Pictures extending our vision are not only gratifying as camera revelations but appeal to us aesthetically also." More than this, a good photograph does not imitate others, in as much as any image can be completely new.

Thus, documenting is something at which photography is exceptional, and this leads to one approach that emphasizes clarity, objectivity and a calm, cool eye, without involving personal expression. The Paris photography of Eugène Atget, the social documentary portraits of August Sander, and the drab landscapes of Robert Adams follow this route. A large part of their appeal is that they are "sensitive and technically impeccable readings" (Siegfried Kracauer again). Reportage with expression, capturing especially evocative moments, is another approach that also relies on the uniqueness of the medium, as in the work of much of the Magnum cooperative. Another aspect of the medium is the specific optical characteristics in photography, such as flare, differential focus, motion blur, reflections and projections like shadows and caustics, which all offer rich possibilities for exploration, partly because they are so easily captured by the camera, and partly because they have an illusory quality parallel to photographs themselves.

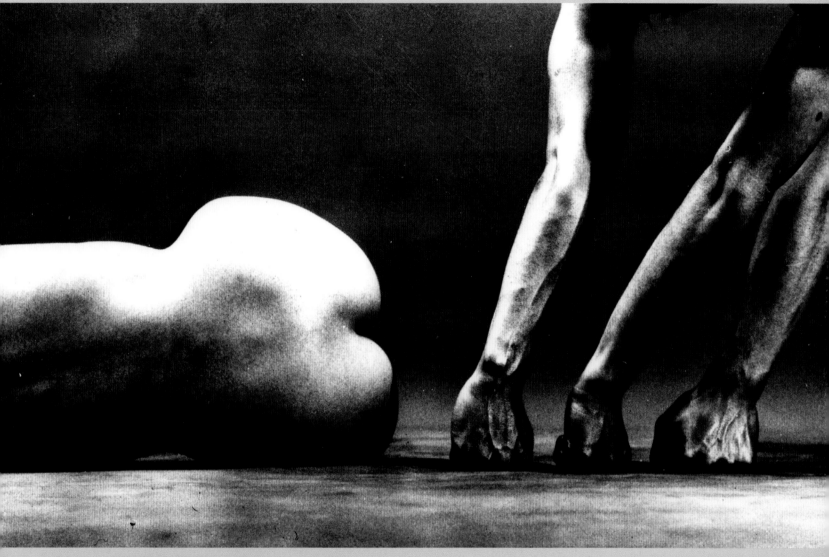

© Eikoh Hosoe, Courtesy Howard Greenberg Gallery, NYC

▲ **Man and woman 24, 1960, by Eikoh Hosoe**
One of a series of photographs under the
Japanese title "otoka to onna," which treated the
rivalry between the sexes by means of unusual
juxtapositions of parts of naked bodies. Hosoe
took the body as object, separated from individual
personality. His psychologically charged imagery
and dramatic lighting, highly original, were also an
exploration of photographic form.

DOES THE AUDIENCE MATTER?

The practical dangers of playing to an audience, as spelled out, are real enough. At a particular level in any art, the audience becomes suspicious, or is simply turned off, if it thinks the artist is just ticking boxes to make people happy. And yet photography that is financially successful clearly does meet the needs of its audience, and most successful photographers know perfectly well who likes their work, and why.

This raises two questions that few critics or commentators like to think about. Can a photograph be calculated to appeal, and still be good? And, even more tricky, does good photography always have to be challenging, or can it work if its sights are set to a more popular taste?

The first question first. The received wisdom on serious photography, mainly photojournalism and contemporary fine art, is that the photographer should stay pure to his or her own agenda, and trust that the results are admired by a discriminating audience. The reality is usually more knowing. As mentioned above, all photographers who take it seriously enough to want to carve out a place for themselves are fully aware of where their work fits in—who the competition is, what picture editors and critics think, and so on. It helps, of course, that most photography is about some sort of capture from life, and only a small proportion is constructed and fabricated as in painting or sculpture. So far, this has helped to keep photography grounded, making it harder to be calculating than in other art.

The second issue is really about who sets the standards for judging photography. There are different audiences for it, as there are for any art. This is nothing new. You just have to think about the scorn that the West Coast Group ƒ/64 photographers, including Ansel Adams and Edward Weston, heaped upon the Pictorialists. Weston called them "fuzzy-wuzzies," and Adams considered their work "shallow sentimentalism." Well, what goes around comes around, and the meticulous craftsmanship and grand landscape visions of Ansel Adams nowadays come in for criticism from those who champion a deadpan, uninflected style.

Another clash of audiences occurred in 1959, when Robert Frank's road pictures were published as *The Americans* (this U.S. edition appeared a year after the original in Europe). *Popular Photography* was, and still is, the largest magazine on photography in the world, founded in 1937, and highly influential among amateur photographers in the United States. The editors' review of the book was both dismissive and strongly critical, including "meaningless blur, grain, muddy exposures, drunken horizons and general sloppiness." Yet, as time went by, Frank's

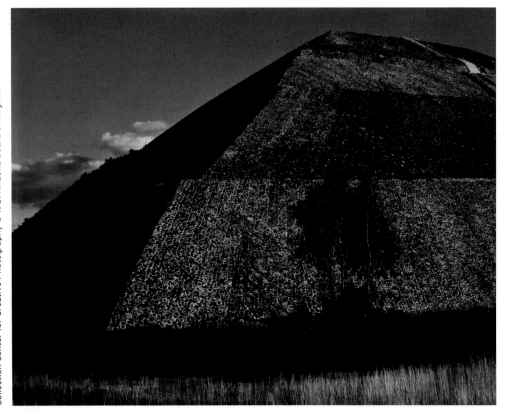

◄ **Pyrámide del Sol, Mexico, 1923,**
by Edward Weston
Like other West Coast photographers of the time, Weston combined formalism with technical excellence that extended to sharp focus throughout the image. The result, particularly when it was applied to landscape and sites such as this Mexican pyramid, was easy for a wide American audience to like, because it met rather than challenged basic assumptions.

radical style came to be accepted as normal by more and more people. This well-known example is a classic case of the leading edge of photography gradually filtering down from an elite audience to a popular one. This is the model that art critics like, because it justifies their existence. They have been proved right to lead the way against the bad taste of the masses. Frank's case, of course, proves nothing other than that his work broke through and stood the test of time. Many, many photographers who were seen as being part of the avant garde then simply didn't make the grade, despite the hype being applied. It's neither polite nor necessary to list any of these unknowns, but the argument that contemporary and challenging photography always leads the way is flimsy.

There is no neutral way to describe the "class" division between these two audiences. There is the smaller one that is more educated in contemporary art movements, more discriminating, looking for creative breakthroughs, possibly elitist and equally possibly feeling intellectually superior. There is the much larger audience that enjoys the more obvious appeal of clarity, skill and craft, more traditional, preferring to relax in front of art rather than be constantly challenged. And so on. Neither of these two audiences—let's call them high-concept and popular for want of anything better—will ever change its fundamental likes and dislikes. The particular photographers and artists being looked at and judged may come and go, but the high-concept audience will always dismiss the obvious, lush, emotional, and beautiful in photography, just as the popular audience will always embrace these qualities. The two audiences have a mutual distrust, the view in one direction looking unsophisticated and too easily pleased, the view in the other elitism, pretension, and the emperor's new clothes.

I'll single out just one example of a popular audience reaction, which is the very American one towards romantic landscapes in the style of Ansel Adams and his color descendants, David

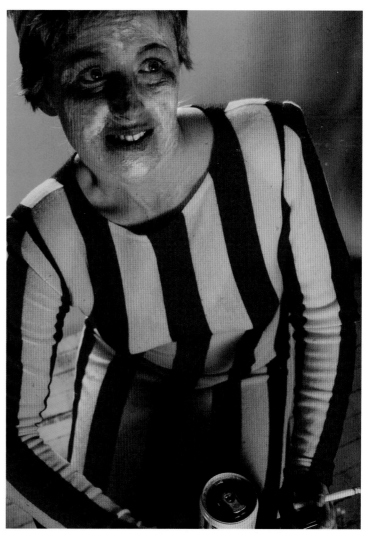

➤ **Untitled, 1984, Color photograph, 67 x 47 inches (170.2 x 119.4cm), Edition of 5, by Cindy Sherman**
One of the anchors of American conceptual photography has been Sherman's "several" series in which she photographs herself playing (often) exaggerated fictional roles. "There is a stereotype of a girl who dreams all her life of being a movie star," she writes of her most famous series. "She tries to make it to the stage in films and either succeeds or fails. I was more interested in the types of characters that fail. Maybe I related to that."

Muench et al. The standards of both beauty and craft are extremely high, and the audience is large and generally satisfied—just look at the number of books and calendars of this kind published— and also the number of books on how to take this kind of photograph. But you won't find this work celebrated in contemporary galleries or contemporary museum shows. The reason is that it does not meet the conceptual criteria, and is not considered intellectually challenging.

What has changed is that the different audiences for photography have more voice these days, through the Internet, where few people are shy about expressing opinion, likes and dislikes. Online forums and other social media that feature photography are having the effect of reinforcing differences between audiences, and hardening the edges. A common attitude is "we like it this way, and there are enough of us to matter." So yes, audiences matter, and by being noisy and opinionated they increasingly help to set the standards by which photography is judged. You might not like this or that style, but you cannot reasonably dismiss it out of hand.

HOW SHOOTING HAPPENS

In a sense, the creative process in taking a photograph is like a wedge. The options are often broad and open at the start, and narrow gradually because of the situation and because of whatever ideas the photographer has and techniques he or she wants to use. I particularly like the wedge comparison because photography, unlike any other visual art, ends in a point, a split-second of capture. Time itself drives the wedge home.

Let me try and make this clearer with a diagram. Or rather two diagrams, because there's a difference between unplanned and planned photography. Unplanned is much more common, and means, generally speaking, reacting to events and situations rather than trying to set them up and control them. It's how most photographers work. As we will see, the dynamics are sufficiently different that they affect the creative process.

UNPLANNED

The first diagram shows the "wedge" in a street photography shot. It narrows from bottom to top as the photographer makes choices and refines them until, at the end (the top), it's the final decision on lighting, composition, and exact moment. The circumstances may look a little exotic to many people—a lane in the Burmese city of Mandalay given over to the carving of marble Buddha images—but in principle it's no different from countless street scenes around the world where there is some moderately interesting activity going on. Street photography is very much of the moment, and usually the only plan is to have no plan other than choosing a time and an area to walk around. That was the case here, an early morning walk, not knowing exactly what to expect. It's one thing knowing that such and such happens in a particular place—guide book stuff—but quite another finding lighting and exact subjects that appeal to a particular photographer. The general street activity forms the context. In this situation, the photographer followed a number of possibilities over the course of nearly an hour. Some of them were dead ends, others showed promise and were worth spending time on. This

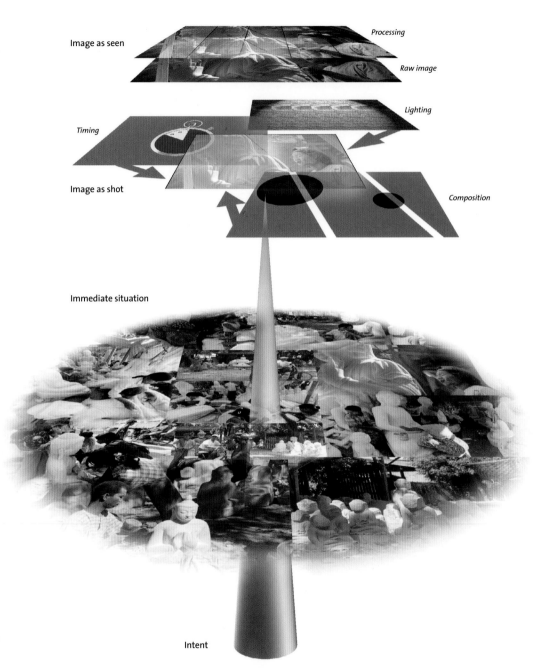

Λ Above: The shooting process in a street setting, bottom to top. The large disc represents the range of possible subjects available. The choice is then narrowed down to the likeliest or most appealing. The upper section shows the interaction of composition, lighting, and timing. The very top is an add-on from digital photography: the range of ways in which the raw image can be processed and presented.

26

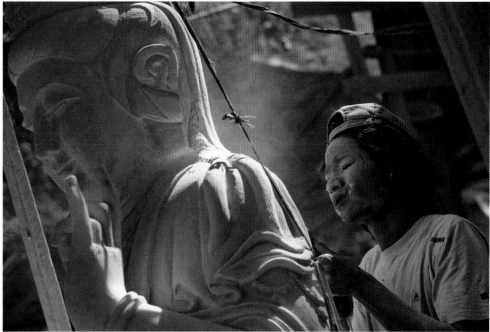

◄ **Left:** The actual shoot in a situation like this is likely to go through a number of frames, as the photographer tries to capture the best out of the final situation. This sequence took just over a minute. Part of this is simple improvement: trying to get a better frame than the previous ones.

▸ **Top left:** The final step of processing allows a huge range of interpretations, and all of those available in a standard raw processor are valid.

meant trying to improve on one aspect or another: camera position, moment, lighting, composition, varying focal length, and so on. The workers were there all day, so it was a general situation that could take some on-the-spot mini-planning.

Something we'll come back to later under "Photographers' Skills" is the problem of when to give up on a possible subject, and when to keep going. Dorothea Lange once said, "Photographers stop photographing a subject too soon before they have exhausted the possibilities." That's too sweeping a statement, but it highlights the dilemma that many photographers have to face every day. There are shots that can never be repeated—the photograph on page 141 of the D-day landings is one example—but there are also those that look like they could be improved upon, with some creative effort and a bit of luck. But how long do you spend on these before moving on to the next possibility? One of the marble-carving scenes that the photographer

chose to follow through was this one. The lighting, with all the marble dust flying around, was one attraction. Another was the man's face, covered in white dust except for lips bright red from chewing betel. Then there was the correspondence between worker and statue.

Choice of camera position, focal length, depth of field and exposure—all approximate—were the next step, and the last seventy seconds were taken up with refining these, particularly the composition. That meant small movements to the camera position, slight adjustments to focal length, and waiting for certain moments in the man's work. This took up a dozen frames. As shown here, the final moment of shooting meshes three things: lighting, composition, and timing. Of these, composition is a catch-all, combining not only framing and focal length, but also the depth of field and the speed at which movement is captured—frozen or blurred. These last two are set, respectively, by the aperture and shutter

speed, and this is the point at which the camera's technical controls also have an effect on the character of the image. Aperture, shutter speed, and the ISO setting (formerly film speed) have one role in fixing the exposure, but also another in creating the character of the image. This may sound like it's from the pages of a camera manual, but these choices, well applied, can make a real difference to an image.

That's it, the moment of capture, but one more step remains. The way the image is processed brings its own qualities, never more so than in digital photography, where it is both a necessary step and one full of choice. The choices involve contrast, saturation, brightness, together with more obscure qualities for which new names have had to be invented, like clarity and vibrance. As far as the subject is concerned, the photography stops with the shutter release, but the image itself needs these later processing steps.

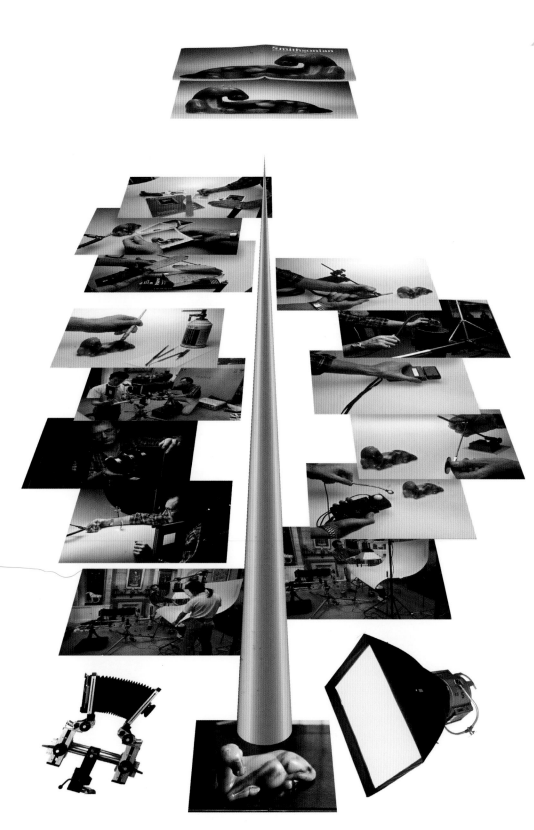

▲ Above: The different style of creative workflow from spontaneous street shooting is reflected in the relative importance of the three actions: composition, lighting, and timing. Composition is prime, and evolves over time (represented by the "depth" of the diagram), followed by lighting. Timing in this shot hardly matters—I could have gone for coffee and it would still have been there when I returned.

◄ Left: The same process of shooting in a highly controlled situation, here a studio shot done to a prior layout. The major difference, as explained in the text, is that the creative work is spread out over a much longer period, and is more or less complete by the time the shot is actually ready to be taken.

PLANNED

Now on to the planned counterpart of this diagram break down. Although every photograph has a slightly different flow of creation, the great divide is between planned and unplanned, as I hope this second walk-through will show. There are many kinds of planned photography, foremost being architecture, interiors, portraits, and still life, not to mention heavily Photoshopped creations. The example here is a still life, commissioned to fit a layout, so it had to be very precise and meticulously planned, from sourcing the subject onwards.

The important difference from the first situation is that there is no last-minute reactive burst of activity. This does not make planned

photography any less creative or demanding, just that the energy is spread out and happens in a different way. The on-set nuances and surprises are certainly there, as any professional or fine-art still-life photographer will tell you, but the hard graft goes into the set-up. In this example, the brief (planned photography usually follows a brief) was to shoot an exquisite jade masterpiece that would fit both the front cover of a magazine (the *Smithsonian*) and wrap around the back cover as a horizontal image. Time here is not an issue, as we will see in the Still Life section of "The Genres of Photography" on page 61. There is all the time in the world—a week in this case—to set things up.

As the illustration shows, the preparation for shooting follows parallel strands that intersect. Here, for this studio-on-location shot (the jade piece was too valuable to leave Spink and Sons, the dealers), lighting was always going to play a very important part. In fact, it was lighting that had to transform this quite small object into one with an almost monumental presence. We've separated out the lighting strand on the right, and it begins with choosing studio flash units. The basic lighting plan had been decided in advance, after a preparatory visit to look at the jade horse. It involved a large, overhead "window" light for broad but well-shaped highlights and soft shadows, and base lighting to give a sense of the piece floating. The translucent curved plastic base (curved so as to appear seamless for an "infinity" appearance) would be lit with a variety of softly colored warm gels, and the choice of background tint made later, after shooting. A dental mirror was positioned just out of shot to reflect some light from the overhead flash up into the shaded neck of the horse. Finally, a fiber-optic cable was hooked up to another studio flash unit and the light piped up to give a very precise catch-light in the eye of the horse—a small but ultimately telling detail.

The shoot took about three hours on site, the first part being taken up with building the set—a customized light table with positions for the lights. As the shoot progressed, the actions and decisions became more and more those of refinement,

concentrating on finer and finer detail. As this was a close-up still life that would be reproduced large, an almost microscopic attention to detail was needed. The eye has a great capacity for skipping over things and seeing only what it wants to see, and it takes a kind of training to examine a small set for specks of dust and other blemishes. This was shot on 4 x 5 inch transparency film, before the days of digital retouching, and so everything had to be perfect as shot. The repro house could always retouch, of course, but professional standards meant that this would be a sort of failure on the part of the photographer.

The creative process in making a photograph, as here, and taking a photograph as in the previous street shot, is quite different, which is why I've run the two side by side. The creative process is stretched over a period of time, which means that the last-minute, spontaneous decisions that are so important in, say, reportage photography play a much smaller role here. There are certainly small touches, and even important inspirations that can elevate the image to a higher level (look at the portrait of Winston Churchill by Yousuf

Karsh on page 144, and the accompanying story), but generally it is the photographer's idea that is important. A photograph like that by artist Jeff Wall on page 125 is almost all idea. In a way, this raises the standard for what makes a really good image. In a still life, for example, technical perfection, particularly for lighting, is expected, so that alone is not going to be sufficient to impress many viewers.

▼ **Below:** It was clear in advance that the image would have to be flopped left to right, because planned as a wraparound cover.

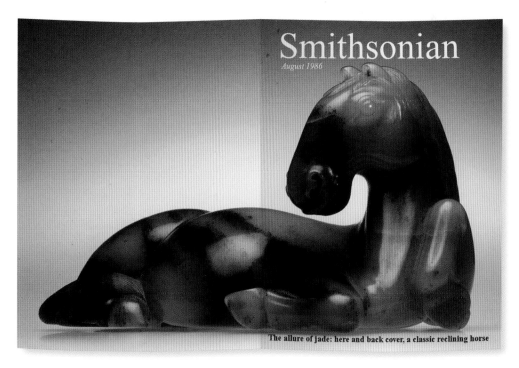

The allure of jade: here and back cover, a classic reclining horse

GLOBAL PHOTOGRAPHY

One of the most important recent changes in the world of photography is that photography is now finally international. It was not seen that way before; instead, it was taken almost without question as a Western activity. Until at least the middle of the twentieth century, the perception of photography was as something that Americans and Europeans did. There were a very, very few exceptions, such as Manuel Àlvarez Bravo in Mexico, but, by and large, Indian, Chinese, African, and South American photographers might not have existed as far as published photography was concerned.

This is a little strange. Photography was supposed to be universal, to cross barriers of culture and language. Wasn't that the idea behind the hugely popular exhibition *The Family of Man* mounted in 1955 by Edward Steichen? He wrote that its goals were "to show the relationship of man to man; to demonstrate what a wonderfully effective language photography is in explaining man to man…" And later, Cornell Capa, photographer, curator and younger brother of Robert Capa, wrote that photography "is the most vital, effective and universal means of communication of facts and ideas between people and between nations."

These may be true, but while photography could be a universal means of communication, the twentieth-century media that delivered it to audiences were not. Photography flourished more than anywhere else in magazines, especially in the great picture magazines like *Life*, *Look*, *Picture Post*, *Paris-Match*, and *National Geographic*. Photographs depend on being seen by as many people as possible, and until very recently mass media meant print media. Print media meant large publishing corporations, so that effectively very few people—owners, editors and picture editors—got to decide what was good photography and what would interest their readers. As the market for these magazines was in the West, it followed naturally that published photography would be about things that Westerners wanted to see, and by Western photographers.

More than this, magazines and newspapers are language-specific, and it was America that had the largest affluent market for print media in the world. It still does, for that matter, as anyone in book publishing knows. *Life* magazine's circulation at its peak was 13.5 million copies a week; the *National Geographic* is now nearly nine million copies a month. In these two areas, weekly and monthly, no other picture magazine has ever come anywhere close. And until the decline set in in the 1970s, picture magazines were the vehicle for important photography (*National Geographic* and the *Smithsonian* still are healthy exceptions). That made magazines like *Life* the arbiters of what and who was good in photography, so there was naturally an Americacentric bias. Now, America has something of a corporate sensibility. Large corporations get a measure of public respect that they do not in Europe. Part of the reason may be that Americans are joiners by nature, despite the ideal of rugged frontiersman independence. Not only this, but corporate America and government have generally worked together. Hence all the major picture magazines have been essentially conservative and "American" in spirit.

Most Americans think of the twentieth century as an American century, and with good reason. It was the period in which the United States grew economically and politically to dominate the world stage. It was also the period when photography blossomed professionally, and as art, and for amateurs, so perhaps we shouldn't be too surprised that Americans tended to think that photography belonged to them. As (American) art historian Gretchen Garner wrote in her excellent book *Disappearing Witness*, "for most of the twentieth century, photography flourished most strongly in the United States."

For the first two-thirds, until approximately the beginning of the 1970s, photography was understood by most people to have one job, to document. It showed its audiences how things looked, how people looked and behaved, and the unfolding of events on the world stage and in ordinary street scenes. Sometimes photographers

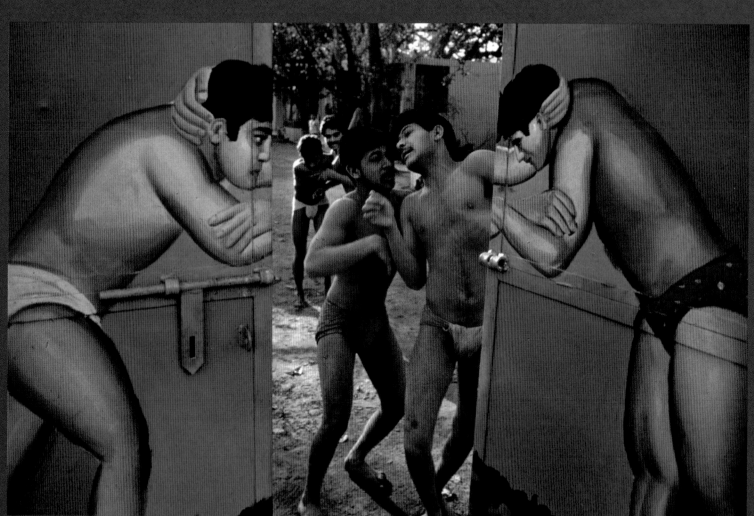

▲ **Through the doors of a wrestling school, Delhi, 1989, by Raghu Rai**
A member of Magnum, Rai is one of the relatively few non-Western photographers who have long had international status.

idealized, invented, even distorted the truth, but the broad direction was still the same: making a visual record of life and the world. Things changed rather when photography discovered post-modernism in the 1970s, and even more so with digital and broadband. The point is that photography found its documentary role while America was booming, and it made for an effective relationship.

In addition, photography in America has also notably been supported and directed by non-media organizations. One of the most powerful in its time was the Farm Security Administration, which in the 1930s commissioned photographers like Dorothea Lange, Walker Evans, and Ben Shahn to document the Depression in rural areas. Then again, in the 1960s came the National Endowment for the Arts, with grants for those photographers who were hooked into the art–academic world. Many millions of dollars were disbursed this way in the 1970s. This was also the time when the Museum of Modern Art began to have great influence under its new curator of photography, John Szarkowski, and the combination of money and official approval meant that American photography started to be molded and supported in an organizational way. In contrast, consider the much less effective and much less confident role of Britain's equivalent, Tate Modern, which held its first show on photography in 2003, three decades later! In the United States in the 1970s, writers from outside the field, like Susan Sontag, chimed in, and before long there was a whole raft of graduate programs in photography in colleges and universities. In effect, American photography acquired official academic status and ever greater prominence, which never happened to anything like this extent in any other country.

In summary, a large and affluent market with a common language and many common cultural ideals allowed the growth of picture magazines, at a time when they were the main vehicle for displaying photography. Added to this was quasi-official support from government bodies and the academic art world. The result:

Western photography, with a strong bias towards America…until now.

Photography is no longer ruled by magazines, no longer even by print media, although for the time being it is print that pays photographers to reproduce their work much more than online media. As photography comes more and more to be published on millions of independent web sites and through forums, the center of gravity is shifting. And the biggest change is that this is worldwide, and begins to redress a serious historical imbalance. It also means that we are beginning to see photography that was "lost" because of the earlier Western bias. For example, in 2003–4, the Guangdong Museum of Art put on an exhibition called *Humanism in China: Contemporary Record of Photography*. It contained reportage work of the highest quality from the 1960s to the present day, hardly any of which has so far been seen outside China (we have eight images in this book). This is just one example of many.

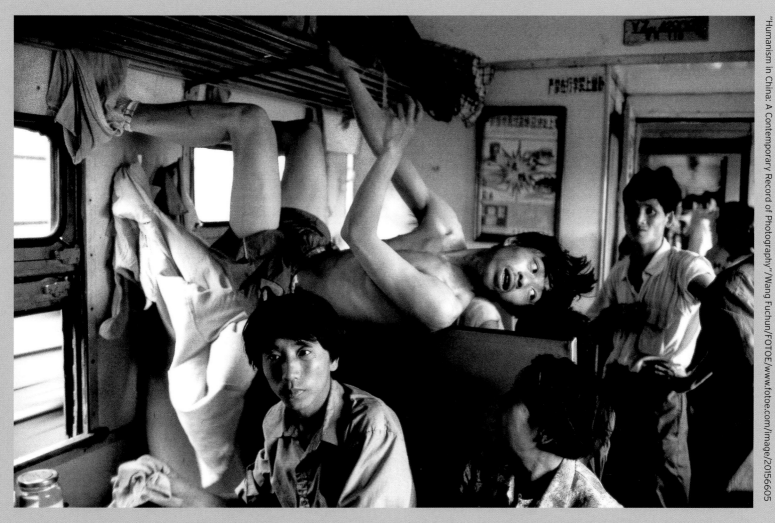

▲ **On the train from Wuhan to Changsha, 1995, by Wang Fuchun**
Included in the important 2003–4 Guangdong Museum of Art show, Wang did a major reportage series on China's rail system. Here, a passenger who bought a ticket without a seat, has improvised a bed from the back of a chair.

HOW TO READ PHOTOGRAPHS

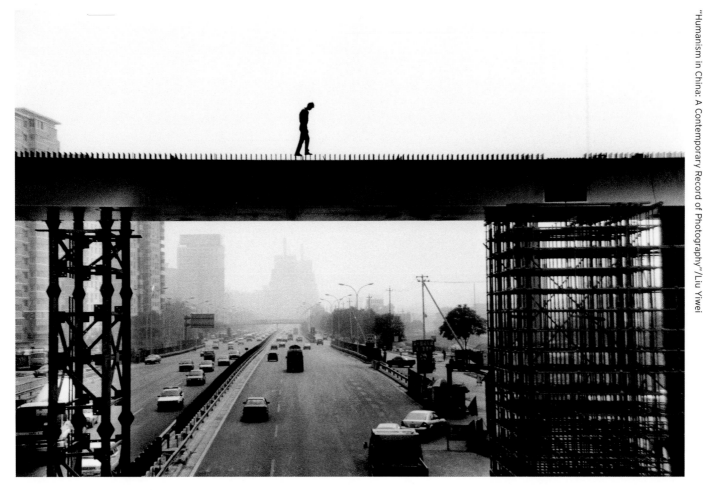

There's a simple proposition here. Reading photographs and taking photographs help each other. More than that, they enhance each other. The more you know about the process of taking photographs, the easier it is to understand what another photographer was trying to do and how he or she set about it. And the reverse is true. If you know better how to read someone else's photograph, you'll better equipped in taking your own. In the world of contemporary photography this has particular resonance, because so many people now use a camera as a means of expression—often creative expression. As I mentioned a little earlier, under "What a Photograph Is…and Isn't," much of the audience for photography considers itself as photographer.

So, what does it take to be able to read a photograph without a critic's prompt-line? First, we need to know what the photographer was setting out to achieve. Also how the photographer chose to treat it in a way that was different from others—style, in other words. And finally, there are the actual circumstances and the timing, blow by blow. This last is quite often secret knowledge, unless the photographer happens to want to explain all, as Ansel Adams (but not many others) did. His book *Examples: The Making of 40 Photographs* is a wonderful recapitulation of situations turned into images, on levels that range from the technical to the conceptual. It works particularly well for his kind of photography—large-format, considered, American grand

⋏ Worker on a viaduct, Beijing, 2002, by Liu Yiwei
As China began major construction projects on a scale never experienced before, photographers sought to capture often surreal scenes, poised between desolation and development. The timing in Liu's shot of one of Beijing's ring roads is impeccable—and essential. The single worker establishes the context.

➤ Female lower half in seamed stockings, yellow background, by Guy Bourdin
One of Bourdin's series for the shoe manufacturer Charles Jourdan, in which he created mysterious and ambiguous narratives, often sexually charged and always surprising. Bourdin's compositions and styling were refreshingly eccentric.

landscape—but not for most others. Nevertheless, thinking as photographers, we can still make an attempt to work some of this out, even when the photographer hasn't added footnotes. The sequence goes: Intent –> Style –> Process.

That's not to say that most photographs are actually taken in this order. It isn't usually a case of "I'm going to do this, and I'll apply this style, and…ah, here's a good subject, I'll tweak the composition just so…" But if we're reading a photograph, we should have an idea of all three. Intent is what the photographer sets out to do, Style is the individual way in which he or she decides to do it, and Process is making it happen, on the ground so to speak. Reading a photograph means deconstructing these three. At the end of this process of reading, we should be better equipped to decide for ourselves how well the photograph succeeds. Is it good? If so, how good?

This method is different from the usual approach and commentary on photographs, which tends to be distanced and cool. This is more like full immersion. The idea, and the ideal, is to try and put yourself in the situation in which the photograph was taken, and in the mind of the photographer. Quite often, there is not enough information to be had just from the image in front of you, and we need to dig for more. In order to read a photograph as a photographer, you need to reconstruct the aims, the personality and the techniques of the person who shot the image, all from the evidence contained inside the frame, helped by whatever else you can find out from research. It's a kind of detective work, even forensic.

Not only that, but as the reader of a photograph, you are presented with everything in reverse order. It starts with the result, there for all to see. What appears in the frame is usually the very last fraction of a second in a series of events that goes all the way back to a photographer's creative development. From this final frozen image, go a few seconds backwards into the immediate situation—to what was happening around the camera at the time, and in many

images what the subjects were doing right up to that moment. This is the sharp end, as it were, of Process, the blow-by-blow decisions and actions during the moments of shooting, which are often brief and concentrated. If you think back to all the details of what was going on at the time for each of your own photographs, you know just how different and specific each situation was, and how unlikely it is that other people would be able to know all of it.

The immediate situation is the exact place and event. Being at the right place and at the right time is central to taking a good photograph, as I well remember being instructed by one of the first art directors I worked for, Lou Klein of *Time-Life*. It's important when reading a photograph to have a pretty good idea of what that time and place were. And looking at the image as photographers, we would all try and project ourselves into it. What would you have done then and there? Interestingly, some strong

situations have a certain kind of logic that tends to drive photographers to do similar things. The two photographs on pages 160–161 are an extreme and deliberately chosen example of this. As described there, the personality and style of the two photographers, Philip Jones Griffiths and Tim Page, could hardly have been more different, but there they were together on that day in Saigon in the same place. The similarity between the two images comes as less of a surprise to professional photographers than it does to most people, because they can more easily project themselves into that situation and figure out the last few moments of the process for themselves.

Go back further in time from the immediate situation and you have the general setting—the context. Context can be historical, cultural, artistic, and is the background to the shooting. For example, if you are looking at and judging a nineteenth-century photograph of a place, it's important to know that photography at that

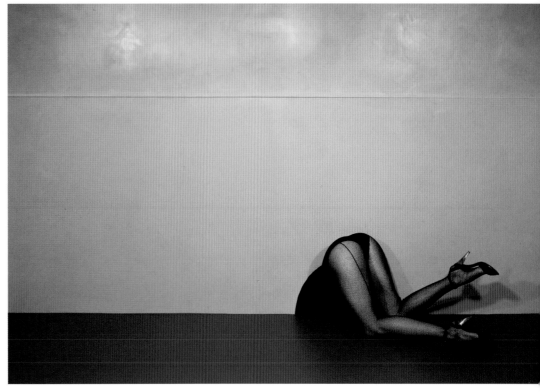

time was being used to show how destinations looked to people who had never seen them, who rarely traveled, and who would probably never visit such places. A very simply composed landscape of the Pyramids and Sphinx outside Cairo, or of the Rocky Mountains, may not set your spine tingling, but at that time they were like the first pictures from another planet. The public was thrilled to see such strange sights. And remember that these images, which now have an antique look, were then the cutting edge of contemporary. The technology also was exciting. Huge mahogany cameras, and glass plates that the photographer had to coat before using, were advanced technology. All this and more is the kind of thing that makes up context.

So, there are two sets of things to think about, and they intersect towards the end-point of the shooting. One is what the photographer brings to it—intent, style, and process. The other is the circumstances, from context to the immediate situation. Reading a photograph involves having some idea about both, and one way of looking at it is that the photographer has a purpose and a style, and drives these into a particular situation.

Let's get down to practicalities. What we need is a procedure, a kind of system, for being able to look at any photograph and understand how and why it was taken. A sort of viewer's guide. As far as I know, this hasn't been done in quite this way, in book form. What follows is a set of questions for any viewer to ask himself or herself. As so much information is often missing from the photograph alone, and because we're dealing with an enormous variety of imagery, there will not always be satisfactory answers, but this in itself is useful: the difficult questions often identify the areas of ambiguity and uncertainty in a picture.

Reading a photograph: ten questions to ask yourself

1. Pay attention to your first impression—what strikes you immediately? First impressions sometimes get closer to the heart of an image and its effect than a lengthy study. However, some images strike home faster than others: a photograph that celebrates rich colors will inevitably make a stronger first impression than a conceptual fine-art image that needs to be looked at carefully.

2. What genre of photography does it belong to? This is usually fairly obvious, though not always. The generally recognized genres, from Landscapes to Portraits to Still Life, are the subject of the beginning of the next section, from page 38 onwards.

3. What was the intended use? This is not always obvious, and may seem an unfair question to have to consider, but at the same time it can often help you to understand more. For example, a news photograph is shot with some very specific objectives, and in particular circumstances. There are three major groups of use: editorial, advertising/commercial, and fine art. Within these, there are also different dynamics, such as between news and feature photography (both editorial), and between high-exposure, high-profile advertising photography and corporate annual reports.

4. What was the immediate situation in which the shot was taken? In other words, what was going on around the photographer? This would be much more relevant in, say, street photography than in a studio, but it's important to know the difference.

5. Is it an unplanned or planned photograph? From the point of view of shooting this is one of the biggest differences of all. A genuine street shot is totally unplanned, a studio shot is all planned, but in between there is a huge range. And while a studio set-up is always what it appears to be, the same can't be said for reportage. Photographers are usually trying to make things work according to their idea of the image, and so asking people to move, or do this, or stop doing that, is extremely common. There is nothing inherently wrong with this, unless the image is presented as something it is not. At times, planning and intervention borders on deception (see page 118).

6. Thinking as a photographer in the same situation, what technical details are obvious? Note that this is important only if details such as the format of the camera (large, small) or the aperture or shutter speed, have a significant effect on the image. A slow shutter speed, for example, might impart motion streaking, but on the other hand it might be due to camera movement. And in either case it might be deliberate, or just inevitable, or even incompetent.

7. Are there any obvious styles or mannerisms used by the photographer? This could be anything from a virtuoso handling of light (see the image by Trent Parke on page 182) to an unexpected choice of timing. Some images wear more style on their sleeves, so to speak, than others. Some contemporary fine-art photography, of the uninflected variety, avoids obvious stylistic technique to such an extent that this itself becomes a style!

8. Getting down to the fundamentals, what was the purpose of the shot? The photographer's intent, in other words. Some images have more conscious purpose behind them than others, so it's easy to fall into the trap of crediting more deliberation than there was. And a good photograph does not have to be intellectual—it could be more visceral, less thought through, and all the better for it.

9. Are you missing background information that would help you understand and appreciate the image better? Often, of course, you might not know, but there are times when you might think to yourself, for example, "If the situation was what I think it looks like, that was a very clever way of dealing with it." Or more crudely, but unfortunately more commonly these days, a shot that could be amazing would be worthless if it turned out that it had been Photoshopped.

10. Finally, does the image work? Is it good? This means evaluating it in the light of the previous nine questions. But it is also the sometimes brutal assessment of question 8. You could distill the judgement of photography into three questions only: What did the photographer set out to do? How did he/she do it? Does it succeed?

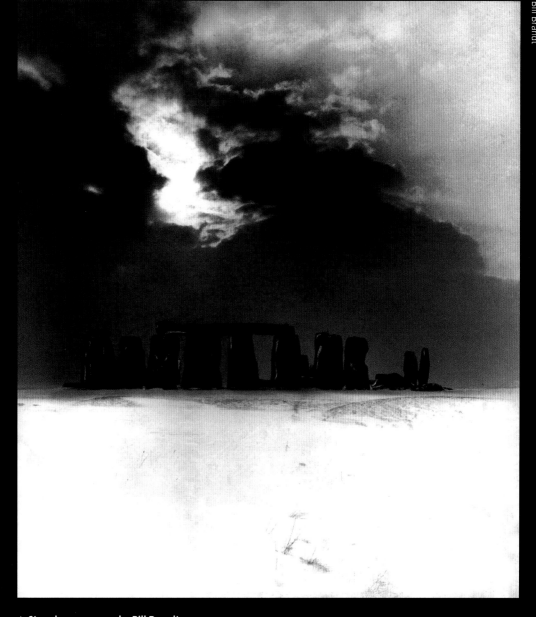

▲ Stonehenge, 1940s, by Bill Brandt

Britain's most famous Bronze Age stone circle has, of course, attracted the attention of countless photographers, but few have been able to escape the trajectory into cliché as strongly as Brandt, in this image shot for *Picture Post*. The dramatic printing style that Brandt evolved serves this scene particularly well—having waited a long time for the right weather conditions, Brandt enhanced the contrast of weight and solidity between stones and snow.

PART 2
UNDERSTANDING PURPOSE

Among the several ways of dividing the entire body of photography, the most usual is thematically, by genre. The expected answer to "What kind of photography?" is something like "landscape," "portraits," "photojournalism," and so on. Almost everyone is comfortable with this, but it's still worth asking the question, where do these genres come from? A commonsense view suggests that it is photographers who have defined it, because each genre calls on a well-defined set of skills and way of working.

Nevertheless, there are other influences at work. With the admission of photography into the contemporary fine-art market—and it is indeed a market—people other than photographers have had a say. Artists who use cameras but whose first concern is not photography are one group. Curators and gallery owners are another, and collectors too have a hidden effect.

THE GENRES OF PHOTOGRAPHY

LANDSCAPE

It is no surprise that landscape became photography's first genre, given that the camera was perfect for capturing how a place looked. That simple trick was what made photography so popular so quickly, and indeed the world's first photograph was a view over rooftops from a window. A slow view for sure, but landscapes were technically easy: they don't move much and they are brightly lit during the day. By the 1850s adventurous photographers such as Maxime Du Camp and Frances Frith were heading off with their bulky equipment to Egypt and the Holy Land, while on the other side of the Atlantic, once the Civil War had ended, their counterparts—William Henry Jackson and Carleton Watkins—were heading west.

Once landscape photography began to be taken seriously in terms of subject matter, viewpoint, composition, and lighting, it inevitably took much of its lighting and composition from painting. There were some technical problems with this, not least that the early images had to be in black and white, or toned. Moreover, early emulsions were orthochromatic, meaning insensitive to red light, and for landscape photography it meant that blue skies went pure white if the exposure was set properly for the rest of the picture. Some photographers, like the American George Barnard, went to great lengths to overcome this lack of interest in their skies, going as far as double-printing to add a sky—the nineteenth-century equivalent of Photoshopping. A few, like Timothy H. O'Sullivan, tried to make the best of this limitation by using the white block of sky as part of the composition.

Even landscape painting is not as old as many might think, because until the seventeenth century, such hills, rivers, and forests as appeared in paintings served either as backdrops for the foreground action, or were places to locate events and features. As religious themes dominated, these landscape backgrounds were generally "biblical," although relocated to more familiar territory such as Italy. Even when the landscape itself was eventually seen as a respectable subject in its own right, the religious references continued. The effect of this was to inject early landscape painting with a strong dose of idealization and the evocative, making things look good for an uplifting reason. The poet William Wordsworth summed it up when he wrote, "To every natural form...I gave a moral purpose."

The first great master of the landscape was Claude Lorrain, hugely influential, even on painters long after him like J. M. W. Turner. His techniques in paintings such as *Rest on the Flight Into Egypt* and *Moses saved from the Waters* evoked ideal and atmospheric vistas. The results were and are very appealing to a large public, and their effects can still be felt in a certain class of rich and sumptuous color photography. The pursuit of beauty in landscape photography has never gone away, even though contemporary approaches, as we'll see below, aim in quite different directions.

▼ **Canyon de Chelly, Navajo, 1904, by Edward Curtis**
Seven Navajo riders on horseback, accompanied by a dog, cross the floor of this Arizona canyon. Curtis' composition, by truncating the immense cliffs, gives an impression of their size more powerfully than would an image that showed all. The orthochromatic emulsion of the time overexposed skies; other photographers like Le Gray double-printed to retain sky detail, while Curtis used its blown-out whiteness as a compositional block.

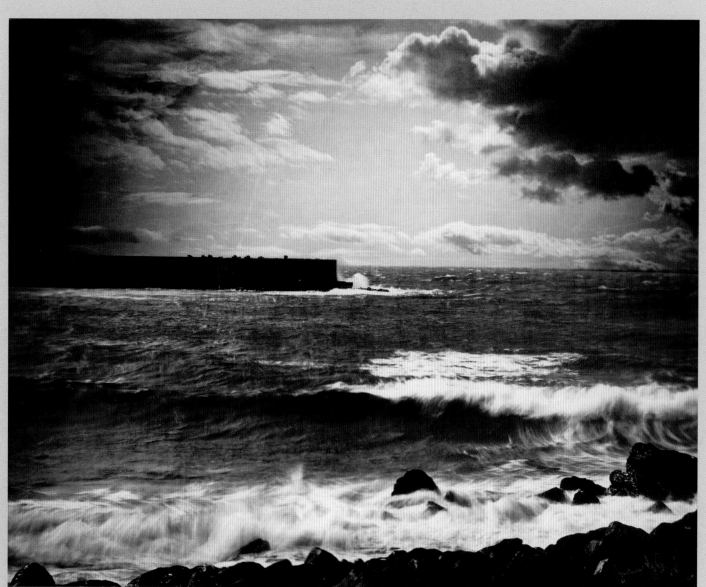

▲ **Grand Vague, Cette (Sète), albumen paper from two glass collodion negatives, 1857, 34.5 x 41.6cm, by Gustave Le Gray**
Marine painting was a popular genre from the seventeenth to the nineteenth centuries. Generally the Dutch were considered the masters at rendering water in its violent form, and the technical handling of texture, transparency and reflection was a greatly admired aspect of the genre. Le Gray took the genre into photography, though the most dramatic scenes and lighting that characterized paintings were not possible. The othochromatic emulsion of the time rendered skies well overexposed, and to overcome this, photographers like Le Gray exposed two negatives with different exposures, combining the two halves in the printing.

kind of photographer. Edward Weston, who was obsessed with form, had earlier decided that landscapes were not really for him. In 1922 he wrote that landscape was too "chaotic…too crude and lacking in arrangement." But two decades later he had something of a revelatory moment as he was being driven around Arizona (he always had someone else to drive, so that he could concentrate on the visual). As they came to an intersection, they passed a small advertising sign. "No! Back up; the sign is a part of it!" he said, and the result was *Storm, Arizona*.

But it was a later generation of photographer, notably Robert Adams, who performed landscape photography without any kind of celebration at all. Adams' aesthetic sensibilities are second to none, but he was far more concerned with the effect that despoiled landscapes were having on people. He wrote, "It seems so utterly naïve that landscape—not that of the pictorial school—is not considered of 'social significance' when it has a far more important bearing on the human race of a given locale than excrescences called cities."

As a genre, landscape photography has become a playground for all kinds of ideas, experiments and techniques. Landscapes are relatively docile as subjects, and their long tradition means that there is plenty to challenge. Some photographers have aimed for graphic, almost abstracted images, others have taken a restrained, laid-back, quietist approach. Rich, evocative and atmospheric treatments appeal to many, as does the drama of the sublime, and these can now be enhanced by increasingly sophisticated processing, ramping up saturation and contrast, for example, or using HDR techniques, or converting to strong black and white. Even infrared camera conversions have a new part to play.

As we saw above, under "Global Photography" on page 30, American influence was strong, and it was a very American view that landscapes should be…well, natural, rather than populated and worked over. The early years of photography coincided neatly with the opening of the American West, and the first landscape photographers were employed to make surveys rather than indulge their aesthetic whims. Timothy H. O'Sullivan began his landscape work at the age of 27, in 1867, accompanying the first of Clarence King's expeditions. Edward Curtis, three decades later, joined the Harriman Alaska expedition, and subsequently devoted his attention to the Native American way of life. Even though the American western frontier was officially gone by 1893, there were, and still are, huge areas of spectacular natural beauty, and celebrating them continued to be an American obsession. Landscape here means wilderness, and in the twentieth century the work of Ansel Adams more than anyone else embodies this.

Elsewhere in the world, the landscapes that interested most audiences were the work of man as well as of nature. A moderately inhabited landscape was evidence of civilization and a harmonious order. Integral to the "European" landscape tradition were signs of agriculture, landscaping, a few figures and isolated buildings (ruins have always had a special appeal). The boundaries were often blurred between landscape and architecture, which is the next genre we look at. If landscape featured habitation, the larger and more impressive structures, whether cathedrals, Egyptian pyramids or Hindu temples, helped to key the composition and give it focus.

It took a relatively long time for American photography to come round to the idea that man-made landscapes were worth photographing. When it did, it began to appeal to a different

◄ **Untitled, Denver, ca. 1970s, by Robert Adams**
An uninflected, highly formal treatment adds
documentary weight to the depressing awfulness
of tract housing despoiling the Colorado landscape,
and arguably does this more effectively than would a
more exaggerated photojournalistic approach.

◄ **Kirkjufell, Iceland, by Tim Rudman**
Selenium- and thiourea-toned lith print. Lighting,
viewpoint, and a sophisticated printing technique
(described on page 179) exploit the drama and
grandeur of Icelandic topography.

ARCHITECTURE

Architectural photography has great potential for being boring, which makes it all the more satisfying to see it in the hands of a photographer who can bring a building to life and at the same time produce a genuinely interesting image. Why boring? Because the photographer is always at risk of simply copying an already-created work. Not quite as unchallenging as copying a painting because of the three-dimensional complexity, but most commercially motivated architectural images have little in the way of spirit. Moreover, a large proportion of architectural imagery is commercial, to meet the demands of architects' offices, real-estate companies, and so on. Nevertheless, these are the works of man in the landscape, and so this is a subject with a long history.

Large-scale public architecture has usually aimed to impress and be a spectacle, and when it really succeeds at this, it makes a tempting subject for the camera. It usually celebrates something, whether the glory of God or gods, civic or national pride, or financial success. Salisbury cathedral, Oscar Niemeyer's Brasilia and the Beijing Olympic stadium all have this in common. All of this easily makes it too obvious a subject, and the world's major striking buildings are all heavily over-photographed. Even new angles and treatments quickly become familiar, and copied, so that good photography of A-list buildings needs to have something special on offer.

While the subject matter is among the most accessible of all, the service that photography could perform for architecture was, as the art historian Kenneth Clark said, to "discover values which would otherwise remain hidden." Architectural photographers have cause to be sympathetic to the work of the architect. Given that the subject is already a designed work, there is some further obligation to be faithful to it. The photographs of monuments by Frederick Evans and Eugène Atget are different in treatment, but both share these qualities of sympathy and

exactness of detail. Although Evans was less interested in documenting architecture than in rendering the qualities of light and volume, part of the value of his pictures and of Atget's for us is that each is an unsurpassed record of the material furniture of past times. None of the city views are the same today, and Atget was certainly aware of the need to document a Paris that was already changing. To a later generation, with no experience of these places at the turn of the century, such photographs are the reality. Even more than the private record in a family album, these images now stand in for their lost subjects.

Architecture that is less celebratory and more functional tends to attract less attention, which gives photographers more scope to find subjects and viewpoints that have not been worked to death by others. It also opens up the choice of what actually makes a good architectural subject, because most people have some idea, even if not articulated, about which buildings are worth making images of, and which are not. The popular view is that a special building is a better subject for a photograph than an ordinary building, but a number of photographers have had other thoughts about this. Eugène Atget was one of the first to take ordinary streets, houses and shops seriously, and between 1897 and 1927 he doggedly recorded his native Paris in a quiet, unmannered way, using a view camera and only occasionally including people in his shots. Self-effacing, and largely unrecognized during his lifetime, Atget intended, and offered, his photographs as "documents for artists," and through constant hard work accumulated 10,000 plates. Fame came late and strangely, through the Surrealists, who saw Atget's subjects as *objets trouvés*—as we'll see under "Capture to Concept."

Vernacular architecture is now every bit as significant for photography as the major works. In fact, its anonymity is the key for the acceptance of "architectural" photography into contemporary fine art. Lack of architectural greatness frees the photographer from being a mere copyist, making pictures of someone else's

▲ **Rue des Ursins, 1923, by Eugène Atget**
From the end of the 1890s almost until his death in 1927, Atget unassumingly documented the streets of Paris, eschewing the grand for the vernacular. He developed no self-conscious style, invented no new way of doing things, but rather maintained a well-crafted consistency. This appealed in particular to the Surrealists, and also to a much later generation of photographers interested in typologies.

grand vision. Instead, the photographer can impose his or her will and visual ideas without competition from the subject. Buildings that were not designed to impress anyone, but simply to do a job, range from the humble domestic to the commercial and industrial. This sense of ordinary and functional meshed perfectly with a general movement in photography that began around the 1970s, which rejected strong stylistic statements,

**▲ A Sea of Steps, Wells Cathedral, 1903,
by Frederick H. Evans**
He wrote, "The beautiful curve of the steps on the right is for all the world like the surge of a great wave that will presently break and subside into smaller ones like those at the top of the picture. It is one of the most imaginative lines it has been my good fortune to try and depict, this superb mounting of the steps…"

lush color, and powerful graphics in favor of an almost aggressive restraint. Bernd and Hilla Becher came to personify this approach, although they had been quietly cataloging obsolete industrial architecture in Germany since the late 1950s. Their completely uninflected, full-frontal imagery was matched by captions that read like factory inventories:

"GAS-HOLDERS

Gas-holders are reservoirs for balancing production and consumption.
They are constructed in such a way that their capacity can increase or decrease according to the gas content.
There are four principally different forms of gas-holders:

1. **A bell-shaped holder.**
2. **A screw principle.**
3. **Cylindrical holder.**
4. **Spherical gas-holder."**

We'll return later to the phenomenon of one genre migrating to another, as happened here, when a meticulous and impersonal recording of architectural heritage became recognized as conceptual art.

Within architectural photography, interiors have become a fairly distinct category, mainly because they seem to offer the possibility of showing how people live, or at least how they inhabit spaces. As "fit" subjects for photography have expanded to include almost everything in the last few decades, the most ordinary and personal of interiors have acquired fascination. The gamut is even wider than "exterior" architectural photography, ranging from grand spaces (cathedrals, palaces) through editorially popular interior-design images, to various forms of decrepit interior. Decrepitude has long fascinated photographers, and the modern versions include both derelict (abandoned factories and other buildings) and sloppily inhabited (the intentional and defiant opposite of *Elle Deco*-style flair and neatness).

PORTRAITURE

From the moment when it was technically possible to freeze an image of a person and overcome the twitches and little movements of a fidgeting face and body, portraiture became the camera's major use. Early portraits involved having the sitter hold still much longer than anyone would have liked, which gave a specific quality to the poses and expressions, but by the 1880s photographers in their studios were able to concentrate on other things, like coaxing a particular expression out of their subject or capturing what they thought was an appropriate mood.

This is one genre about which we are not short of opinions. For some reason, portrait photographers (and photographers who take portraits, not necessarily the same thing) have always been among the most talkative. There is little reticence about what works and how to set about getting it, and for this genre of photography I'm going to let the practitioners have their say. Yet note that the advice is often poles apart, and as usual, what photographers say about themselves reveals enormous differences.

First of all, in most portraiture there is a kind of contract between the sitter and the photographer about the outcome. As it is usually the sitter who is paying to have this done, the contract favors a result that is pleasing and even flattering. This is where the photographer's skill at beautification is expected. We'll meet this a number of times throughout this book, and it's worth remembering that most professional photography, and almost all amateur photography, aims at making things look good. Not everyone, however, has the same idea of what does look good, certainly not in portraiture. Most sitters want to look better than they are, with the fewest blemishes, wrinkles, hair loss, and so on. Photographers have a different kind of vanity, and so do not always comply fully with their subjects' wishes. Nevertheless, veteran *Life* photographer Alfred Eisenstaedt expressed it amiably when he wrote, "Making friends is second nature to me.

I like photographing people at their best. This means making them feel relaxed and completely at home with you from beginning." Even August Sander, whose rigorously objective portraiture of Germans in the 1920s was a landmark of documentary photography, maintained, "I never made a person look bad." But he added cuttingly, "They do that themselves. The portrait is your mirror. It's you."

One disputed fact, clearly central to portraiture, is how much a photograph reveals of the "inner person." Even, in fact, if such an entity exists. Countless photographers have claimed the importance of it, and claimed also their own ability at capturing the elusive quality. According to Paul Caponigro, "It's one thing to make a picture of what a person looks like, it's another thing to make a portrait of who they are." Eisenstaedt believed, as do many people,

▲ **Shanghainese Woman wearing a Snood, Shanghai, 1869, by John Thomson**
On his second, four-year stay in Asia, Thomson visited Shanghai at a time when it began to develop as China's most cosmopolitan city. As today, it became the center for consumption of foreign luxury goods, which included velvet, used for this hair-binding, given its Scottish name by Thomson. The relative insensitivity of the emulsion accounts for Thomson using a wide aperture and very shallow depth of field.

➤ **Varnisher, 1930, by August Sander**
One of Sander's extended series of typologies, part of
an ambitious project to record the entire spectrum
of the German people. Sander attempted a kind of
objectivity, although what we see is his own complex
method of selection, embracing (in his own words)
"the highest peak of civilization" and also "downward
according to the subtle classifications to the idiot."

photographers or not, that "In a photograph
a person's eyes tell much, sometimes they tell
all." Richard Avedon, typically oblique and
provocative at the same time, took this further
with, "I often feel that people come to me to be
photographed as they would go to a doctor or
a fortune teller—to find out how they are."

This is all getting uncomfortably close to
the psychiatrist's couch, and as so often when
artists talk about difficult things to describe in
their work, just a tad pompous. The opposing
view (always strong among photographers about
just about everything) was well put by Arnold
Newman: "I am convinced that any photographic
attempt to show the complete man is nonsense.
We can only show, as best we can, what the outer
man reveals. The inner man is seldom revealed to
anyone, sometimes not even to the man himself."

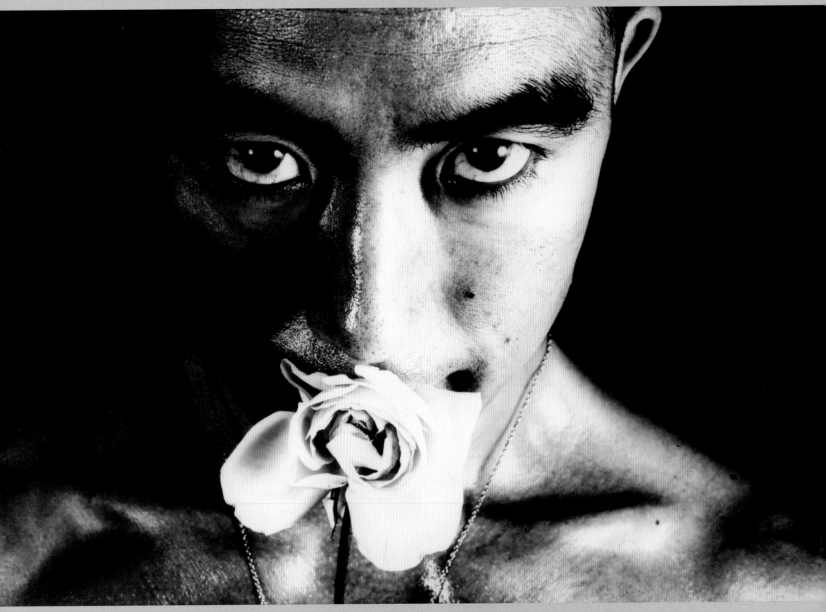

▲ **Ordeal by Roses (Bara-kei) #32, 1961, by Eikoh Hosoe**
With the Japanese writer Yukio Mishima as a model, Hosoe created a series of dark, erotic images centered on the male body, Ordeal by Roses (Bara-kei, 1963). The series (set in Mishima's Tokyo house) positions the writer in melodramatic poses. Mishima would follow his fantasies, eventually committing suicide by seppuku in 1970.

➤ **Garden party at the home of Joseph Avenol during a League of Nations session, Geneva, 1936, by Erich Salomon**
The German photographer pioneered candid photography, specializing in political conferences, courts and offices, taking advantage of the first miniature camera, the Ermanox, which appeared in 1924. Although it used glass plates, much slower to load than the 35mm film used in the Leica, its $f2$ and $f1.8$ Ernostar lenses were fast enough to be used in relatively low lighting. Salomon's dress and demeanor gained him acceptance into the circles he wanted to cover, and he acquired a kind of affectionate notoriety.

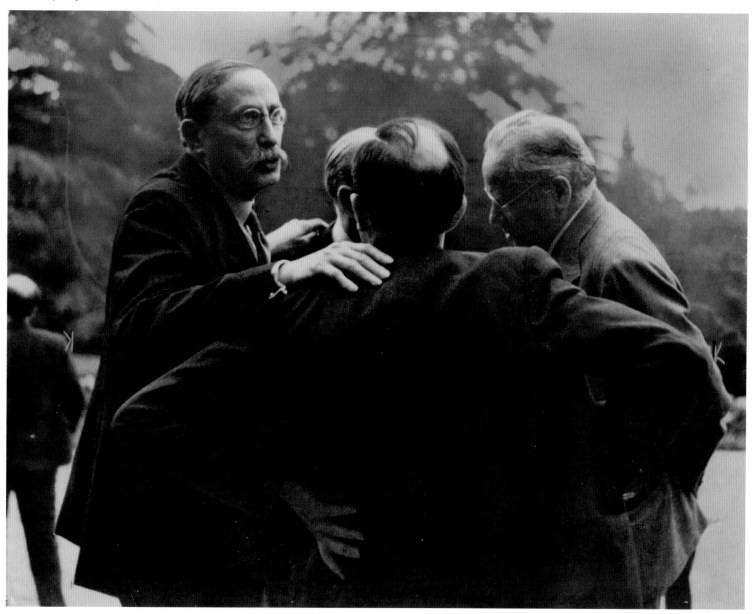

And the sitter's point of view? Often more pragmatic, being freed from the need that photographers have to refer to their craft. Abraham Lincoln remarked admirably, "There are no bad pictures; that's just how your face looks sometimes." Oscar Wilde found it an excuse to be witty: "The camera, you know, will never capture you. Photography, in my experience, has the miraculous power of transferring wine into water." Playwright George Bernard Shaw, who did a stint of male modeling, wrote, "I've posed nude for a photographer in the manner of Rodin's *Thinker*, but I merely looked constipated."

Another area of conflicting advice and opinion is the relationship between sitter and photographer. A fairly generous and commonsense view is that of Patrick Lichfield, who said, "Remember that the person you are photographing is fifty percent of the portrait and you are the other fifty percent. You need the model as much as he or she needs you. If they don't want to help you, it will be a very dull picture." Philippe Halsman allowed more to the subject, "It is the sitter's mind that controls the portrait a photographer makes, not the photographer's skills with his camera or with direction," while Arnold Newman put it down to relationship and understanding: "The more I get to know my subject the more he gets to know me, and so often the pictures taken at the end of a sitting are much better both creatively and interpretively."

Others favor a more adversarial approach. In Richard Avedon's view, "[The sitter's] need to plead his case is probably as deep as my need to plead mine. But the control is with me." Helmut Newton was more complicated: "To this question, 'What people do you like to photograph?' my answer is 'Those I love, those I admire, and those I hate.'"

PHOTOJOURNALISM

For many people, photojournalism comes closest of all to fulfilling the ideals of photography, because it makes the clearest and most obvious use of the camera's unique way of making an instant single record. This is essentially a Modernist view—using the technology for what it's good at—and photojournalism did indeed come of age in the 1930s. As soon as it became technically possible to shoot quickly and accurately in normal lighting, with a fast lens (as in the Ermanox) and with 35mm film (the Leica), it took off.

This timing of photojournalism's entry has much to do with its continuing ethos: independent, investigative, socially aware. From the 1930s onwards there was no shortage of war and social issues to report on. Photojournalists themselves have tended to the opinion that theirs is the purest form of photography, not least because of a sense of moral purpose. As Europe approached war in the 1930s, Cartier-Bresson commented, "The world is going to pieces and people like Adams and Weston are photographing rocks!"

One of the embedded ideals of photojournalism is that it can make a difference—an actual social and political difference. A landmark was Cornell Capa's exhibition and book *The Concerned Photographer* in 1968, in which the idealism that had been taking shape among photographers such as the members of the Magnum Agency was expressed coherently. Capa's expression describes humanitarian photography, but, as happens, the present is often defined in terms of the past. Lewis W. Hine, an early humanitarian with a camera, may have stated it best when he wrote, "There were two things I wanted to do. I wanted to show the things that had to be corrected; I wanted to show the things that had to be appreciated." The tradition of social awareness in photojournalism, which reached a kind of peak in the late 1960s when civil rights and the Vietnam war were major concerns, remains, although less editorial space today is allocated to uncomfortable issues. In Cornell Capa's view, "The concerned photographer finds much in the present unacceptable, which he tries to alter. Our goal is simply to let the world also know why it is unacceptable." The social and political views of those photographers who are "committed" have for the most part been liberal rather than conservative, also anti-establishment and concerned with the basic rights of the individual. Dan Weiner, whose work was exhibited in *The Concerned Photographer*, expressed the sentiments shared by such photographers when he wrote: "The thread of humanism has greater vitality than ever, even if abused today."

Images are a compelling adjunct to written reporting, and in the hands of an expert can even supplant words. For many photojournalists, the ideal is to tell everything, or as much as possible, within a single frame. Plan B is to tell a story through a selection of images—what came to be known as a photo essay or picture story (see pages 78–87). Either way, a central idea is that a story is being told. Or, at least, some part of a story. At a high professional level, photographers routinely think beyond the immediacy of a striking composition and apt timing. They look to convey more depth to the occasion. One example of this is the 1968 photograph of Ibo recruits in Biafra by Romano Cagnoni. Biafra's attempt to secede from Nigeria prompted a three-year civil war. Cagnoni spent this day shooting the induction and drilling of recruits for the Biafran army, and by late afternoon was still dissatisfied with what he had. He wanted to convey the numbers, the

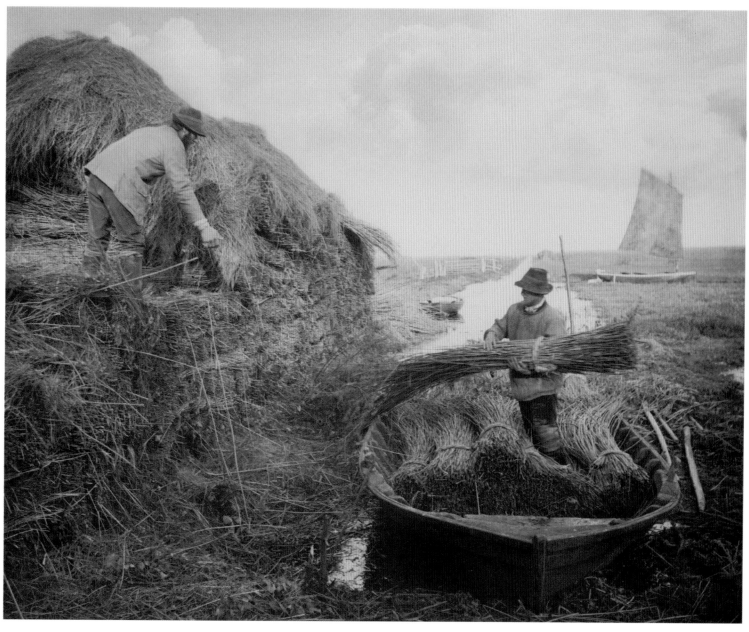

⋏ Ricking the Reed, Twixt Land and Water, 1886, from *Life and Landscape on the Norfolk Broads*, by Peter Henry Emerson
Taking a combative stance against contrived photography that mimicked painting, Emerson argued for naturalism, and while he fluctuated in his preference between sharp and soft focus, his record of an already disappearing way of life on the Norfolk Broads is one of the earliest attempts at photojournalism. This very finely organized image, with each element in its separate place, is one of his best.

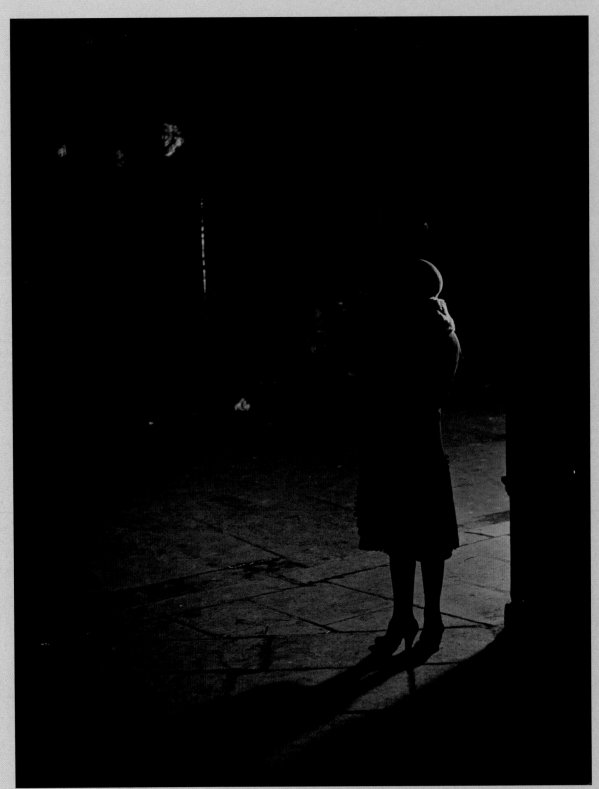

THE PHOTOGRAPHER'S VISION

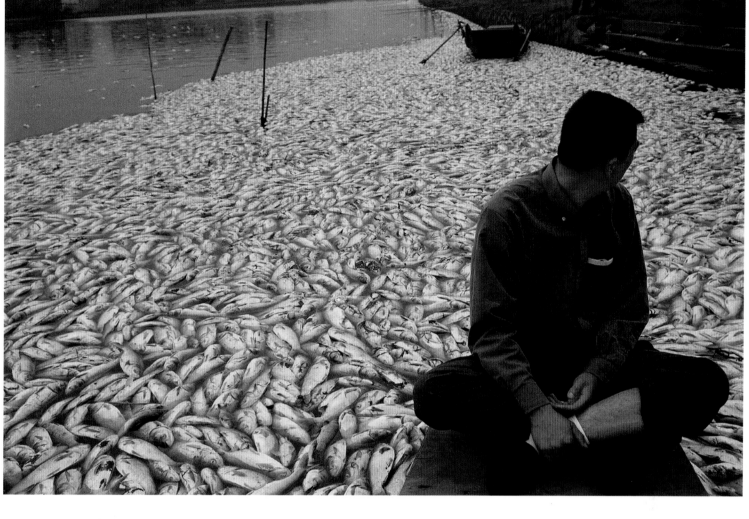
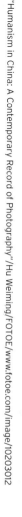

"Humanism in China: A Contemporary Record of Photography"/Hu Weiming/FOTOE/www.fotoe.com/image/10203012

▲ **Dead fish in polluted pool, Wuhan, Hubei, May 1999, by Hu Weiming**
One of the results of the Chinese economic reform program (another is under "Lives Unlike Ours" on page 103) was booming industry, without the Western-style restraints. Industrial pollution was widespread and often disastrous, and one legacy is that some large lakes like Kunming's Dianchi remain polluted beyond anyone's ability to clean them.

◄ **Bijou, 1932, by Brassaï**
The Transylvanian photographer Gyula Halász, whose adopted name was taken after his home town, specialized in night pictures, with his book *Paris de Nuit* making his reputation. Rather than the more convenient 35mm Leica, Brassaï preferred a Voigtlander Bergheil, a drop-bed folding-plate camera, and posed many of his scenes. His shadowy style of street photography, making use of silhouettes as in this shot of a prostitute, suited his preferred subject matter, the *demi-monde* of Paris.

anonymity from shaven heads and bodies stripped to the waist, and that these were young men being processed for war. As columns of them were being taught to drill, he spotted a balcony that offered a possible overview. Using a long lens—a 500mm mirror lens—Cagnoni was able to create a sense of compression and massing. This was for him a case of choosing a lens to create form rather than to solve a problem such as being too distant. Cagnoni does not care much for labels such as "photojournalist," and certainly images like this are at the other end of the spectrum from spot news.

The extreme, or high point—whichever you like—of photojournalism is war photography. The coverage of human conflict, with extremes of violence, is dangerous and demanding, particularly if the photographer aims to achieve all the usual goals of composition, timing and a

deep understanding of the subject. With danger, of course, comes romance, fostered in this case by movies such as *Under Fire* and *Apocalypse Now*. The latter was co-written by Michael Herr, author of the famous book on the Vietnam War, *Dispatches*, and he reputedly based the character of the photojournalist in the film, played by Dennis Hopper, on the photographer Tim Page. The great success of *Dispatches*, published in 1977 and written in a quasi-Gonzo style, probably did more than any other work to glamorize war photojournalism. Page is on record as saying, "Oh, war is good for you, you can't take the glamour out of that." Concerning himself and his colleagues, Herr wrote, "In any other war, they would have made a movie about us…" and then went on to make that happen, with Francis Ford Coppola.

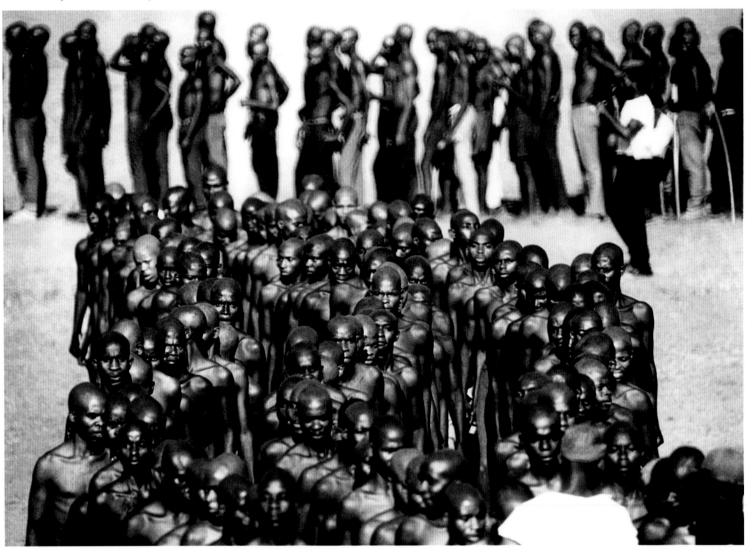

The reality is usually more ugly, as the Vietnam work of Philip Jones Griffiths (Vietnam, Inc 1971) and Don McCullin (Shaped by War 2010) show. Without sentimentality, Horst Faas, who was the Associated Press chief photographer for Southeast Asia, wrote, "I think the best war photos I have taken have always been made when a battle was actually taking place—when people were confused and scared and courageous and stupid and showed all these things. When you look at people at the moment of truth, everything is quite human…" Photographers like Griffiths felt passionately that they had to show just how bad war—and other areas of cruelty, inequality and suffering—were. There was a liberal, activist sentiment in the 1960s and early '70s that made this seem possible. Many editors also believe that there is a social service to be performed, although this may be tempered by the commercial demands of selling a newspaper or magazine. Indeed, social value is the only morally unassailable argument for photographing the bleaker side of human life.

The record of effectiveness, however, is not at all clear and probably never can be. The jury is still out on whether powerful images of human conflict and the inevitable intense suffering have ever had a practical effect. Raising awareness is one thing, provoking action to end conflict is another. Images such as the notorious *Saigon Execution* photograph by Eddie Adams received wide publicity (and their contents wide condemnation). But from a longer perspective it's difficult to point to any improvement they may have made. Julia Scully, former editor of *Modern Photography*, in looking for evidence of

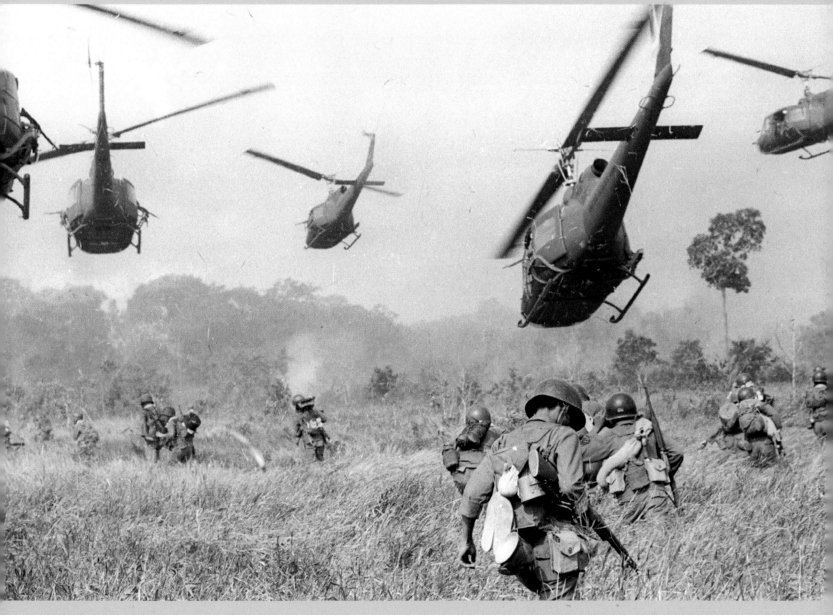

Horst Faas/AP/Press Association Images

◄ **Biafra, 1968, by Romano Cagnoni**
Ibo recruits for the armed conflict in which Biafra
tried to secede from Nigeria.

▲ **Vietnam War, U.S. Army/Vietnamese,
by Horst Faas**
Hovering U.S. Army helicopters pour machine-gun
fire into the tree line to cover the advance of South
Vietnamese ground troops in an attack on a Viet
Cong camp 18 miles north of Tay Ninh, northwest of
Saigon near the Cambodian border, in March 1965.

▲ **Gangotri, the source of Ganga River, 2004,**
by Raghu Rai
A sadhu sits in meditation in the strange landscape
at the source of India's holy river, the Ganges.
Rai, who has been recording India with a keen
photojournalist's eye for detail and juxtaposition,
writes, "Either you capture the mystery of things or
you reveal the mystery," he explains. "Everything
else is just information."

pictures that ever had any effect on the progress of a war, concluded that only Ronald Haeberle's photographs of the My Lai massacre in Vietnam played any significant part in turning public opinion. She added, "but that seems almost negligible considering that photographers have been documenting wars since Roger Fenton went to the Crimean front in 1855." As soon as photographers begin to look for universal visual truths, they run the danger of producing either images that no one could possibly disagree with, or else, if the image is genuinely shocking, of numbing the audience.

John Szarkowski dismissed the whole enterprise with, "Photography's failure to explain large public issues has become increasingly clear…most issues of importance cannot be photographed." There is some truth in this, although at the same time it did no harm for Szarkowski to claim this as extra argument for his view of the direction that photography should take, which was away from the earlier Modernist certainty—with photographers knowing exactly what they were doing—toward a more complex and fluid post-modernism, in which the curator would understand more of what goes on than would the photographer. In writing "The study of photography touches the broader issues of modern art and modern sensibility," he in effect was trying to push photojournalism back into its "place," and his basic argument was that photojournalism has bitten off more than it can chew, and is inherently too superficial to deal with complex events. The critic John Berger was more cautious, but still pessimistic about the effect that photographers of agony and violence have on the public; in an essay on the war photographs of Don McCullin, he came to the conclusion that any really shocking image merely brings out in the viewer a sense of his own moral inadequacy.

Not surprisingly, in view of all this, photojournalism excites passions like no other area of photography. It deals best with the specifics, not the broad picture, and the specifics are inevitably individuals caught up in events. It is, however, facing something of a crisis—a double crisis, actually. One cause is that assignments from supportive news organizations have plummeted, the other is a growing sense that photo opportunities are being increasingly stage-managed. On the gradual disappearance of assignments, former Magnum bureau chief Neil Burgess voiced this view in 2010 when he wrote, "Today I look at the world of magazine and newspaper publishing and I see no photojournalism being produced. There are some things which look very like photojournalism, but scratch the surface and you'll find they were produced with the aid of a grant, were commissioned by an NGO, or that they were a self-financed project, a book extract, or a preview of an exhibition. Magazines and newspapers are no longer putting any money into photojournalism. They will commission a portrait or two. They might send a photographer off with a writer to illustrate the writer's story, but they no longer fund photojournalism. They no longer fund photo-reportage. They only fund photo illustration."

The same disenchantment has been felt in other areas of the editorial world, even in areas that you might think were immune. In fashion photography, Jeanloup Sieff wrote, "Magazines were once produced by people who had something to say. People who had a point of view that you shared, or didn't share. Now magazines are produced by marketing people who only want to sell advertising pages. And the editorial part? Nobody cares." Norman Parkinson, though no photojournalist, summed it up for many when he said, "A photographer without a magazine behind him is like a farmer without fields." From the same area of publishing, Grace Coddington, creative director of American *Vogue*, remarked, "You've got to have something to put your work in. Otherwise it's not valid." We'll come back to this later, because it's at the heart of what is either a crisis or a turning point in all photography.

As for stage management applied to journalism, this is nothing new, but it is definitely now being attempted more regularly. Press offices, PR consultants and spin-doctors are regularly employed—by government departments, armed forces, corporations, individuals—not with the purpose of providing information and access, but of controlling it. They have a dual role, protection against the unasked-for attentions of journalists and photojournalists, and at the same time doing their best to create a favorable, scripted version of themselves and their activities through more amenable photographers. According to Elliott Erwitt, "Now very often events are set up for photographers," drawing parallels with what has curiously and pretentiously come to be called, "social photography": "The weddings are orchestrated about the photographers taking the picture, because if it hasn't been photographed it doesn't really exist." Honest reporting is frequently unpopular among those being reported. Even Mahatma Gandhi, and this might surprise you, said, "I believe in equality for everyone, except reporters and photographers."

▲ Polar bears sparring, ursus
maritimus, Hudson Bay, Canada,
by Frans Lanting

WILDLIFE AND NATURE

What we've seen so far—landscape (natural and man-made), portraits and photojournalism—are the big themes in photography. There are other, tighter genres, and the reason they are treated as such, instead of being just part of the larger themes, is not simply because the subjects are so specific. It's also because of what is involved practically in the photography. Wildlife photography is a perfect example. Animals have a very particular appeal to a broad audience, witness the popularity of television documentaries. But more than this, wildlife photography at a high level demands specialized techniques, the knowledge of a zoologist, heavy logistics and a full-time commitment. Top wildlife photographers do just that, nothing else. Field trips can last months, with repeated visits. Equipment dominates as in few other fields, with very long, very fast lenses at the forefront. It has sub-genres that are even more esoteric in their technical demands, and even less open to casual amateurs, such as underwater photography.

Over just a few decades, the standards of wildlife photography have rocketed—in reporting, in technical results and in creativity. It is, of course, highly competitive in the sense that there is a continuing demand for more amazing images, both moving and still. Current trends push in two particular directions: rarity and behavior. Never-before-seen images of, say, elephants swimming in the sea, or of a snow leopard in the wild are valuable prizes. In fact,

so much goes into being in the right place at the right time that the usual creative distinction between still and moving images (moments captured versus narrative flow) is quite small. Many wildlife photographers do both.

All of this means that when you judge a wildlife photograph, there is an almost ironclad case for treating it according to very specialized standards. This is not an area of photography that someone just picks up casually and succeeds because they have a quirky or special vision. Wildlife photography competitions (there are many) are more clearcut than most, and, as a subject, wildlife photography is comfortable for everyone who enjoys it. Pushing artistic boundaries is more or less irrelevant. Interestingly, this makes it less comfortable for people involved in contemporary fine-art photography. There is not much room for concept, and even less for the kind of interpretation that curators and critics love.

That said, a profound understanding of the subject and a sensitive eye for imagery definitely have their place. One of the most acclaimed contemporary wildlife photographers is Frans Lanting, whose approach is based on an understanding of, and full acceptance by, the particular animals he is photographing. He says this about it: "What my eyes seek in these encounters is not just the beauty traditionally revered by wildlife photographers. The perfection I seek in my photographic composition is a means to show the strength and dignity of

animals in nature." This, of course, is added to the technical and documentary qualities. Context, and a total, realistic view of wilderness are important—not sentimentalizing, in other words. Lanting's experience on assignment with sea elephants, who compete violently for mating opportunities, affected him for years, calling it "this experience of senseless violence, that lack of any compassion, a living hell." Unusual words for what is usually thought of as a "feel-good" genre.

It's interesting, if seemingly a little unfair, to compare standards of wildlife photography over time. The way they have risen, and the improving technical support from better lenses and more light-sensitive digital sensors, have reduced the perceived value of the work of pioneers as in no other genre of photography. For example, during the 1970s, one photographer who enjoyed a high reputation was Hugo van Lawick, shooting in East Africa. Like Lanting, he knew his subject, and spent more than fifteen years in the Serengeti. But, limited by the technology of the day, he was restricted in what he could capture.

Wildlife and nature photography is now taken more seriously than it was because of increased ecological awareness. Lanting says, "Since [the 1990s] wildlife photography has become an important kind of photography because many people are now interested in conservation. The fact that a species is endangered can nowadays have consequences in international politics."

SPORT

Like wildlife photography, sport has technical and access issues that set it apart as a genre. Otherwise, most of it would sit happily within, I suppose, photojournalism. Although the subject is contained and organized in a way that wildlife is definitely not, precise moments of action are critical, and long, fast lenses—the same as used in wildlife photography—are the prime equipment for getting close to that action. What makes a good sports photograph is usually a mixture of the importance of the event itself, the revelation of an exact moment in a way that ordinary spectators do not experience, and as a final touch for the very best of this kind of imagery, some visual elegance. Newsworthiness is important in

the short term, and sometimes lasts beyond the immediate sporting season. A winning goal in World Cup soccer, for example, automatically has the attention of millions. The revelation of an instant in time continually surprises, because although major sports are televised very efficiently, and the audience can see much for themselves, moments such as the beginnings of a major cycle crash, as here, are clearly special and unexpected. Viewpoint, the timing of a very experienced photographer who anticipates what may happen, the freezing from a high shutter speed, and that long lens again, are the hallmarks of the best in this genre.

˄ Crash on the Tour de Suisse, 2010,
by Christian Hartmann
The pack of riders including HTC Columbia's team rider Mark Cavendish (3rd from the right) crash during their sprint to the finish line in the fourth stage of the Tour de Suisse from Schwarzenburg to Wettingen, June 15, 2010.

◄ **Saltine Box, platinum print, 1922, by Paul Outerbridge**

STILL LIFE

It may seem odd for a genre that most people would think mundane, but arguably it took photography to make still life blossom. There are plenty of examples from painting, naturally, but not many great ones. Objects, after all, are rather lacking in personality and do not lend themselves to important themes. They often attracted artists more as studies than as major works, and at the same time there were fewer commissions for them than there were for portraits. Notable still-life paintings include *The Ray*, 1728, by Jean-Baptiste-Simèon Chardin, Van Gogh's *Sunflower* series, and the cubist experiments of Picasso and Georges Braque. Still-life as a subject for Cubism was to be expected. A completely arrangeable collection of recognizable objects made convenient subject matter for what was a revolutionary attempt at re-defining perspective and viewpoint.

And this was exactly the appeal for photography too. Still life offers the photographer total control, not only over lighting and other studio variables, but over the arrangement of things. Still-life pictures do sometimes move—when liquids are involved, for instance—but in general, the subject matter is so amenable that the photographer can experiment endlessly. It's little surprise, then, that still life has always been the strongest genre for formalism. As Modernism swept through photography in the 1920s, formal and geometric imagery became fashionable, particularly among magazine picture editors and in advertising. Influenced by the Cubist, Futurist and Constructivist movements in art, this style, of which Paul Outerbridge's *Saltine Box* is a good example, seemed to mesh with the advances in technology and manufacturing. The experimentation, which we'll look at in more detail later, under "Capture to Concept" and "Compositional Skills," was most conveniently done with still life, as Picasso and Braque had found. Photographers like Outerbridge, Hans Finsler and Paul Steiner played with abstraction, dramatic lighting, geometric framing and, above all, shadows.

Not only this, but one of the tenets of Surrealism that greatly appealed to photographers at the time was that the extraordinary could be discovered in the ordinary. Commonplace objects fitted the bill. Edward Weston's *Pepper No. 30* from 1930 may be iconic now, but at the time it was just a bell pepper. The setting was equally mundane—Weston put it in a bucket to shield it from direct sunlight and get the reflected light he was looking for. In early conceptual art, Marcel Duchamp's upturned urinal in 1917 (*Fountain*) was part of this process of liberating ordinary things to become fit subjects for art—and for photography. It was Alfred Stieglitz who photographed the piece itself, and who, according to Duchamp's biographer, probably threw it out as rubbish after the show. In any case, it disappeared.

Photography, moreover, enjoyed something new—commissions, lots of them. They were commercial, of course, but in a sense most art commissions are. Cheap branded goods like soap powders and toothpaste offer limited scope for creating art, but they demanded all the artistic skills that studio photographers could summon. Mass-market goods came with healthy advertising budgets, and by this means sponsored high quality still-life imagery. The best still-life photographers working commercially found ways of making some products, at least, into works of art. Irving Penn is arguably the most famous, and his principal patron was *Vogue* magazine, but there were others who transcended the basic material they were given to work with, including Paul Outerbridge, Hiro, Lester Bookbinder and Henry Sandbank. And inevitably, with a well-equipped studio that could be used to conjure up any imaginable lighting, photographers who spent the day shooting burgers always had a string of personal projects going at the same time.

Still life encourages a particular thoughtfulness about how the subject is treated and what it means, because the page is blank at the start. Robert Golden, whose food photograph is shown on page 64, writes: "All photographs are about presence— the sense of something having an existence of its own, possessing something distinctive, individual and representative of who and what we are. Objects, the material of still life, represent the hands and minds and arts and crafts that formed them. In that sense they are about a moment in history, an indication of a society's economic and technical level of development. Often, as in the case of religious objects, weapons and cooking apparatus, they are also signs of the deeper reaches of a culture's preoccupations. In that sense, the still life becomes a reading of history and therefore of the human condition. I saw an actor named Yoshi Oida speak about handling props on stage. He pointed out that if they had no importance they should not be on stage and if they did they must be handled to give them weight, meaning, and presence."

Bohnchang Koo

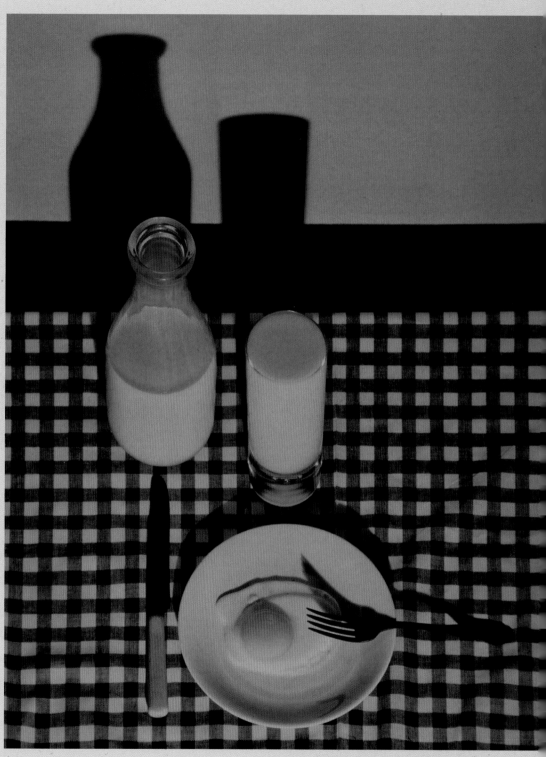

◄ **Original Vessel, Horim Museum, Seoul, 2006, by Bohnchang Koo**
Korean photographer Koo focuses on impermanence and the life of things as they pass through time, changing gradually and decaying. Art critic Hyunsook Kim writes that Koo "photographs images of the fragile and the fleeting, never the immortal, of distance and solitude, never attachment or survival. An object gets old from use, remaining indifferent to artistic intention and control, attentive only to its own unerring interior progression, which leaves its disappearing traces long after the photo has been taken, thus moving its past into the future."

► **Untitled, c. 1970, by Henry Sandbank**
Personal work by one of the established names in advertising still-life photography. In this genre, the commercial work that pays is bound by all kinds of client requirements. While a fellow professional such as an agency art director can understand the skill that went into shooting a Big Mac, say, the photographers need for their own sakes to set aside time to do personal work, and this plays an important role in the portfolio. Such shots show what the photographer is capable of when not restrained by the client brief. Sandbank takes what he calls an "askance approach," often including in his personal imagery "a playful twist or disturbing tension." In this, a well-known image, he takes "a familiar scene, the quintessential American farm breakfast," but makes it "subtly distorted for an almost nauseating effect." The sense of vertigo comes from highly skilled use of the front and back movements on a view camera, which creates an optical displacement. Sandbank added to this a harsh and precisely controlled lighting. It is worth noting that at the time, advertising still lifes generally favored soft directional lighting from large light banks—quite the opposite of this. While not conceived as a Modernist image, it nevertheless echoes the graphic sense of that period.

Untitled c. 1970 Henry Sandbank

Robert Golden

A more specific task of advertising photography is to develop one particular quality of subject as far as possible; often it is a non-visual quality—a smell, taste or texture—and this makes the problem more interesting. Food photography is an important sub-genre of still life, and again for commercial reasons has a healthy output in magazines, books, and advertising. Technical specialities, such as having a kitchen as part of the studio, and culinary knowledge, keep it very specific. Although rarely reaching the level of art, it furnished Irving Penn with some of his best-known still-life pictures. While much commercial food photography is relatively uninspired, concerned mainly with presenting specific dishes or products

as attractively as possible, the best expresses the sensuality of eating. A virtually universal aim is to present the food in as appetizing and decorative a manner as possible, but as much of food's delight comes from the sensations of taste and texture, lighting and composition are even more crucial considerations than they are normally. Photographer Robert Golden, whose work is shown above, says, "If you create a mood, then you create a sense of life, and within that sense of life you create the relationship between people and their experience of food. This is all a sensual experience; food is an integral part of the sensuality of life, just like sex. I don't think they're a far cry from each other, in fact."

▲ Smoked Fish, 1980s, by Robert Golden
With the aid of on-lens filters to soften and blend the elements in this food still life, as well as to hide what he calls "unseemly detail," the photographer was here concerned with how the subject is experienced: "The still life, as all photographs, must pay homage to the subject matter. The concentration of light, form, color, style, composition and technique combined with the photographer's sense of what the object is and represents creates the presence."

FASHION

Fashion qualifies as a special genre of photography for two reasons. First, it relies entirely on skilled visuals to bring it to life and sell it. Second, it needs constant, seasonal attention, and so there is a huge output of new imagery, much of it at a very high level of skill and imagination. The sheer size of the fashion industry, the publicity machines that it needs in order to generate seasonal sales, and its glamorous subject matter, all ensure that fashion photography has high exposure and is influential. Two magazines in particular, *Vogue* and *Harper's Bazaar*, both sponsored and controlled the way in which fashion photography developed creatively. Anna Wintour, American *Vogue*'s editor-in-chief since 1988, expressed one of the basic conflicts in commercial photography (and fashion is commerical) when she said, "Our needs are simple. We want a photographer to take a dress, make the girl look pretty, give us lots of images to choose from, and not give us any attitude," while on the other hand, "Photographers—if they are any good—want to create art." These photographers, at the top level, included Baron de Meyer, Edward Steichen, Cecil Beaton, Norman Parkinson, and Richard Avedon, among others.

▼ **Lily Cole by Miles Aldridge**
The model Lily Cole sprawls across shattered television sets, lit in counter-hues, inhabiting Aldridge's strange and unhinged world. Propelled to be different from the prevailing fashion style when he began ("lots of glamorous women on yachts, that sort of thing. Fatuous, really.") he combines, as he put it when describing the picture selection for a book, "innocence and dirtiness, charm and seediness, happiness and strangeness."

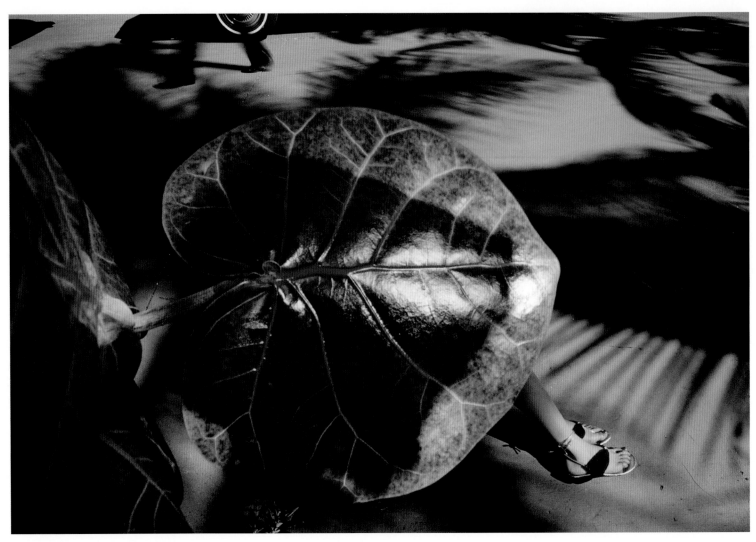

One relatively recent trend is for the top end of fashion photography to be considered worthy of entry into museum collections. Even admitting some self-interest on the part of museums who want to broaden their appeal and have hit shows, the best fashion photography, like the best still life, does transcend the ephemeral and commercial side of the business. The Victoria and Albert Museum in London, for example, has collected the work of British fashion photographer Nick Knight. Although fashion photography appearing in art collections may be new, it has always had relationships with art. Indeed, Lucien Vogel, legendary French editor and publisher, challenged Edward Steichen in 1911 to lend his fine-art reputation to the cause of fashion, and the resulting shoot was published in *Art et Dècoration*.

Rarely are genres completely isolated, and there are often border areas where one leaks into another. This has always been the case between still life and fashion, simply because of the accessories that need to be lit and shot beautifully and imaginatively. The shoe imagery of Guy Bourdin is one classic example. In New York, the Japanese photographer Hiro (Yasuhiro Wakabayashi), who had assisted Avedon, also made art from fashion accessories, including handbags, as well as more traditional fashion imagery. On occasion, it's hard to distinguish between still life and fashion, as when Irving Penn photographed Issey Miyake creations more as sculpture than as clothing for people to wear.

▲ **Image of feet under huge leaf, by Guy Bourdin**
Another image from the advertising campaign Bourdin executed for Charles Jourdan (the other is on page 35). Bourdin was allowed unusual freedom to interpret the manufacturer's product.

SCIENTIFIC

This description is something of a catch-all, but has in common a rigorously documentary approach that explores science visually, using highly specialized equipment, often to reveal previously unseen things. In the process, it has turned up imagery that surprises because it shows views previously unimagined. While the 1920s saw a surge of interest in science, the heyday of popular scientific imagery was the 1970s, when new imaging techniques and new scientific discoveries intersected, especially at the macro and micro level. The macro was the universe and space in general—planetary probes changed the way we thought about the solar system. The micro delved ever deeper in scale, producing such remarkable images as foetuses in the womb by Lennart Nilsson, and breaking boundaries of visibility with electron microscopy and ultra-sound. Even now, every time a science-based never-before-seen image is published it sparks a flurry of editorial interest, but the special circumstances of the 1970s, when it was all new, will probably not be repeated.

➤ **A Superconducting Quantum Interference Device (SQUID)**
Used for measuring magnetic fields and as an ultra-fast switch, in bubbling liquid nitrogen, used to cool it to superconducting temperatures.

WHAT FOR?

Long underestimated is the importance of understanding how a photograph—any photograph—is meant to be seen. This is typically relegated to the arena of presentation, a kind of showman's skill that happens later and may, or may not, make a difference to how an audience appreciates the imagery.

In fact, most skillful photographers not only have a very good idea of the workflow that their images will go through and how they should end up in front of viewers, but they plan and shoot to that end. Images will be re-purposed by others, certainly, and taken out of context, but when it comes to the intention behind a picture as the photographer shoots it, there is often a full line of reasoning that extends to its final use. Probably the strongest example of this is in photojournalism, in the shape of the photo essay, and we'll shortly take an extended look at this powerful form, highly innovative in its day. Simply put, photographers who shot for a photo essay in its heyday did so in a very particular way—and this was quite different from what they would have done had they been aiming for encapsulation of a single idea or image.

➤ **A soldier is saying goodbye to his wife and child who came to see him, Weichang, Hebei, 1987, by Feng Jianxin**
The photographer's aim is to encapsulate as much as possible about this poignant occasion in a single image. This is the strongest tradition in photojournalism, though not, as we will see later, the only one. Feng's image is notable for its elegant economy. We see all that we need to know from this pared-down composition and moment, including the soldier's stoicism.

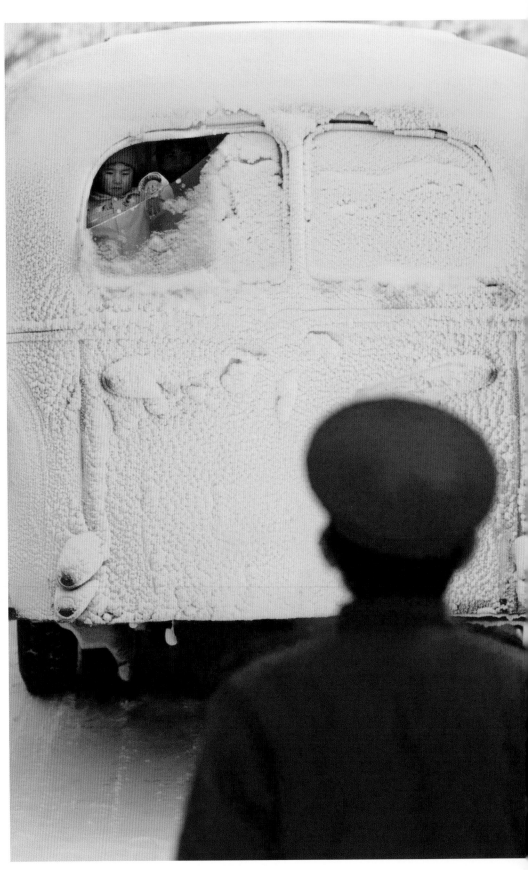

"Humanism in China: A Contemporary Record of Photography"/Feng Jianxin

THE PHOTOGRAPHER'S VISION

THE SINGLE PRINT

The majority of photographs are taken with just the single image that is framed within the viewfinder in mind—in the mind of the photographer. This one shot, standing apart from everything else, with the potential to be special. Most serious photographers, most of the time, aim for an image that will be worth concentrated attention. The default experience that this assumes—even if it doesn't actually come to that—is a print on a wall. This is the image as sole focus of attention, important enough for people to stand one by one in front of it and give it their undivided attention. I don't mean "print on a wall" to be taken completely literally, because most photographers do not have a succession of exhibitions showcasing their best work. It is, however, the ultimate expression of the single image, and even if not realized, is a kind of ideal. There are contemporary, Web-based versions of this (see below), but the principle of a special image that stands alone remains the same. Cartier-Bresson believed in this ideal, writing, "Sometimes there is one picture whose composition possesses such vigour and richness, and whose content so radiates outward from it, that this single picture is a whole story in itself."

The context in which you see a photograph will affect how you respond to it—which is the whole point of this section of the book. There is some mystery in this, but it doesn't have to be resolved in order to enjoy the result. In fact, photographs acquire a different personality when printed and viewed, even more so when larger than, shall we say, "hand"-sized. Many things are involved in this, including the materiality, or physical presence of the print as object. The size, too, has a significant effect, beginning with the simple response that size equates to worth—at least for any class of object that can vary from small to large. In practice, the size of a print affects the viewer's relationship to the space, because given the choice, everyone has a naturally comfortable viewing angle. Typically, people at an exhibition move backwards or forwards to find

the distance at which the view feels right. A large print pushes them back, and so demands a certain volume of space for the room.

Even this, however, is more complicated than you might think. There is, first, the concept of a "normal" angle of view that most photographers are familiar with because of "standard" lenses. The "standard" lens for a particular film or sensor format has a focal length the same as the diagonal of the frame. This gives an angle of view of between about 40 and 50 degrees—what you would get by standing about a foot and a half in front of a 16 x 20 inch print. That is a reasonable distance for many people, if a little on the close side. There have been a number of studies done for lit screens, from computer monitors to cinema, and the result is a number of recommendations from organizations like the U.S. Department of Labor, the SMPTE (Society of Motion Picture and Television Engineers) and THX, the cinema reproduction standard developed by Lucasfilm. Generally, these are for a viewing angle between about 25 degrees and 35 degrees. Lit screens place more strain on the eye than normal reflection-lit prints, but the recommendations translate well nevertheless.

Added to this is the issue of perspective. Lenses of different focal lengths have not only a practical value in allowing the photographer to cover more, or less, of the scene, but they create a visual effect for the viewer. This is familiar to everyone, especially the distorted and immersive wide-angle effect and the compressing, flattened telephoto effect. However, they work in this strong graphic way only when the print is viewed at a "contrary" distance. The true, "literal" perspective view, at which there is none of this visual effect, is straightforward to calculate: the original distance from lens to sensor in the camera times the magnification of the print. Enlarge an image from a typical digital SLR to a print 20 x 30 inches, and if the shot were taken with a wide-angle 20mm lens, you could view this from 66.9 x about 17 inches (a little over 40cm) and feel the perspective was normal. At the same

time, it would feel uncomfortably close for most people. There is, of course, nothing "right" or necessary about this, and most photographers who use fairly extreme focal lengths are actually striving for effect, not trying to eliminate it.

Finally, and, from a creative point of view, probably the most important influence, is the content of the photograph. Some images—most photojournalism, in fact—work best in their totality, seen and appreciated at a single distance. Others contain detail and the promise of more to be discovered by moving in and looking closer at a different scale of viewing. How close you need to approach a photograph in order to see all the detail possible depends on the resolving power of your eyes. People with good vision can resolve to one arc second, which means being able to see a millimeter gap or line from about 11 feet away. For what has become the standard for digital printing, 300 dpi, the distance is about two feet. These are ultimately personal decisions for the photographer and gallerist.

It's worth mentioning here that very small images have a special, miniaturist appeal which works in a particular way. Film photography provided an excellent reason for the miniaturist approach in the form of a contact print. In the nineteenth century almost all printing was done in this way, typically using sunlight, because of the low sensitivity of the papers available. When view cameras using glass or film negatives 8 x 10 inches or larger were common, the print was perfectly viewable, and well accepted at that size. The practice persisted with a few photographers into the twentieth century. Edward Weston did this, using a basic printing frame and a single bulb hanging from the ceiling. He manipulated the tones by dodging during the basic exposure time, followed by burning in for extra time. Though, as Ansel Adams pointed out, if the negative were dense, "it is difficult to see the image from above, and dodging and burning are not as certain as when the image is projected on the enlarging paper."

© Wang Qingsong/www.wangqingsong.com

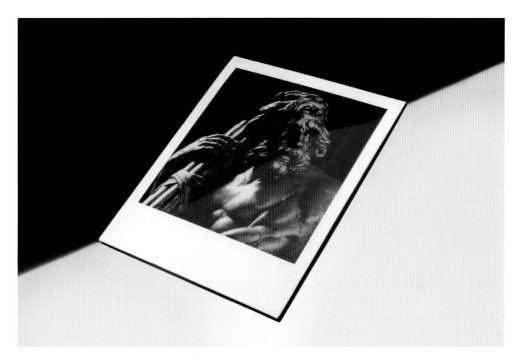

➤ **A Polaroid SX-70 print**
The 8 x 8cm image is encased in plastic, within a 9 x 11 sealed mount. This packaging, together with the slightly lustrous finish that is enhanced by the transparent plastic window, gives this kind of print a distinct physical presence. This, in turn, adds to its miniaturist appeal.

◄ **Competition, 2004, 70" x 51" (170 x 130cm), by Wang Qingsong**
Wang is one of China's most successful fine-art photographers, and works on a large scale in two ways: in the size of the tableaux he creates, which are often, as here, huge sets, and also in the size of the finished prints. The issue he tackles here is out-of-control advertising and promotion, and large scale is essential to show this. He writes, "I constructed a huge wall that stood about 14 meters high and 40 meters across, and then we posted over 600 pieces of paper (110 x 90cm each) on which I wrote in traditional Chinese ink-brush style in some instances and in felt-tip pen and magic marker in others, a random selection of slogans and phrases from the advertisements that bombard us here every day. These ads include both domestic and international information about companies and famous brands, such as the lease of houses, education programs, restaurants, foot massage, etc. Everything is advertised, from items as big as airplanes (eg. BOEING) or as small as vinegar and condoms. On my gigantic wall, I make the fight for advertising as fierce as a struggle for military power, with inevitable casualties on the battlefield. I have also included some of the famous brands that proliferate in China, such as Shell, McDonald's, Durex, Starbuck's, along with a few of the anecdotes behind them and the misunderstandings that arise in translating these into Chinese for a foreign audience. Altogether, I've used around 3000 varieties of products and services on my wall to show off the allure of this mass advertising campaign that surrounds us."

There was another advantage to contact printing—resolution. No optical softness or distortion is introduced, and the result is exquisite detail. Now, an 8 x 10 inch contact print is hardly a miniature, but film sizes became smaller in the twentieth century, and 4 x 5 inch and 6 x 6cm negatives had the potential for this new role. As did Polaroid prints, which were unique and not enlargeable in the normal way. Their aesthetic appeal borrows from miniature paintings, most famously Persian miniatures, although without the sheer admiration of technique that these inspire. As a viewing experience, there is a drawing-in, compelling the audience to come close and peer and study. This experience can be enhanced by displaying them within an over-sized overmat and frame.

At the other extreme are giant prints, measured in meters. From about 1980, an important change began to happen for photography and galleries. Gradually, gaining strength over the years, photography of a certain kind started to be conceived from the outset as belonging on a gallery wall and being large. The critic Michael Fried has pressed this view of contemporary fine-art photography, writing, "something started to transpire around 1980 when the pictures get larger and they get made for the wall. Once that happens they naturally engage with issues which have to do with their relation to the viewer." This is different from most photography, for which a gallery show was a good thing to have, but was just one incident in the life of a particular photograph. The new large images "made for the wall" by photographers such as Gursky, Struth, and Wall—all of them carefully constructed, not seized rapidly from life—were intended to be seen and studied in an exhibition space. The photographers are very conscious, more than ever, of the audience that will stand in front of the prints.

The amount of information that photographers are prepared to supply alongside images varies a great deal. With constructed fine-art photography, ambiguity and uncertainty may be an intentional part of the experience intended for the viewer. In some cases, such as the work of Jeff Wall (see page 125), the audience is expected to know the style of the photographer's work and have read something about it; Wall himself is happy to explain a great deal, probably because of his background as an art historian. But even with less deliberately conceived imagery, it is curious that very many photographers believe their best images can, and ought to, speak for themselves, without benefit of captions, explanation or context. This is a conceit that is at one and the same time completely understandable yet perfectly unreasonable, especially given that professionally-taken photographs are paid for to do a job, such as in a newspaper or magazine or as an advertisement. Sounds strange? Harold Evans' fifteen years as editor of the *Sunday Times* and *Times* left him under no illusions that "photographers and art editors tend to be snooty about headlines and captions," and that far too common was "the idea that words pollute photographs. This is a piece of intellectual debris from the early idea that photography was art or nothing." It gets its comeuppance in publishing (see below).

The question of size continues to exercise photographers who print, and while the trend now is very much toward something larger, there are still those who prefer the traditional 8 x 10 inch size, or even smaller. The arguments for large are not surprising: they demand more attention, they justify higher prices for the gallerist, and like widescreen cinema aspect ratios they more than fill the field of vision, giving the viewer a more immersive experience. Jeff Wall writes, "I don't like the traditional 8 by 10; they were done that size as displays for prints to run in books. It's too shrunken, too compressed. When you're making things to go on the wall, as I do, that seems too small."

The 8 x 10 inch and 16 x 20 inch were certainly the traditional print sizes for most exhibitions, and one reason was print quality. There are subtle but important differences between printing from a film negative and from a digital file. Leaving contact prints aside for the moment, all prints from film need optical enlargement. This inevitably introduces some slight softness, but it is widely accepted, because enlargement is a normal process. More significant is that the small-scale limit of the image in a negative is the grain, or more accurately, the clusters of grains. The pattern of grain clumping varies between makes and brands of film, and even when visible is by no means always considered a defect. The grittiness associated with big enlargements from Kodak's Tri-X, for example, are admired by many. Grain can perfectly well be seen as part of the very structure of the image, being embedded as it is in an emulsion.

Enlargement is a different matter digitally. There is no optical projection involved. Instead, if the print is to be larger than the actual size of digital file, software is used to interpolate upwards. This can involve sophisticated algorithms that in a sense actually introduce detail—detail that was not there originally but which looks to the eye as if it it should have been. This is typically combined with software sharpening, another quality unique to digital images. As it is possible to overdo any of the software processes to the point at which the image looks false, there are more issues of judgment involved than ever before. And images taken at a higher light sensitivity, measured as an ISO "speed," are likely to show noise, particularly in featureless middle tones, and the more so the bigger the enlargement.

Judgment of technical qualities like sharpness, noisiness and tonal range varies hugely between genres of photography and between individuals. Ansel Adams, as you might expect, was committed to the highest print quality, and this influenced the size at which he and his assistants typically printed. Despite the fact that he used

▲ **Andreas Gursky**
Paris, Montparnasse, 1993, c-print
Formal and geometric, its strict composition,
typical of this photographer's work, is achieved
by a montage of two images to maintain the full-
frontal aspect. The size of the image also reflects its
subject, and allows the viewer at least two levels of
experience: standing back for the scale, then moving
closer for the detail. This physical relationship
between the viewer in the gallery and the image is
one of the justifications for the contemporary large
print. This is a chromogenic print (wet darkroom, in
other words, rather than digital ink-jet), measuring
63 $\frac{1}{2}$ x 121 x 2 inches (161.5 x 306.5 x 5.2cm) unframed,
which means, of course, that it is taller than
the viewer.

mainly 4 x 5 inch and 8 x 10 inch cameras for his landscape work, most prints were either 8 x 10 inches or 16 x 20 inches, to the frequent surprise of many people seeing a show for the first time.

Contemporary large-print photographers such as Andreas Gursky and Edward Burtynsky keep the same commitment to detail, but for slightly different reasons. Technically it is more demanding to plan and shoot for prints that are a meter or more in length (Gursky has gone as far as five meters, joining together a number of large sheets). The need for detail is really because images such as *99 Cent* present two aspects. One is the large view from standing back. The other is the minutiae of many similar small units making up the whole. Standing back and moving close, then back again, gives a very particular viewer experience, which incidentally works to destroy a clear sense of perspective and point of view. By the time a viewer is looking at tiny details from a few inches, he is immersed within the scene. There are occasional aberrations; Gursky's *Kuwait Stock Exchange 2007*, which is three meters tall, reveals very strong noise, which seems at odds with the essence of this kind of print.

While methods of framing and hanging add subtle differences to the experience of viewing (see the Tillmans show, page 76), a marked alternative is a backlit transparency. Conceptual photographer Jeff Wall (see page 125) uses this method, which involves making a large Cibachrome (silver-dye bleach process) transparency from the original, and mounting it on its own, purpose-built lightbox. As explained more fully later, under-color and not-backlit images display a wider dynamic range and in color look richer, all for sound technical reasons. This can be a powerful effect when the image is large, as in this case. It also alters the relationship with the viewer visiting the gallery, and the increased interaction between image and viewer is a large part of what big gallery photographs are about. A large backlit transparency tends to take over the attention much more than a print. Reproduction in a book, as here and despite the high-quality reproduction and color accuracy, fails almost completely to convey the experience of looking into a transparency suspended in its own lightbox.

For a different sensibility to resolution and print quality we need to turn to photojournalism. A considerable number of photojournalists see technical print quality as less important than the content. Even if the shooting technique is rather rough, it may matter very little, the important thing being that the shot was taken in the right place at the right time. Perhaps paradoxically, while the technical side of cameras and lenses improves, more and more pictures are being taken with low-tech equipment, like mobile phones, and one result is that there is a greater acceptance of rough technique. Eamonn McCabe, a former picture editor of the *Guardian* newspaper, uses the term "raw." In talking about his book compilation of images from the first ten years of the twenty-first century, *Decade*, he said, "What's happening more and more now is that we're in a business of images from news events taken on a mobile phone, and in the world of news and television news it doesn't matter how raw it is as long as it's from the right place." They can still end up in a book or on the wall. For the classic example of this, see Robert Capa's image of the D-Day Normandy landings, discussed on page 141.

THE CURATED SHOW

If an increasing number of photographs are being taken "for the wall," in Michael Fried's phrase, the step beyond that is a complete exhibition. This is a body of work, conceived for presentation in this way, and while it may coincide with the publication of a book or exhibition catalog (which can amount to much the same thing), the driving force is a multiple hanging. This may include earlier archival photographs to make up the number of images, rarely fewer than 20, but of more interest here is the show which is planned well in advance, before the photography.

As we'll see shortly when we come to published picture stories and photo essays, the dynamics of picture selection (and by implication picture taking) differ greatly between gallery and magazine. Gallery shows are usually built around sets of images, often a single set, so that similarity and a linking theme are typically seen as necessary. Magazine presentation is much more likely to emphasize variety, with art directors deliberately setting one picture off against the other.

For a detailed look at how this works, here is a 2010–2011 show of still lifes by John Stewart, who studied under Alexey Brodovitch, art director of *Harper's Bazaar* in the 1940s and 1950s, and shot for *Vogue* and *Look*. The show, curated by Tristan Hoare at the Wilmotte Gallery, London, explored the photographer's forty-year interest in still life, and featured a total of 53 prints, in three sets, including a folds and draperies series, flowers and found objects in a Ming village in China. The print sizes were 40 x 50 inches and 90 x 75 inches, and three print processes were shown. One of these was the Fresson Process, a variety of charcoal printing invented in the nineteenth century that uses pigments instead of dyes. Still maintained by the family studio, only 2000 prints a year are produced because of the several hours of work needed for each print. The common theme was transience, as Stewart explains. "All my pictures are based on the traces that time leaves behind. It could be something very transient, like a fold in a piece of cloth, or something much longer-lasting, like a worn-away stone." He continues, "Some photographers never set foot in a laboratory; they don't care about the print. For Cartier-Bresson [a personal friend],

▼ John Stewart exhibition at the Wilmotte Gallery, London, summer 2010

for example, the only thing that mattered was the instant of taking the photograph. For me, it's the final product that matters. The texture of the picture—what I call the grammar—comes from the printing."

But things are changing. Wolfgang Tillmans hung his own 2010 show at the Serpentine Gallery in London, and made a deliberate effort to challenge the usual homogeneity of presentation. This was a show conceived for the gallery, and the wide range of Tillmans' interests and work, from portraits to abstract still lifes and even more abstract camera-less images, was matched by a variety of presentation. Meticulously and traditionally framed and glazed photographs hung alongside naked prints taped to the wall, or in one case a door. The largest print was hung with clips without a frame, and a set of color prints were partly folded and mounted in perspex boxes. This all-embracing, every-way-works approach is part of what Tillmans' photography is about, but it may also be a forerunner of a less traditional, more experimental way of hanging photographs that is likely to spread. Though this is just a prediction.

➤ **Wolfgang Tillmans' Installation View, Serpentine Gallery, London, summer 2010, photograph by Gautier de Blonde**
This was notable for the variety of hanging, which breaks out of the predictable mold of frames.

THE SINGLE PUBLISHED IMAGE

From spot news to an insertion in a larger story in a magazine or book, photographs destined for repro, as it's called, are one of the staple commodities of editorial photography. It's true that nowadays much of this is secondary use coming from stock libraries, and as such is not so interesting—it has no effect on what most photographers actually do. (There is a minority exception: stock photographers, who shoot specifically for this all-purpose purpose, but by the nature of the business, it is rarely innovative photography). The spot news picture is probably the most concentrated and focused form of this kind of image, and at its best demands a huge amount of concentration and energy. This kind of shooting is highly competitive and immediate, adding greatly to the pressure which any photographer is under to produce a powerful image from an unfolding event.

➤ **Talmud students, Mukacevo, c. 1935–38, by Roman Vishniac**
In the 1930s, Vishniac, who was born in Russia, made trips to Eastern Europe on behalf of the Joint Distribution Committee, a Jewish relief organization. He was tasked with propagandizing for a fund-raising project, which meant concentrating on poor and religious life. His photographic coverage was powerful and successful, but the way it was presented, particularly in his 1983 book *Vanished World*, concealed the fact that he was commissioned to document only the poor and the Orthodox. In print, especially, the accompanying text description can alter perceptions strongly.

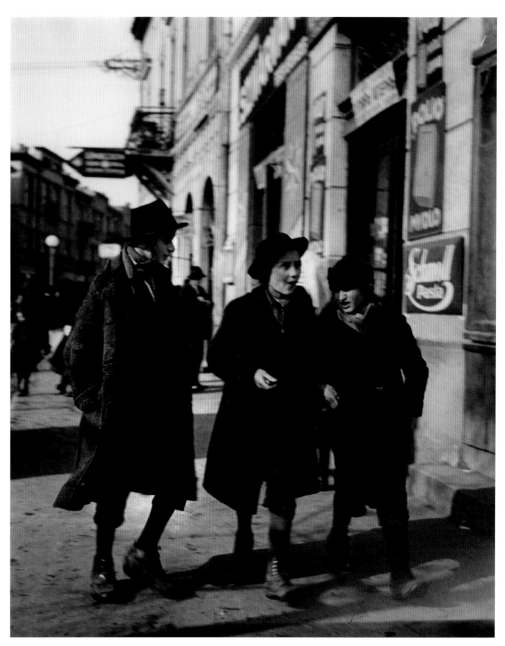

© Mara Vishniac Kohn, courtesy International Center of Photography

Many of the events covered by spot news photography are well enough known to attract many photographers to the scene, which is what makes it competitive. In addition, the images have to be filed as quickly as possible, because the news media itself is competitive. What it means for the photographer is actively hunting down a scene, a moment that will encapsulate what is happening, be strikingly eye-catching, and beat the other photographers to publication. In reading photographs such as Philip Jones Griffiths' and Tim Page's images on pages 160–161, it is essential to appreciate this context, because it explains the relentless concentration on subject, clarity and moment—decisive moment. The repeated theme in this book is that photographs need to be read and appreciated in the context of what they set out to do. In the case of a news photograph such as Brigitte Dahm's image on page 145, playing conceptual games with the "meaningful" moment is completely out of place.

There are some other things that the photographer can anticipate. One is that he or she will have absolutely no say in what happens to the picture. That is what the editors, and in particular the picture editor, will decide. It will almost certainly be cropped, and while photographers from other areas see this as interference, and anathema, for the news world it is a creative form in its own right—just that it's one practiced by art directors and picture editors, not by photographers. Harold Evans, former editor of the *Sunday Times* and *Times*, and author of *Pictures on a Page* (still by far the best book on the editorial use of photographs), distinguished between "routine" and "creative" cropping. By this point the image is well out of the hands of the photographer. Routine cropping tidies the image up and shapes its purpose in order to support the story. Creative cropping, in Evans' words, either "rescues an apparently dull photograph," or is "the recognition that a portion within the picture is really its main story."

Another change to the nature of the photograph is that it will acquire a caption, always. Wilson Hicks, photo editor of *Life* magazine from 1937 to 1950, made it perfectly clear when he wrote that "the basic unit of photojournalism is one picture with words." He considered captions to be an "equal partner" of the photographer. Many, if not most, photographers would howl in dismay at this. Cartier-Bresson was decidedly snooty when he wrote that for a well-taken photograph, the only caption needed should be where and when, while "the who or what and the why are incorporated in the subject—or should be—and the how is unimportant." Photographers are rarely permitted anywhere near the layout room. It was an unusual privilege when one day Ed Thompson, the editor of *Life*, allowed me in to a picture selection on a story I'd shot, but I pushed my luck when I suggested I write a caption. "No you won't," he snapped back.

THE PHOTO ESSAY

Most people think of photographs as single units, but this not at all always the case, even in the mind of the photographer. What did more to change this than any other concept was the photo essay (or picture story). This is much more than a simple grouping of images on a page, and has been a formative influence on editorial photography since around the 1940s. The work of at least two generations of editorial photographers, including W. Eugene Smith, Larry Burrows, and Alfred Eisenstaedt, acquired its form and personality because of the photo essay. In the world of appreciating photography, this has received far too little attention. Good photo essays deserve to be seen as they were printed, laid out in sequence. They are an art form in their own right that both enhance the photography and at the same time use it. We can't match the size of the original stories here, but we can do justice to the layouts.

Illustrated newspapers and magazines began using images before photography. In the nineteenth century, reporters for publications like the *Illustrated London News* sent reporters with sketchbooks, and their sketches were worked up into printable images by engravers— often taking great liberties with the view. What might seem odd to those of us raised on digital photography is that it was the introduction of the camera that put an end to frequently outrageous manipulation of the visual "truth." First the camera, then in the 1890s the halftone printing process allowed photographs and type to appear on the same page. This combination was crucial, and remains so, because only this combination allows a story to be told in print. The words are essential, even if they are limited to just headlines and captions—a point often missed when people look at and discuss editorial photography.

Once photographs of events started to become available in quantity, which happened because of the rise of the photo-agency, art directors began to think of illustrating stories with more than one photograph. In this way, they could make editorial points with a particular selection. The earliest arrangements and sequencing of photographs at the turn of the twentieth century were simple and usually in chronological order, but the process had begun. It evolved, with editors choosing themes and making "statements" by means of picture selection, until it reached full maturity in *Life* magazine.

Another point often missed in looking at editorial photography is that in some ways photographs are more subtle than words, meaning less definite, more ambiguous, less easy to hold to account. Selecting and arranging photographs in a certain way allowed an editor and art director to create an impression, whereas words alone would have had to be more definite and declare what was being attempted. For an extreme example, you can do many things to annoy or upset or misrepresent people with a "true," un-manipulated photograph of them, but libel is much more difficult to prove without the accompanying words (most libel cases involve written statements). This ability to create an impression without necessarily spelling

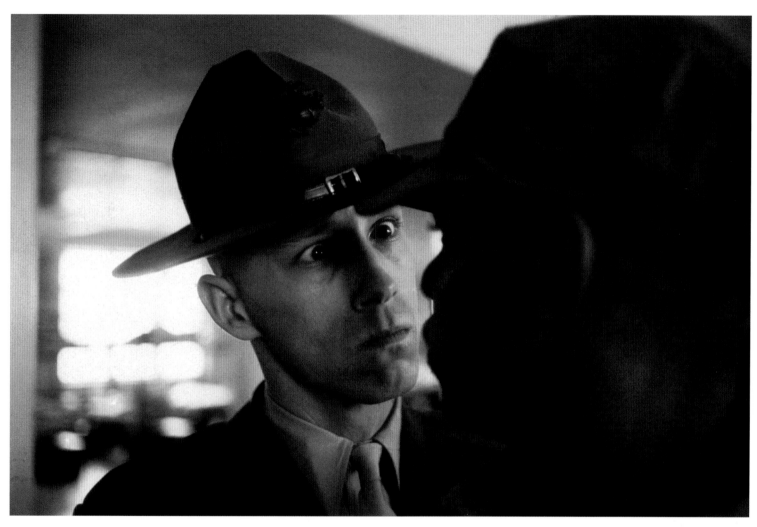

everything out had considerable appeal, and eventually allowed the photo essay to become its own creative work.

Life magazine took the photo essay to new heights, deliberately and with great attention to detail. From the late 1940s into the 1960s, the classic *Life* photo essays were brilliantly conceived and artfully produced masterpieces of visual storytelling. Little was left to chance. A great deal of research went into planning and executing, photographers were chosen who were thought would match the story, and expenses were available to do whatever needed to be done. The man widely credited as the pioneer and

master of the photo essay was W. Eugene Smith, working for the magazine, particularly between 1948 and 1954. One of the classic early picture stories was "Country Doctor," which Smith shot on assignment for *Life* magazine in 1948. It took four weeks, longer than the editors anticipated, as was usual with this photographer. This is widely regarded as the first modern photo essay, and indeed, Smith is considered by most to have perfected the form, although of course this was in the context of *Life* magazine's commitment to running picture stories. Considerable preparation went into the story, beginning with finding two things that the magazine thought important: a

▲ **A drill sergeant delivers a severe reprimand to a recruit, Parris Island, South Carolina, 1970, by Thomas Hoepker**
From a photo story on the U.S. Marines Boot Camp on Parris Island. As shown on the following pages, photo essays were intended to be seen whole, as a set of images interacting with each other. Nevertheless, the more powerful ones are usually extracted to live as individual images, as this one from Magnum photographer Hoepker.

scenic setting and an attractive-looking person. Smith himself had no qualms about organizing a story to ensure that the pictures would be strong, an issue we explore further under "Intervention" on page 152. Smith wrote, "The majority of photographic stories require a certain amount of setting up, re-arranging and stage direction to bring pictorial and editorial coherency to pictures…it is done for the purpose of a better translation of the spirit of the actuality, it is completely ethical."

Ed Thompson, who joined the magazine in 1937, and who from 1949 to 1961 was its most famous managing editor, controlled the story. "Somewhat like Gene," he wrote, "the doctor was intense, worked grueling hours, and was compassionate. No one had to suggest what individual pictures Smith should take; he knew instinctively." In fact, the editorial construction of the story is on two levels. The surface level, the most obvious, is a human interest story that works on the emotions. The readers are given a privileged insight into the life of a sympathetic and important member of a community. *Life* researched the location—it needed to be attractive—and the doctor, who was chosen partly for his looks. But there was another level, reflecting policy, as described by Glenn G. Willumsun in his book *W. Eugene Smith and the Photographic Essay*. This is a story about the modernization of medicine at a local level. *Life* took a conservative stance against the Truman administration's plans for national health insurance, and the message of this story was that local communities were perfectly capable of looking after themselves. Note how the opening image, which was set up, is a traditional view of a doctor making house calls, bag in hand. In the closing shot, however, Ceriani looks more like a surgeon, and in between, most of his work is shown at the hospital. The contrast is intentional—the narrative is about modernization and local competence. Thompson explained, "Art director Charles Tudor and I laid out this story. Gene and I argued a bit about using the exhausted

doctor with his cigarette and a cup of coffee as a full-page picture to end the essay, but I prevailed. I never heard a complaint thereafter. Dr. Ceriani became famous." This last shot was also set up, and the out-takes show what an awkward position he is holding, with his feet splayed out uncomfortably, in order for Smith to get this precise angle.

A longer, equally classic photo essay by Smith was "Spanish Village," which ran in 1951. Spain at that time, under Franco and not long after World War II and the Civil War immediately before, was little known to the outside world. *Life* wanted access, and this was duly secured, with some difficulty. Ed Thompson wrote in his autobiography, "As was the case with the doctor, Smith's 'Spanish Village' essay would not have been possible without advance work by *Life*'s correspondents. We wanted to have some kind of look at the closed society that was Franco Spain."

Smith spent several weeks in the village that they found, as usual much longer than planned. The same considered effort went into the layouts, each working a spread at a time, with images juxtaposed both for what they showed and for variety of graphic arrangement. This latter can best be appreciated by looking at the spreads from a distance, seeing the images and text as shapes. However, more than in "Country Doctor," Smith succeeded in making two extremely powerful images that could have stood alone in their own right. One of them, indeed, was treated that way by the editorial team. Thomson wrote, "Although he said he was avoiding a political statement, Gene conveyed a strong impression of stern governmental control with his portrait of a trio of Franco's Civil Guards. What gave the essay universality was a two-page photograph of a grieving family around the coffin of a husband and father." This image was run as a bleed double-spread, the ultimate presentation in a magazine.

Smith really understood how a photo essay worked, and shot to that end, to tell a story. Most other magazine photographers did the same, but by no means everyone fell into place. One of the sticking points was authorial control, which was

ultimately in the hands of the magazines who commissioned. They were more than clients who used photographs; they involved themselves deeply with the imagery to the extent that they created something new out of it. Smith understood this, did not at all object to the assembly of pictures to manipulate an audience and deliver a message, but he wanted to be in charge of doing it. Despite his ability, and value to *Life*, he lost the fight.

But there was objection to the photo essay from some other photographers, who thought that it devalued the single image. Cartier-Bresson championed this view. Writing about the exceptional single image, see page 78 above, he continued, "But this rarely happens. The elements which, together, can strike sparks from a subject, are often scattered." So, he conceded, a story could be put together from several pictures: "The page serves to reunite the complementary elements which are dispersed throughout several photographs." Reading his commentary on the photo essay, it's hard not to be struck by a kind of resigned irritation that he appeared to feel. The photo essay seems, according to Cartier-Bresson, to be the next best thing if you were unable to get it all gathered in one successful frame.

➤ **"Country Doctor," with photographs by W. Eugene Smith, which ran in *Life* on September 20, 1948**
Even with individually strong images, such as the photograph of the doctor tending a child on the fifth page, the 28 images were intended to be seen together and in this exact form, as a means of telling a two-layered story.

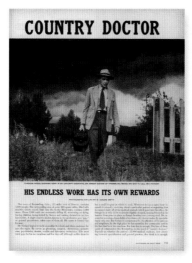

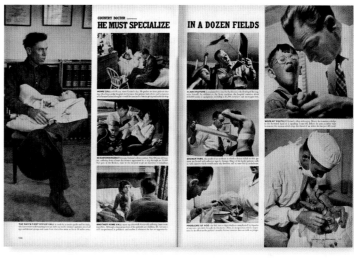

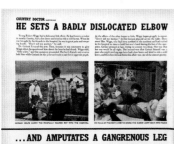
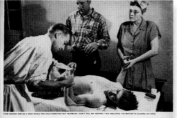
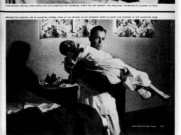
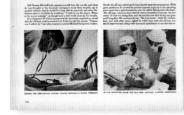

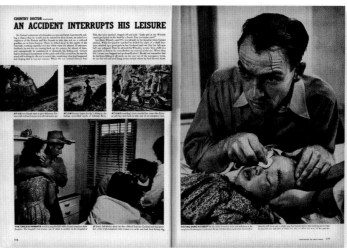

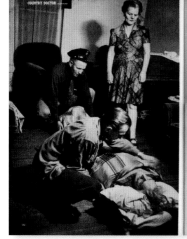
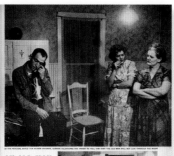

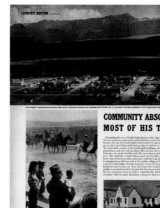
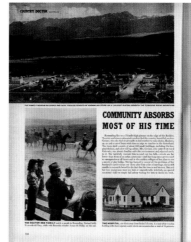

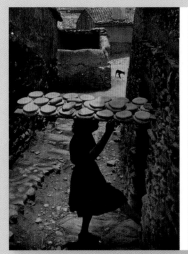
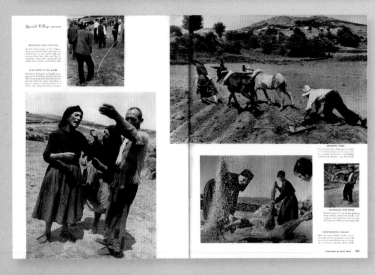
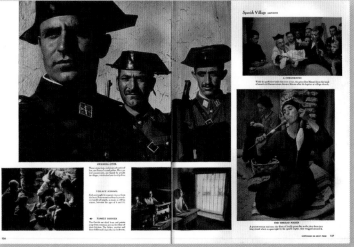
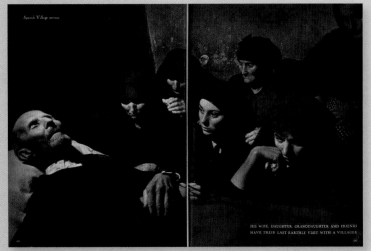

▲ The "Spanish Village" story,
with photographs by W. Eugene Smith,
which ran in *Life* on April 9, 1951

THE PHOTOGRAPHER'S VISION

This colored his view of how to execute an assignment, and it's a view held by quite a number of editorial photographers. While acknowledging (a little condescendingly) the "great art of the layout man," he was adamant that the photographer should have nothing to do with it, and "when he is actually taking the pictures for his story, should never give a thought to the ways in which it will be possible to lay out those pictures to the most advantage." This is a curious statement of self-denial, because it assumes, quite correctly, that a professional photographer shooting a photo essay can indeed work out in advance where and how images might go. It is at odds with the way in which most photographers worked for magazines.

A more immediate, compressed sequence was the single event, which by its nature was unplanned. One of the strongest and most celebrated was Larry Burrows' shoot of a helicopter rescue mission in Vietnam, in which helicopter Yankee Papa 13 attends to another downed helicopter at a landing zone under heavy fire from the Vietcong. The pilot is already dead when they get there, but they evacuate the two other crew members, still alive. However, on the flight back to Da Nang, the wounded co-pilot dies, and the crew chief Farley is distraught. Burrows captured all the essential elements of the story, including the all-important but often forgotten beginning, when everyone is in good spirits. The contrast between Farley smiling as he carries weapons onto the helicopter at the start, and his weeping at the end, is powerful and emotional. In between, Burrows achieved an impressive variety of imagery in an enclosed space, including of Farley firing a machine gun from the outside (with a camera mounted on the outside, facing back, and linked to the gun).

Life decided the story was strong enough to run as the cover in April 1965, and gave it 12 pages/6 spreads, using 19 of Burrows' images. They did not repeat the cover image, which was arguably the strongest single image, of Farley, just after the extraction, in-air, shouting by the open door with the dying co-pilot below him. Instead, they followed the strict sequence of events, each spread being a unit in time. Burrows made this possible for them by providing strong and varied imagery throughout. As an example of his preparation, he had devised a rig to carry a Nikon on the outside of the helicopter, and which was linked to the movement of the door machine gun. He was able to trigger this by cable from inside the ship, in addition to the handheld shooting. Burrows described the events later in a BBC documentary: "We tried to rescue a pilot off a ship, and we were trapped between these two .30-caliber machine guns. The V.C. were on the tail of the downed helicopter. We landed alongside; the co-pilot from this downed ship, wounded, climbed on board. The pilot in our ship gave word for Farley, who was the crew chief, to go and rescue the pilot—who was slumped over the controls. We could see him."

Burrows then left the helicopter, behind Farley, and ran across the short distance to the other ship. "Farley ran across, I ran after him, and visually—the sound of gunfire and with all that was happening—but trying to do it visually was extremely difficult. It looked documentary. It was frustrating. But rather than go into a long story about that—the co-pilot who had climbed onto our ship had two bullet holes, one in the arm and one in the leg, and one we hadn't noticed, which was a third one, which was just under the armpit. And he died." What is particularly interesting here is Burrows' on-the-spot professional concern, while running and under fire, that the shooting is looking "documentary," meaning not under his visual control. Burrows was famous for his well-framed images under difficult circumstances. Like all good photojournalists, his mind was in hyperdrive when he was shooting, and he considered carefully what he was doing.

Back in the helicopter was the moment of the cover shot, and having used it there, the editors at *Life* had to come up with an alternative spread for the flight back. They used a single shot double-truck—the most powerful device in the photo essay, if used sparingly. We then have the debriefing back at Da Nang, and the moment of Farley breaking down. Burrows said, "It was a very sad moment, a very touching moment, when our crew chief broke down—cried. Everybody was very tense because everyone had suffered through it. And so often I wonder whether it is my right to capitalize, as I feel, so often, on the grief of others. But then I justify, in my own particular thoughts, by feeling that I can contribute a little to the understanding of what others are going through; then there is a reason for doing it."

The additional interest for us here is that *Paris-Match*, which at the time was in many ways the parallel European equivalent of *Life*, also picked up the story and ran it as an essay. The differences between the two layouts are instructive. *Paris-Match* was only fractionally smaller than *Life* at 52 x 34cm for a spread, and had the same proportions. They chose not to run it as a cover (understandably, as it was a "foreign" story, lacking the gut emotional connection for the French readership). They also ran it shorter, at 8 pages/4 spreads. The great difference is that they chose not to follow the time sequence, but instead in the opening spread played on the contrast between Farley smiling and setting out on the mission, and crying at the end. They gave the two photographs maximum space by running the headline as type over. Fewer pages than *Life* meant that they lost the powerful machine-gun shot, but this was not as direct to the storyline as the rescue, to which they gave two spreads. The final spread is built around the most memorable shot of the take—the one that *Life* used for its cover. The reason why there are three images on this spread is to preserve the main image without cropping; the other two fill the otherwise blank space, and give the reader the kind of privileged extra view that picture editors normally have from seeing the out-takes. How to open and close a photo essay is always a preoccupation among editors, picture editors, and art directors.

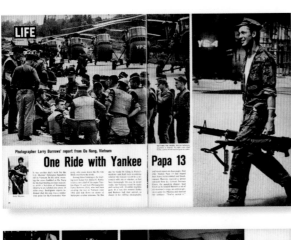

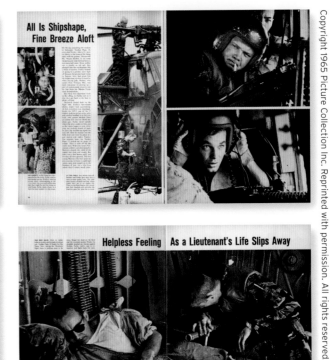

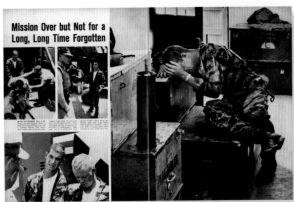

◄ "One Ride with Yankee Papa 13," with photographs by Larry Burrows, considered strong enough to be the cover story for *Life* magazine on April 16, 1965.

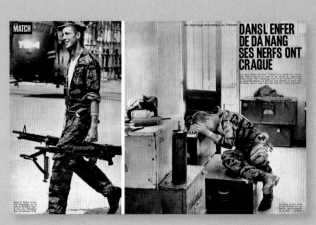

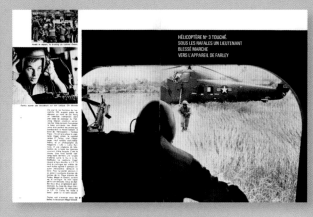

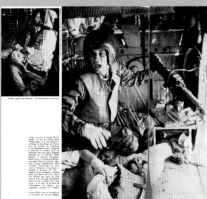

▲ Following the *Life* April 9 issue, *Paris-Match* laid out the same story in a different way, choosing to encapsulate the events on the very first spread by contrasting the demeanor of the crew chief at the start and at the end.

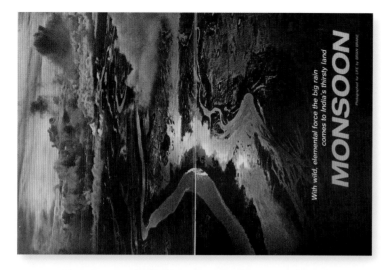

With wild, elemental force the big rain comes to India's thirsty land

MONSOON

Photographed for LIFE by BRIAN BRAKE

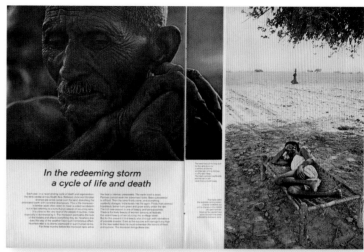

In the redeeming storm a cycle of life and death

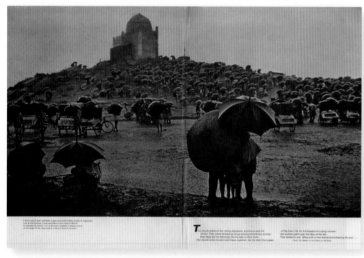

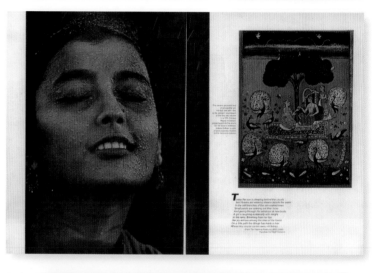

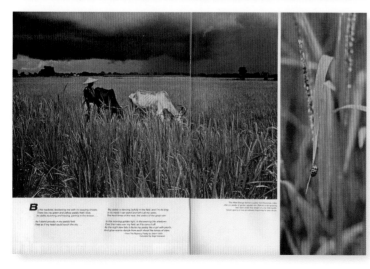

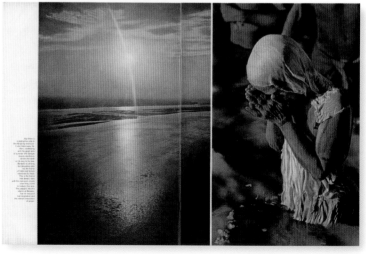

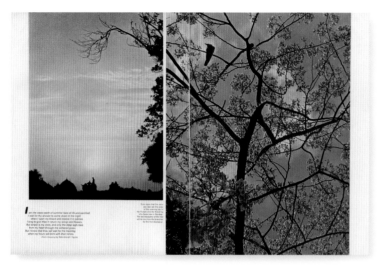

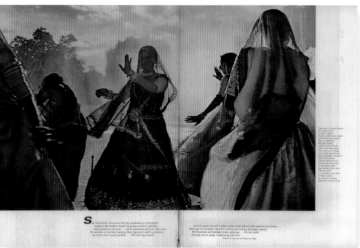

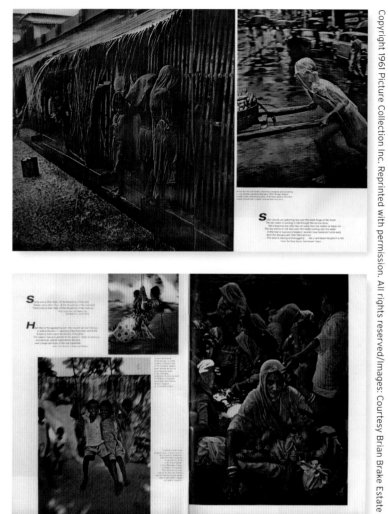

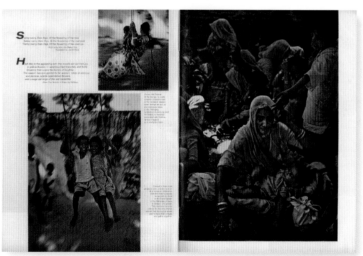

▲ "Monsoon," an early *Life* experiment with a lavish and long visual photo essay, and no substantial text. It ran on September 8, 1961.

This is a lengthy analysis of a single photo essay, but justified, I think, by what this famous story tells us about the use of photographs. Two or three of these images would hold their own anywhere as single images (and they have), but working together under strong art direction they become something else, and arguably more powerful, more memorable, and they deliver a coherent message.

Events in the life of a person or group of people remain popular, and one particular kind became formalized as a "Day in the Life." It spread throughout publishing, in both magazines and books. Just two examples: the *Sunday Times Magazine* began a back-page feature in 1977 with a single (small) picture in a text-led article that they titled, rather cutely, "A Life in the Day." And in the book world, Rick Smolan, who began as a photographer and became a publisher, created a new photographic book format, that of a day in the life of a country, as seen by a large number of photographers, who all shot for the same 24 hours. The first was "A Day in the Life of Australia," and there were many more. Singapore-based French publisher Didier Millet took a different approach by extending the timescale to one week, in the interests of coverage in depth. Most of us who worked on these projects, typically 50 photographers together, found the project-based editorial approach satisfyingly complex and intense. They were, inevitably, rich in the experience of shooting, though always faced by the challenges of selecting down from a huge number of images, stylistically varied.

Back in the magazine world, however, the photo essay began to change in the 1960s. Or rather, an alternative style emerged, one in which the narrative storyline was less powerful and the pictures were given almost the entire space. Photographers loved this because it gave them a better show, but it also meant that such a photo essay lacked some substance. Visually appealing yes, thought-provoking less so. Again, it was *Life* that ran one of the most famous examples of the pictorial photo essay, in 1961. This was a long story, that took nine months to shoot and was given 20 pages/10 spreads. The subject was an extended look at India's monsoon, and it made the name of New Zealand photographer Brian Brake, who pitched the story to *Life* a year earlier. They accepted the heavily researched and detailed proposal and he shot in 1960–61, following a simple, lyrical storyline that begins with the parched dry months and the arrival of life-giving rains as a blessing. There was not much more of a story than this, and the accompanying words were short captions and extracts from Indian poetry (the latter could almost be thought of as "word-images" rather than explanatory text).

There was a reason why *Life* at this point was prepared to experiment with an unusually pictorial big essay, and the evolution from "Country Doctor" to "Monsoon" was not simply an aesthetic progression. There was sound business logic behind the move to this more showy kind of art direction. By the early 1960s *Life* magazine was fighting seriously for its readership, now in decline in the face of television. The magazine took the deliberate decision to exploit its remaining display advantages over television. These were size and color reproduction. A double spread measured 21 x 14 inches (54 x 36cm), while a typical television set had a 20-inch screen, looking much smaller when seen from an armchair; and while color television was introduced in the 1950s, it was too expensive to be significant until the late 1960s. It made perfect commercial sense to run color essays large and long, and with occasional design innovations—such as opening the "Monsoon" essay with a vertical image run sideways. These innovations were used to sell the magazine to advertisers.

This was indeed a major change, and has deeply influenced the way in which published photography is now seen. This kind of photo essay, in which the imagery rules almost completely, is essentially a story without words, relying on the purely visual progression through pages to create the effect on the reader. Now, as long as the subject is either self-explanatory or can be summarized at the beginning in a short opening-text introduction, it works. It is not, however, capable of handling a complex or contradictory story. This has carried over into the photo book, as we'll see next. And perhaps even more so into the online slideshow, again below.

➤ *Sudan: The Land and the People,* by Michael Freeman, Timothy Carney and Victoria Butler
To an extent irrespective of subject matter, high production quality in an illustrated book brings its own sense of value and enjoyment. Paper weight, large format, print excellence and spot varnishing on images, for instance, emphasize the materiality of a photo book. This book, *Sudan: The Land and the People*, included all of the above, its 340 pages weighing 3kg.

THE PHOTO BOOK

A fully conceived book of photographs on a single theme is the development of the photo essay into something bigger. Yes, a book can be compiled from individually conceived and taken photographs, and, more often than not, is, but it can also be created as a thing in its own right, with the images deliberately made to serve it. The form is necessarily different from a several-page essay running in a magazine, because the photographs are seen sequentially over a longer period of time (the time it takes to view and read, at a pace chosen by the audience). Most of all, only a medium the size of a book can do justice to a large, single-themed project, and if properly conceived and well produced, the book itself becomes the work. There are many examples of conceived photo books, including Robert Frank's *The Americans* and Eiko Hosoe's *Kamaitachi*, and Walker Evans *Let Us Now Praise Famous Men* with writer James Agee. When photographs truly are shot for a book, then the book, like the magazine photo essay above, becomes the work. Ideally, the images need to be seen in this form rather than in isolation.

There is more audience participation than in most other ways of viewing photographs, because the reader chooses how slowly or quickly to take in the sequence, and even in what order. Books can be dipped into, can be flicked backwards (very common), but the photographer and designer aim to control this, or at least to encourage the reader to follow their plan. The other major difference between a book of photographs and a magazine story is that most books (apart from those in a series) can have a completely fresh and original design, with format and length chosen to suit the collection of images. Magazines, on the other hand, each have an established format of style, and photo essays have to conform. In practice, this usually means that photo books carry fewer images on a spread— often just one or two. The number of pages is adjustable, so that the images can spread out comfortably. So, because the photographs don't need to be crowded (generally), the carefully organized double-page spread that works as a refined visual unit in magazines is rare in this kind of book.

As a result, photo books are much more about sequencing than they are about complex, all-in-a-glance layouts. This has important repercussions not just on picture selection but on shooting itself, and the first casualty is the point picture. Images that can and should run small in a magazine layout, because they are informative but not much else, don't even need to be taken if the final work is a book. Photographer Nadav Kander writes, "Sometimes when…I'm not sure that what I'm looking at is valid and worthwhile pursuing (feeling as if I am having a bout of blindness), I imagine the picture on the page of a book. This is my gauge of worthiness, my test as to whether to carry on or abandon the picture or idea. I see books above all else in this medium, partly because they can be such beautiful objects but most importantly they are a way of putting a period of your life and a set of works to bed, beautifully encased in a jacket, and allowing you to be free to carry on." There is also less call for sizing and strong cropping. Even though readers can flick through a book in any way they like, the design assumes linear sequencing, and with this as the main structure, the photographer and designer order the pictures with extreme care. If a book is long—more than, say, 200 pages—it needs a certain amount of pacing, as it's called, to create variations in the flow. Varying scale, such as a surprise jump from macro to micro, is just one possibility. Or, a sequence may rise to a kind of climax, then a new cycle or chapter begins. The analogies with the two most obvious linear art forms, music and cinema, are obvious.

As we just saw, because of the influence of the way in which the magazine photo essay developed, photo books have generally made less use of words, not more. This is despite the history of books themselves, which is very much a history of words. Of course, it depends on how you define "photography book." Most photographers think of this as a book with the main purpose of displaying their imagery, rather than a book on a particular subject that happens to use their pictures. And, by the same token, the more personal and heartfelt the images are, with the photographer in charge of the selection, the more it qualifies. The obvious danger is self-indulgence, though some would say that this is fine, and certainly some of the great photography books are uncompromising in this way.

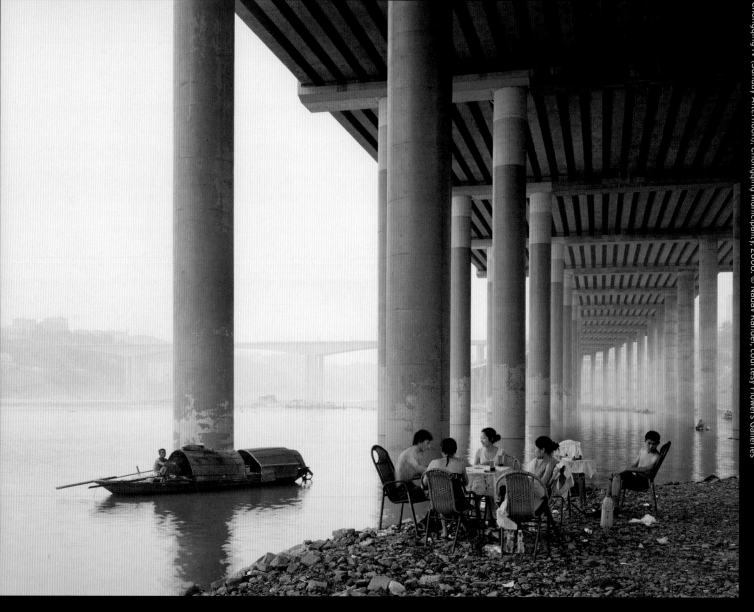

▲ **Chongqing IV (Sunday Picnic), Chongqing Municipality, from the book** *Yangtze,*
The Long River, **2009, by Nadav Kander**

Kander began this "journey" book with as few preconceptions as possible: "I worked
intuitively, trying not to be influenced by what I already knew about the country," but he
gradually realized that he was responding to "a formalness and unease, a country that feels
both at the beginning of a new era and at odds with itself. China is a nation that appears
to be severing its roots by destroying its past in the wake of the sheer force of its moving
'forward'." The images cohere through the haze of pollution that permeates each scene, and
through Kander's way of framing: "I felt a complete outsider and explained this pictorially

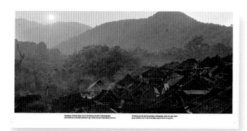
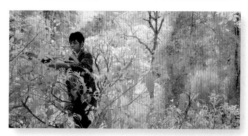
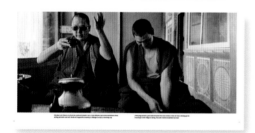
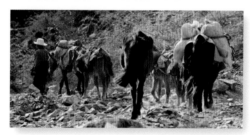

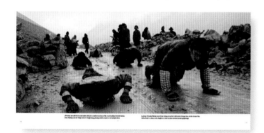
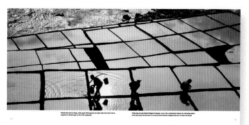
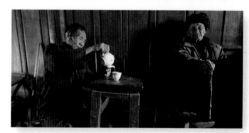

▲ *The Tea Horse Road*, by Michael Freeman and Selena Ahmed
The opening sequence of 15 spreads from my own book, *The Tea Horse Road*,
342 pages and 290 x 290cm. All but 54 pages carry photography alone.
This was conceived as a journey book, following an ancient trade route from
southwest Yunnan to Tibet, with another branch joining from Sichuan. The
themes were bio-diversity, minority culture, the politics of trade between China
and Tibet, and the history of the route. In addition to carrying the required title,
half-title, contents and introduction (with a map), these spreads were designed
to be a sampler, covering the style of imagery and the six regional chapters.
Spread-to-spread visual variety was important for this section.

THE SLIDESHOW

What began as a salon performance, evolved by the end of the twentieth century into an audio-visual show for large audiences, and evolved yet again more recently into the standard small-scale on-screen method of delivering a sequence of photographs. Arguably, the slideshow reached its highest creative point in the 1970s and 1980s as the backdrop to rock concerts, often on multiple screens. The reason was largely technical: slides could be projected more brightly and give a richer visual impression than could video at the time. This was short-lived, and video took over for live performances. Cross-fading carousel projectors gave way to digital projectors displaying sequences constructed in software applications. Still called a slideshow long after slides disappeared, the linear-sequenced presentation of images is now ubiquitous on web sites. The size has decreased from the old mechanical days of Kodak Carousels, but then, looking regularly at web sites has lowered expectations among the viewing public. The legacy of a slideshow as being "just" a way of showing a number of images, as in a photographer presenting a shoot to a magazine editor, has held it back rather from its full potential of being a creative form in its own right, but this is slowly being tackled by web publishers.

▼ The Moody Blues in concert in 1975, with a three-screen slideshow projected the width of the stage behind the group.

▲ A giant 5 x 15 meter back-projected screen at the Shanghai Art Museum.

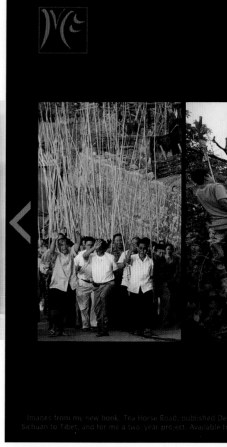

Slideshows, in whatever form, are linear presentations, and enjoy both the benefits and drawbacks of one image following another. The first benefit is a firm control of the sequencing. This goes further than simply the photographer imposing his or her will on the audience. Just as in the traditional photo essay on a magazine double-page spread, the choice of which images to partner can create associations. On a page, juxtapositions are spatial, as we saw in the photo essay examples above. In a slideshow, the linear sequence means that it is more cinematic, and makes much more of the coincidence of shapes and lines. At its simplest, similar shapes at similar sizes can provide a graphic continuity that links subjects that have nothing in common. Circles,

for example, can be found in the sun, a watch face, the head of a flower, the lens of a camera, and so on. As these examples suggest, there is also great potential for creating silly and overly obvious sequences, but then art-directing a slideshow needs skill, as much as does curating a gallery show or laying out a print or a web page. Time sequences, as shot, are another grouping that benefit from slideshow presentation: an action being performed, someone walking, a time-lapse of the moon rising or a flower wilting.

All of this is helped enormously by fading, or dissolving, from one image to the next, and the speed at which this happens can have a surprising effect. "Normal" dissolves are around two or three seconds in length, but rapid cutting

can create a staccato, movie-like effect. At the other end of the scale, a very slow dissolve of several to many seconds can have the strange effect of actually combining two carefully chosen images, making a three-image sequence—the first, then a composite, and finally the second. If the slideshow is timed and made automatic (as opposed to allowing the user to click through), it can be very cinematic indeed, with a soundtrack and simulated camera moves, tracking along an image or very slowly zooming in or out. At this point, the show crosses over from still imagery to a video made from stills.

The main drawback of a slideshow comes from the same source—that the viewer has no knowledge, or preview, of what is coming next,

and is in the hands of the photographer, whether willing or not. For some people accustomed to seeing photographs on a wall or on the printed page, this can be mildly irritating. Going back to the gallery setting as a way of showing photographs, there the visitor has complete choice of how to look, and a glance around gives a preview of what is on offer. The same applies to flicking through a book or magazine, and this viewer/reader choice is an important part of the experience of looking at photographs, even if it goes largely unacknowledged. Linear sequences like a slideshow take this choice away and replace it with a captive-audience model. It suits some people, but not everyone.

⋏ **Above:** A typical contemporary slideshow for a web site with user-activated arrows. Clicking creates a push animation, in which the next image in the sequence slides horizontally in as the existing one slides out. The impression for the viewer is that the screen is a window through to a continuous horizontal sequence of images.

WEB SITES AND E-BOOKS

Most photographs by far are viewed on computer screens and on tablets. This change has happened recently and rapidly, and while for some people the image on the screen is thought of as a reference for the "real" photograph, the reality is that for most people these screen views *are* the photographs. Relatively few are seen in any other way. Susan Sontag was not the first, nor the last, to say something on the lines of "Movies and television programs light up walls and flicker, go out; but with still photographs the image is also an object, lightweight, cheap to produce, easy to carry about, accumulate, store" (from the first page of *On Photography*). Entire art-crit philosophical arguments have ranged around the seeming paradox of an image that is in one sense dimensionless, yet in another sense a physical object. Web viewing—screen viewing—makes this instantly redundant. The image is back to where it was in the camera at the time of shooting: virtual.

Screen quality continues to improve, with resolution rising on devices like the iPad, so the size loss is in part compensated by the image quality. A screen is basically a backlit viewer, and most photographs benefit from this higher dynamic range, often looking better than they would as prints. One drawback, not always seen as such, is that many screens have a relatively high gamma. The practical effect of this is of more contrast, a slightly darker appearance, with more "punch" and less subtlety.

There are several ways of showing images on web sites. A slideshow, as already described, is a common one. Another is click-and-enlarge, which allows a number of thumbnails together on the screen, but when one is clicked, it takes over most or all of the screen temporarily. Another is medium-to-large images on a scrolling page, usually top to bottom, and this is typical of blogs. Flash, a platform for animation and interactivity, allows fancier, more dynamic displays, such as various kinds of on-screen carousel.

E-books and e-zines are more recent, gaining ground rapidly with the launch of the iPad, which has introduced a new and finally acceptable level of viewing experience. Interactivity and animation seem to be the way forward in this, and at the time of writing publishers are rushing to develop an extended kind of book and magazine that will eventually bear little resemblance to the traditional print kind. The possibilities are new and exciting, though hardly touched yet. Art directors, as we saw in print publishing above, particularly for the photo essay, have brought a great deal to the use of photographs, and a new generation working on-line and on-screen is beginning to do the same.

Susan Meiselas, whose shocking image of civil war is on page 133, is one of many who sees a new platform here, even if it doesn't address the problem of how to fund new stories (see page 57 above): "Many photographers in Magnum are now producing digital essays with pictures and sound that are being seen on slate.com, which has ten million monthly viewers—that is more than any print publication can provide. We are totally determining the content, with editorial or aesthetic control. This is what one hopes for with galleries, books, and magazines where control is negotiated, but rarely fully achieved. Of course it is not the same experience: in some ways it is more intimate, and I often miss the physical materiality of the work in digital form. But the sound alone is a very compelling element that profoundly shapes the reading of the work. One needs to think about whether a physical space or virtual one is right for a particular work, but at least there is a new environment to experiment with and learn about." In this, as in most other settings, viewing and enjoying photographs depends on more, much more, than just the images themselves.

➤ **Tablet display opportunities**
The Apple iPad and its competitors have introduced a way of presenting photography and video that extends the familiar computer-screen experience by being book-sized and easy to handle. Pages sequence by swiping the screen from side to side and up and down. Tapping launches changes such as those shown here. The size of the tablets, considerably smaller than an open magazine, limits the layout possibilities when photographs are used: the juxtapositions and crops that we saw in the development of the photo essay in magazines are difficult to pull off. Nevertheless, the eye adapts to the smaller page to an extent, and on-page animation can be a useful way of holding together a home page with several choices. Illustrated here are two on-page features: a page-flip animation, and a movie. The principal method of photo display, however, is tap-and-enlarge (or click-and-enlarge on computer screens). This makes full use of the screen, and within this there are numerous possibilities. Shown here are a slideshow, a thumbnails-to-full-image sequence, and a full-screen image that launches with an embedded movie, and a talking head that links to the home-page layout.

CAPTURE TO CONCEPT

So far, under "Purpose," we've seen how both genre and practical function have molded the way photographs are taken. There is a third influence, which for want of a better term we could call creative purpose. This is how the photographer sees his or her approach and, as with all individual creative endeavors, there is an enormous range. You may think, for example, that you're looking at a piece of mainstream photojournalism, whereas actually the photographer had something else entirely in mind, such as an attempt to symbolize the human condition. Or, in another case, a set of expressionless portraits, identical in pose and lighting, and in which each subject's eyes are a bright blue: you might think you are looking at a kind of August Sander collection of subjects who have been sourced for their blue eyes. In fact, these portraits, by Thomas Ruff, have been Photoshopped for the blue eyes, and are a comment on the photography's pretence to truthfulness.

Creative purpose is now more varied than it ever has been, due to two things, mainly. One is photography's acceptance into the fine-art market. The other is the much greater technical ability that photographers now have to make images of any kind, and most of this comes from digital processes. Photography's entry into contemporary fine art in a big way has meant that concept has risen rapidly into prominence. This is not to say that concept was absent earlier, but it now plays such a large role in contemporary fine art in general, that photography was encouraged to embrace it. As we'll soon see, a large swathe of photography is now about concept, rather than anything as mundane as the world in front of the camera.

By far the largest category of photography is concerned with making a record, a document, of events and scenes that are taking place irrespective of the camera. If this seems too obvious and over-explained, it's because there are other types of photography that are gaining ground, and which focus more on the photographer's imagination and on creating— setting up—scenes and situations to photograph. If there was ever a kind of Age of Innocence in photography, when a camera in one's hands was a marvelous instrument that showed what things were like, it keeps getting revived each time that someone begins. And millions do, quite seriously. For all the philosophical and academic interpretations that photography has to endure, it's worth keeping sight of this straightforward, simple pleasure.

But within the overall idea of catching and isolating what is there, there is a wide range of purpose. Objectivity, which you might think is the default for camerawork, has turned out to be one of the rarest aims. The skills that are the subject of the third and last section of the book allow photographers to interpret. They also allow photographers to manipulate—not necessarily the image, as we've all become used to in the digital era, but much more importantly the mind of the viewer.

MODERNISM AND SURREALISM

Photography's relationship with philosophy began in the 1920s, with Modernism. This went further than style and aesthetics. For the avant-garde Modernists of Europe, the camera was peculiarly well suited to displaying the ideology of social progressiveness, the exploration of the new, and in imagery, concentration on form. First, the new cameras of the decade, such as the Leica, and the new film, 35mm, gave photographers a new freedom to explore, experiment and capture. Second, photography was an art based on technology, and so shared the same promise and future that the Modernists saw in technical progress. The Russian Alexander Rodchenko was in many way the archetypal Modernist (the Bolsheviks saw the potential in photography for ideological propaganda and promoted it). As a kind of manifesto, he declared, "Photography has all the rights, and all the merits, necessary for us to turn towards it as the art of our time." He listed the ways of doing this: "Contradictions of perspective. Contrasts of light. Contrasts of form. Points of view impossible to achieve in drawing and painting. Foreshortenings with a strong distortion of the objects, with a crude handling of matter. Moments altogether new, never seen before…compositions whose boldness outstrips the imagination of painters…Then the creation of those instants which do not exist, contrived by means of photomontage. The negative transmits altogether new stimuli to the sentient mind and eye."

At the same time as Modernism, photography also fed the Surrealist philosophy, in two ways. Perhaps the most obvious from today's point of view was the creation of strange imagery through distortion and collage, but Surrealism also held that strangeness can be found in the ordinary, the vernacular, if only we look at it in a certain way and with a receptive mind. The found object and the discovered image were at the heart of the philosophy. Writing about hollows in the bark of a tree trunk that to him looked eye-like, Hungarian photographer László Moholy-Nagy wrote that "The surrealist often finds images in nature which express his feelings." The Parisian street scenes of photographer Eugène Atget, who worked diligently to record the mundane details of the city, were much admired by the Surrealists. For all his lack of pretension and dogged ordinariness—he claimed that he was doing no more than making "documents for artists," and passed by the famous sights—Atget has influenced more than one generation of photographer by the way he valued the vernacular. The influential critic Walter Benjamin wrote, "Atget's photographs are the forerunners of Surrealist photography…he disinfected the sticky atmosphere spread by conventional portrait photography in that period of decline. He cleansed this atmosphere, he cleared it; he began the liberation of the object from the aura."

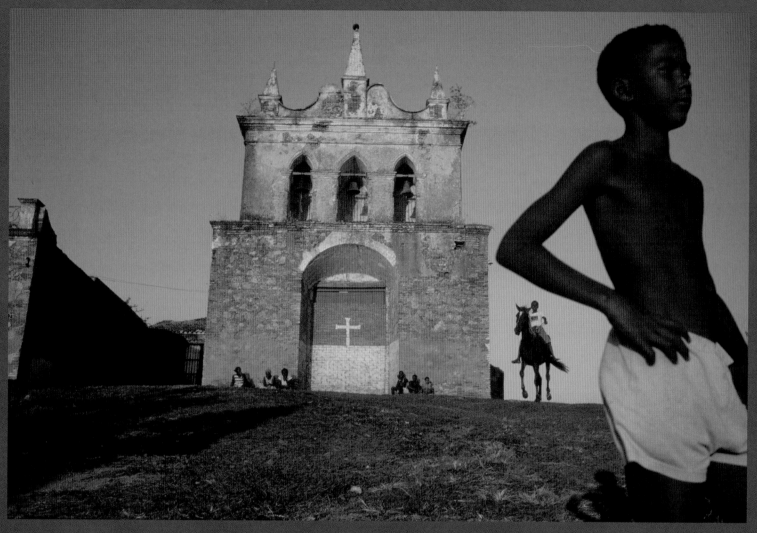

▲ **Nuestra Señora de la Candelaria de la Popa,
the oldest church in Trinidad, Cuba, 1998,
by David Alan Harvey**
Photography as capture, employing observation,
viewpoint, moment, all rapidly executed, without
intervention or setting up.

⋀ **Stairway, 1930, by Alexander Rodchenko**
Modernism in photography searched for the new,
particularly in its graphic treatment. High contrast,
patterns, and shadows were all exploited by
photographers like the Russian Rodchenko.

➤ **Chair Abstract, Twin Lakes, Connecticut, 1916,
by Paul Strand**
European Modernism was taken up by several
photographers in the United States, including Strand,
with the same approach to experimenting with the
graphics of imagery. This inevitably furthered the
causes of high-contrast printing and of abstraction.
Abstraction itself encouraged the choice of ordinary
or hard-to-identify subjects.

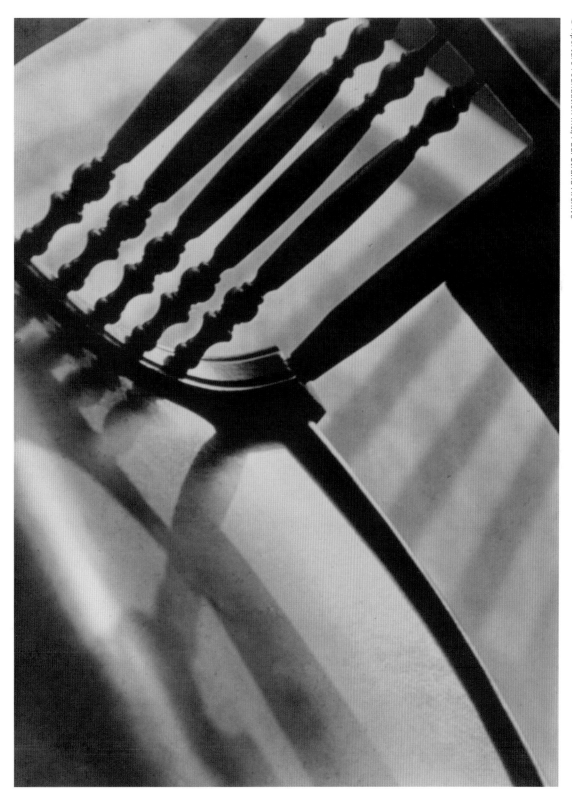

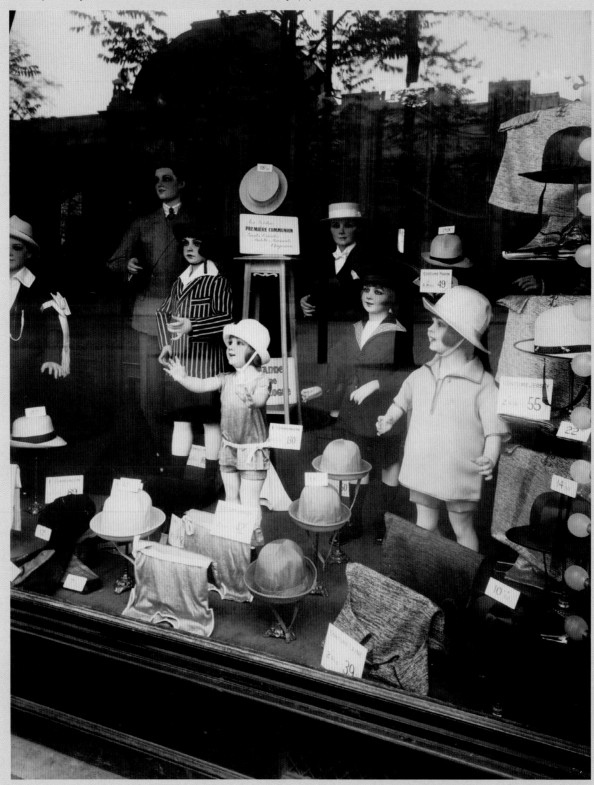

THE PHOTOGRAPHER'S VISION

LIVES UNLIKE OURS

While both modernist and surrealist photography were located in the familiar, although changing world of Europe and America, one of the strongest themes running through photography from the earliest days has been depicting the exotic. As we saw in *The Genres of Photography*, landscape photographers from the nineteenth century were hauling their equipment abroad to satisfy the public's appetite for seeing strange sights and ancient ruins. As soon as it became technically possible to include them, the cultures and societies of these places became another subject. Glass plates, view cameras and slow emulsions were inconvenient tools for this, but photographers like the Scottish John Thomson persevered. Many simple situations in which people moved and did things—very common fare for the camera these days—needed to be managed and directed, as shown below on page 153.

As photography became easier—once again, with the invention of the 35mm camera—the world opened to foreign picture stories. And as we saw, there were new weekly illustrated magazines to publish them, followed by monthly magazines, then weekend supplements to daily newspapers. *National Geographic* and the German *GEO* are among the monthlies that specialize in this. There was a cachet and glamour attached to overseas photo reporting—and still is, although there is less of it published. The cost and energy that had to go into this kind of photography kept it special. Two basic ingredients are involved: first, very strong subject material, meaning previously unseen or imagined by its (largely Western) audience, and strangeness. Collectors climbing rope ladders for hundreds of feet in dark tropical caves to gather birds' nests worth their weight in gold; monkeys bathing in hot springs in the snow; a primitive gold rush in a remote site looking like Dante's inferno; ethnic minorities seemingly doing very odd things; and more like these. Second, the standard of photography has to be much higher than in standard news reporting, because if the story is to be worth the huge expense, there have to be two "wow" factors: amazing subject, and amazing treatment.

One of the most celebrated practitioners is Sebastião Salgado, a Brazilian photographer who had a career as an economist before switching to photography. Salgado's original speciality was manual labor, and he brought to this an economist's understanding, deep research to find the story, and a very good eye. He says, "I have tried to bring about better communication between people. I believe that humanitarian photography is like economics. Economy is a kind of sociology, as is documentary photography." From here, he extended his work to remote and endangered ethnic minorities.

Audiences have certainly been fascinated with the exotic for a long time, but the explosion of international tourism since the 1980s has weakened the excitement. Cartier-Bresson predicted dyspeptically that travel by aircraft would create "generations of little cretins, especially in our line of work." The sheen of adventure and exploration has faded somewhat for readers and viewers, but photographers themselves try to keep the enterprise going. There is an element of nostalgia in the way new generations of documentary photographers look to those four decades, from the 1930s to the 1960s, that were the high point of foreign photo magazine reporting, for inspiration to cover strange worlds that few have seen. There are now many more photographers trying to launch projects that will take them to remote and challenging places than there are publishers willing to sponsor them. To make this happen, contemporary documentary photographers with these ideals have to work harder and go further, and the results are often impressive, even though there is much less support from clients and probably less wide-eyed acceptance from the viewing and reading public.

◄ **Avenue des Gobelins, 1925, by Eugène Atget**
Atget himself was no Surrealist, but his meticulous record photography of the commonplace in Parisian streets, such as this shop window, appealed to the Surrealist idea of the found object. The extra image layer from the reflections in the window further appealed to Surrealists.

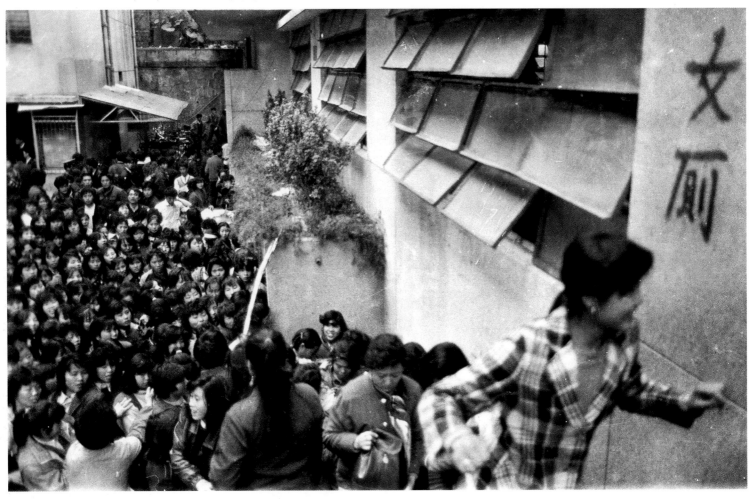

▲ **Crowds waiting to get into the toilet at the station, Guangzhou, Guangdong, 1991, by Ye Jianqiang**

Even when this shot was taken, not so long ago, the scene was notable. All those crowds waiting just for a toilet! No wonder the young woman closest to the camera looks pleased. However, even though on the face of it this is one of daily life's mini-horrors ("thank goodness not my daily life," is the typical viewer's reaction), it is of course a photograph of progress. The reason all these people are here at all is that it is the railway station in the economic powerhouse city of Guangzhou, and in 1991 the second stage of the Chinese economic reform was well under way, and people were able to relocate for work. That is what these people are doing—pouring south to make money. The infrastructure, in this case toilets, had not kept pace. The surprise of seeing this situation increases with time; this is a fast-tracked historical photograph, as striking now for Chinese people to see as it is for anyone else.

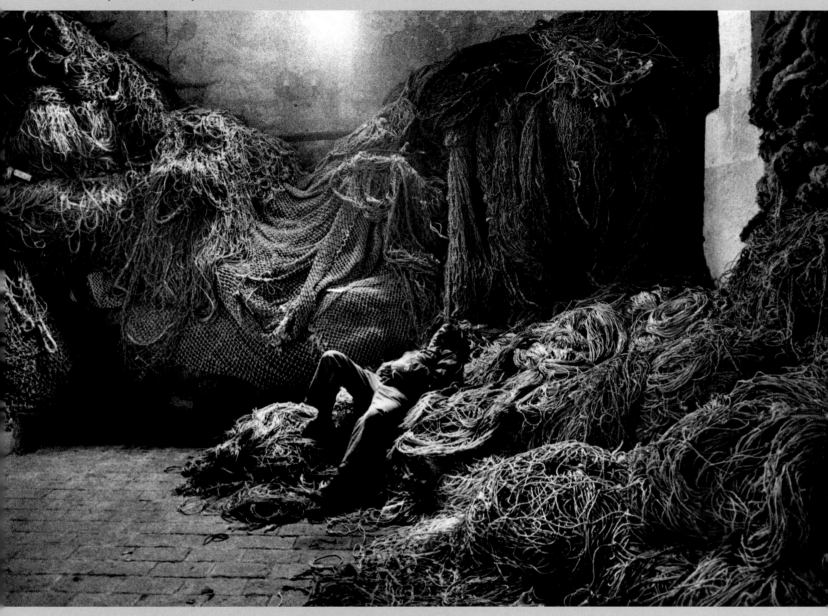

▲ **Fisherman resting, The Mattanza, traditional tuna fishing, Trapani, Sicily, by Sebastião Salgado** The Brazilian photographer, using his training as an economist as a launch pad for documenting human labor, also brings a monumental and sometimes heroic style of imagery to his subject matter.

POLEMIC

Robert Frank may well have been right when he said, "A message picture is something that's simply too clear," but that was a judgment of technique rather than of intention, and photographers do, often, want to get a message across. This is especially true of photojournalism. Not all of it, by any means, but a crusading, liberal and activist element has been there since photojournalism's birth in the years between the two world wars. Social injustice was hard to ignore in the 1930s, from the American Depression to the Sino-Japanese and Spanish Civil Wars, and gave many of the new documentary photographers an ideological, and emotional, basis for their career.

Social purpose was very much on the mind of Roy E. Stryker of the Farm Security Administration, when he assigned his team of photographers to go out and document the hardships faced by sharecroppers during the years of the Depression. The FSA managed rural rehabilitation programs to aid displaced tenant farmers, sharecroppers, and laborers, and its photography program, which lasted from 1935 to 1940, was intended to show the plight of the poor to the public. Stryker headed the Information Division of the FSA, and recruited a talented group of photographers. Their instructions were to produce images that "related people to the land and vice versa," to support the idea that poverty could indeed be tackled by "changing land practices."

The methods that they used varied, from the emotionally direct that Robert Frank came to criticize (above), to a flatter, seemingly more objective treatment. The output from Dorothea Lange and Walker Evans, in particular, makes an interesting contrast. Probably the most well known of Lange's photographs is *Migrant Mother*, which became an iconic image of the Great Depression—maybe the iconic image. In March 1936, Lange came across Florence Owens Thompson and her children off the side of the road in Nipomo, California. The car they

had been traveling in had broken down, and Thompson had set up camp while her partner and two sons had gone to town to repair the timing chain and radiator. Lange drove up and began taking photographs, shooting six 4 x 5 inch negatives on a Graflex camera in ten minutes.

Lange's notes read "Seven hungry children. Father is native Californian. Destitute in pea pickers' camp…because of failure of the early pea crop. These people had just sold their tires to buy food."

Lange later described the scene in a 1960 interview with *Popular Photography*: "I saw and approached the hungry and desperate mother, as if drawn by a magnet. I do not remember how I explained my presence or my camera to her, but I do remember she asked me no questions. I made five exposures [she actually shot six], working

closer and closer from the direction. I did not ask her name or her history. She told me her age, that she was thirty-two. She said that they had been living on frozen vegetables from the surrounding fields, and birds that the children killed. She had just sold the tires from her car to buy food. There she sat in that lean-to tent with her children huddled around her, and seemed to know that my pictures might help her, and so she helped me. There was a sort of equality about it."

▲ **The corner of the kitchen in the home of Floyd Burroughs, cotton sharecropper, Hale County, Alabama, 1936, by Walker Evans**
Its very simplicity and lack of rhetoric focuses attention on the minutiae of life—a life of poverty. By not sentimentalizing, Evans appeals to a slower, more thoughtful way of understanding in the viewer.

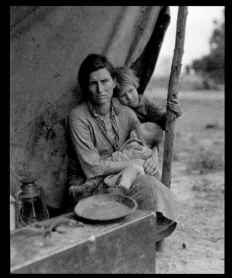

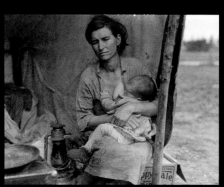

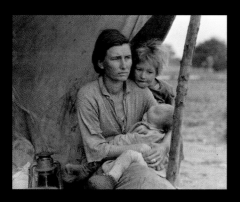

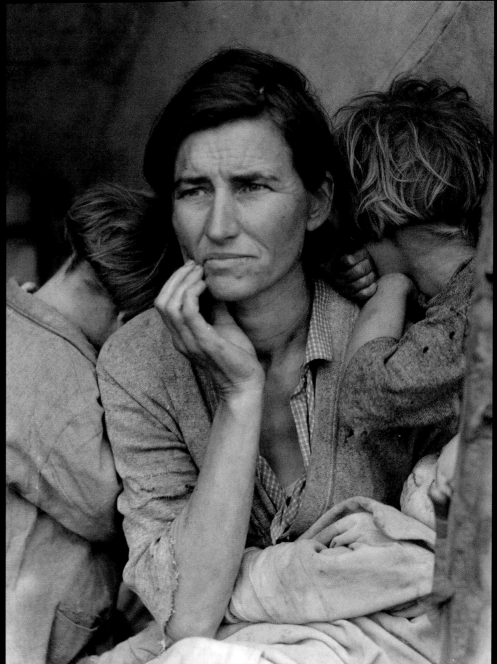

▲ Migrant Mother, California, 1936, by Dorothea Lange

In contrast to Evans' straightforward treatment is the emotional and evocative work of Lange, who also photographed for the FSA, and shot this, her most famous photograph, in the same year as Evans. Lange's work typically conveys the misery of the Depression through the defeated and subdued expressions and postures of her subjects, never more so than in this image. The two girls are hiding their faces to avoid the camera.

◄ Four of the five other 4 x 5 inch negatives that Lange shot. The missing one was never delivered to the Library of Congress, but is a middle-distance view similar to the first, but apparently flared. The order of shooting was not recorded, but as Lange mentioned that she moved closer as she shot, it is likely to have been as shown here, possibly with the famous image last.

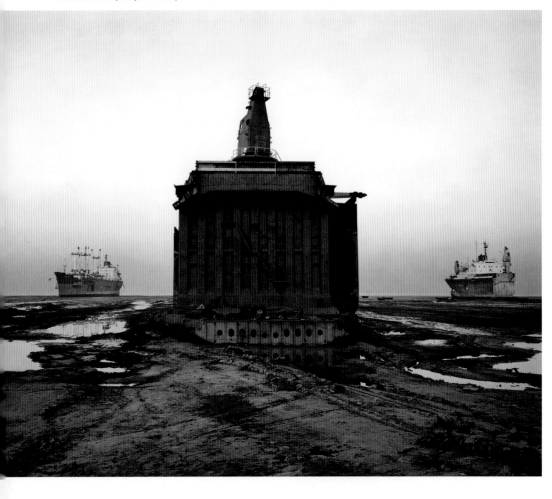

◄ **Shipbreaking No.49 Chittagong, Bangladesh, 2001, by Edward Burtynsky**
While employing some of the formal techniques of imagery in common with Gursky et al, including large-format deliberation and a distanced approach, the Canadian photographer concentrates on environmental issues, in a succession of topics.

There's a coda to the Lange story that spoils it somewhat. Over forty years later the identity of the woman was found by reporters, and the story revived. But the details were disputed. One of the sons later said, "There's no way we sold our tires, because we didn't have any to sell. The only ones we had were on the Hudson and we drove off in them. I don't believe Dorothea Lange was lying, I just think she had one story mixed up with another. Or she was borrowing to fill in what she didn't have." Florence herself felt cheated: "I wish she hadn't taken my picture. I can't get a penny out of it. She didn't ask my name. She said she wouldn't sell the pictures. She said she'd send me a copy. She never did." But later still, after letters poured in, one of the daughters wrote, "None of us ever really understood how deeply Mama's photo affected people. I guess we had only looked at it from our perspective. For Mama and us, the photo had always been a bit of curse. After all those letters came in, I think it gave us a sense of pride." While the photographs are in the public domain, because Lange was employed by the government at the time, prints have been a different case. One, with Lange's signature and handwritten notes, sold for $244,500 at Sotheby's New York in 1998.

Walker Evans did sharecropper portraits too, but he did even more interior details, rigorously composed, like found still lifes. The example on page 106 of the corner of a kitchen, is typical. The formal, plain approach that Evans took may seem at first unenterprising, undramatic. He chose to keep the technique unnoticeable so that nothing would distract attention from the subject. The plainness of the composition and lighting is a clue that the interest lies in the subject matter and not in the cleverness of the photography. This is the corner of a real home, not minimalist from the aesthetic sense of the owners, but barely occupied because of poverty. At the same time, what little there is has been organized by the inhabitants with care, from the angle at which the broom has been placed to the neatly stretched cloth on a string. This is clearly not the American dream of the 1930s, and Evans wanted the people who saw the picture to realize that this was how many Americans were actually living. Evans called his style at this time "pure record not propaganda." He spent several weeks in this area with the writer James Agee and came to know the families well. The result was one of the great photo/text essays, "Let Us Now Praise Famous Men." The Library of Congress called the images "merciless and unsentimental," photographs that "did not propagandize poverty and squalor, they presented the reality of a life that existed long before America was in the Great Depression."

NEWSWORTHY

The creative purpose in news photojournalism is under much tighter constraint, because first and foremost there is the deadline. For the newspaper, any picture may be better than none. News photographers at major events are under great pressure to deliver the expected money shot, and to deliver it fast. It is also highly and inescapably competitive. In other situations where there are other photographers shooting at the same time, it's perfectly permissible to say "Well, in that case I'm going to do it in a completely different way," but with a news event, the picture desks all generally want the same thing—but with a twist that makes their front page more striking.

The story behind the picture here, of an important election speech by the French President Mitterrand, gives some of the flavor of news photojournalism. British photographer Brian Harris was shooting this for the *Independent*. "He was due to start at the election meeting in a large tent in a field near Toulouse at about 9pm. My office needed a picture within half an hour. I arrived early, at 2pm, and parked my car right next to the meeting tent and press area. I sorted out some processing space using a changing bag to load up the one roll of film I knew I would shoot. I then connected my enormous Nikon transmitting machine to the one external international line and hid my contraption with the phone dismantled under some cardboard boxes and rubbish. I photographed the first five minutes of his speech (he used to go on for about two hours) and quickly developed my film on the spot, drying the film stretched between two chairs using meths and a match. I was getting some very strange looks." The single outside line that Harris refers to had to serve every photographer, and as soon as he heard his competitors shouting for it, "I crawled under the table to my secreted transmitter and made the connection to London. My picture went over the wire in three minutes and I made my deadline. I crawled out of my hidey hole to be surrounded by a hostile bunch of fellow hacks baying for blood. One Dior-clad beauty started towards me in a threatening way. I gave her a handful of bits of telephone and wires and shrugged, as you are allowed to do in France, and walked away. Not a great way of improving *entente cordial* but I did what I was paid to do."

"My best images, though, were made two hours later, with the President, sweat in rivulets draining down his face, giving it his all. My paper used that image a few days later as the definitive Mitterrand image." It won a World Press Award.

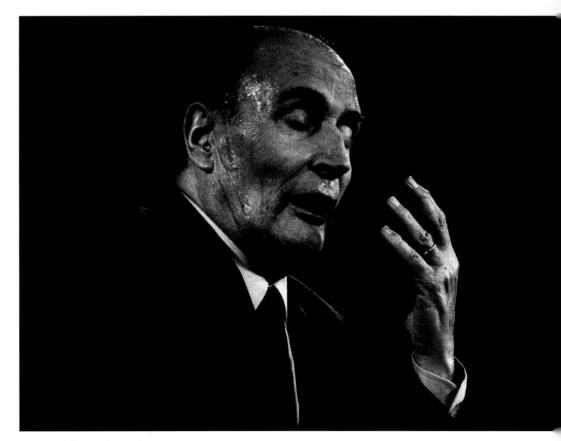

> ➤ **François Mitterand at an election rally, Toulouse, by Brian Harris/*The Independent*** Mitterand's speeches were long and increased in passion the longer they went on. Newspaper deadlines meant that a much earlier and less interesting image ran in the first edition, but the paper ran this one later, when it could.

Brian Harris/The Independent

EXPLORATION

Another way of working is to put to one side structure and intention, and simply explore. This means following leads in the subject, the situation, even the camera technology. This last means starting with the process—the camera and what special kinds of imagery it can make—and through this look for some kind of insight or revelation. This is nothing new in art, just taking up the tools—paintbrush, saxophone, camera—to see where it all leads. But it has been particularly popular, and fruitful, in photography, because the camera is such a convenient, instant machine for throwing up images, whatever you do with it. Just writing that brought to mind one of the more daft ideas of recent years, called tossography. Pretty much as the name suggests, the idea is to throw the camera in the air (protected in some way, as in a casing or attached to an elasticized cord) and let it take its own pictures. This may indeed be too trivial to mention, but it illustrates well a certain spirit of experimentation.

In a slightly more serious tone, but not much, Minor White in 1957 wrote this unpublished piece: "The German publication *Photomagazin* printed a brief and sprightly piece by Roman Frietag in 1955. He said that each camera had a subconscious. He further made the astounding observation that this subconscious is responsible for the extraordinary snapshot—and that it does so while the photographer thinks he is looking. Frietag may have been sprightly instead of serious, because, if serious, no one would have listened to him. So with tongue in cheek (apparently) he traced down the cause of these unexplained photographs to a machine's subconscious. And what a powerful subconscious it is. This personality inadvertently built into cameras at the drafting board can on occasion steer the unsuspecting and probably quite innocent owner." One of White's "accidental" observations is on page 121 below.

He also experimented with infrared photography, which is by now well known for its glowing white rendering of green vegetation. The extra sensitivity of special film emulsions and some digital sensors to longer wavelengths beyond red gives images that are true in the sense that they record physical reality, but also show what is invisible to us. Technically, what happens here is that chlorophyll (in healthy green leaves) reflects strongly in these long wavelengths. In an infrared image they appear "brighter," while clear skies, and clear skies reflected in water, appear darker. The tonal values of the world are quite different, and for White and a number of other photographers it offered a different visual world to explore. Unpredictability at the time of shooting is a part of the appeal. One contemporary photographer who works in infrared in an exploratory way is Martin Reeves. After early experiments with its surreal qualities, and at the same time drawn to traveling in India, "I was keen to see how this film would portray India and after developing the photos from my first trip in 1986, I knew that I had found a way to express…mysticism—and that I would return." Eventually moving to Asia, he continues to develop his own film in a deliberately unsophisticated way: "by the light of a very dimmed torch. I have always done it this way. I'm not even sure if the developing tank is in fact infrared lightproof and so the darkened room is unnecessary…but there is something magical about the atmosphere doing it this way. The silver halide, the glass beakers, the hanging films rustling in the breeze from the fan—and with the right music, yes, I guess the word alchemy comes to mind."

Infrared is just one of many sides to imaging technology that offers a view hidden from our naked eyes. It is not necessarily the most intriguing or unusual, and certainly not the most advanced. But it has a firm place in the history of photographic exploration on the technical level, which is why I use it here. More contemporary imaging inventions, including the scanning tunneling microscope and the Hubble Space Telescope take things much further. It seems

➤ **Resting bull at Pagan, Burma, by Martin Reeves**
"When I first used infrared b/w film, I shot with a deep red filter—the one that is almost opaque. I didn't get on with this as I couldn't see a thing…so changed to a 'red 25' filter. This was perfect for me as I could see what I was shooting. In fact I liked the look of seeing everything in red and white—kind of simplifying the image to monotone and taking away the distraction of the colors. More importantly for me, though, was that it made the infrared photos a lot subtler. I wasn't a big fan of the full-blown infrared effect, but the 'red 25' filter added just about the right amount of strangeness."

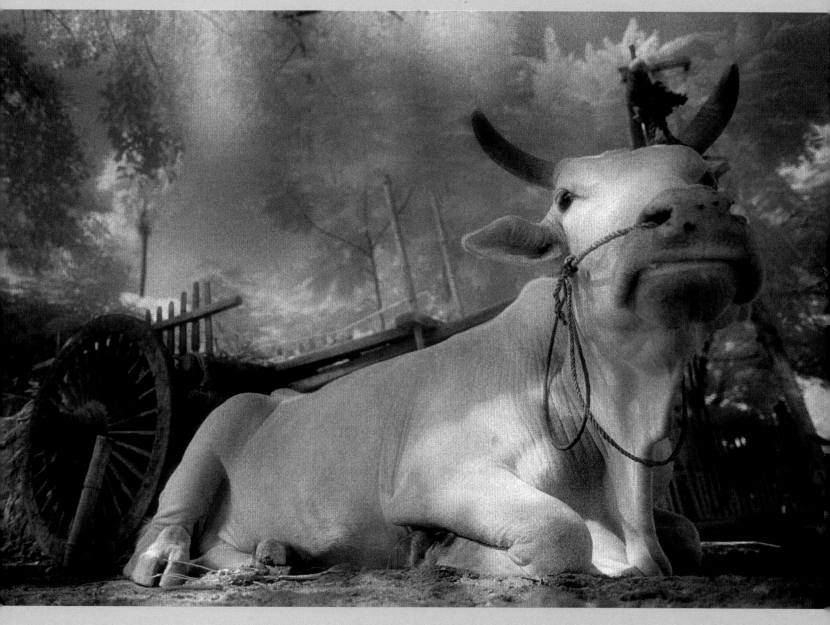

UNDERSTANDING PURPOSE

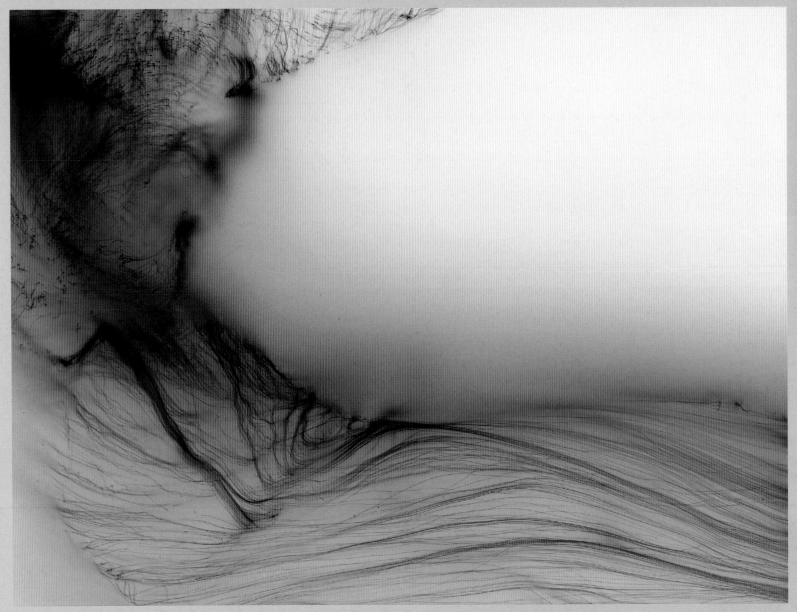

▲ **Freischwimmer 26, 2003, chromogenic print,**
70 x 94 inches, by Wolfgang Tillmans
A form of luminogram, in which light is played
over a light-sensitive emulsion, and the traces
create the image. Tillmans has an all-inclusive
interest in process.

**▲ Self Portrait in Kimono with Brian, NYC, 1983,
by Nan Goldin**
Recording her own life and the lives of her friends
and acquaintances, with emphasis on the raw and
uncomfortable moments, Goldin's use of the camera
has nothing to do with the general practice of family
snapshots, which is intended to commemorate
achievements and bland, pleasant occasions. Goldin
wrote about this shot "This is me and my boyfriend after
sex. What I found intense in hindsight is its prescience in
the expression of fear—foreshadowing future violence."

to make a difference when control, or at least selection, is in the hands of someone with a photographic sensibility, but this is arguable.

Another area of experimentation that involves process subverts what was intended. This approach takes certain stages of the imaging process and plays with them differently. The contemporary British artist Susan Derges, for example, carries large sheets of unexposed light-sensitive paper to dark locations, such as a river at night, where she submerges them and exposes them to an overhead flash, casting patterns of the water's ripples and sometimes the shadow of branches.

In a similar vein, Turner Prize winner Wolfgang Tillmans, the first photographer to win that art prize, created an abstract series that he called *Freischwimmer* (in the sense of "swimming to freedom"). These are large prints, and the process involves playing light in a blacked-out space across light-sensitive paper. This is a form of luminogram, as is Derges' work above. Experimental methods of delivering the light create the unexpected, such as with glass fiber optics. Tillmans, with an appetite for different forms of photography, writes, "In the last ten years, I have worked a lot with purely photographic material and light in the darkroom making pictures I wouldn't be able to do either with paint or with the camera." These, as indeed most photographic abstractions, manage to retain their "photographic" sense in a way that is not easy to explain. Tillmans continues, "Because the eye understands that it's something photographic, it makes much stronger associations in your imagination, whereas if it was painted you would just see this as marks on canvas."

Exploration continues into the realm of subject and situation. One question raised in this way is "what qualifies as a fit subject for photography?" The answer by now is an unsurprising "everything and anything," but it took decades to reach this point. Photography began as special and specialized, and by implication not an activity to be wasted on the trivial. The same has gone for other art forms; it was only in the seventeenth century, for example, that landscape painting in Europe became accepted, divorced from religious themes. Atget's ordinary Paris shopfronts, Modernist graphic still lifes and Irving Penn's monumental close-ups of discarded cigarette butts were all part of the process of exploring "fit" subject matter.

The taboo of the mundane was even stronger when it came to personal life. Photojournalists from the 1920s and 1930s onwards were perfectly happy involving themselves in other people's lives, often intruding as we've seen, but shied at the thought of exposing their own real lives to public scrutiny. There were occasional exceptions, such as Jacques-Henri Lartigue, who took delight in shooting whatever caught his fancy at home and within his social circle. But it was not until the 1970s that candid, personal and largely unabridged photographic coverage began.

The standard critical view stresses the difference between this and the normal run of family snapshot, and takes the line that intimate photographic revelations subvert a simple form that we are all familiar with. In other words, that it draws its strength from this contrast. This smacks of art-crit fluff, because few such photographers ever saw what they were doing as being within the family snapshot world. They were exploring from the word go. Nan Goldin began this form, with her best-known work being the 1986 book *The Ballad of Sexual Dependency*. She had begun a decade earlier, documenting in a photo-diary kind of way the daily life of two drag queens whom she knew well. Her work is intensely personal but put up for public view, an account of love, death, loss, AIDS, and drug addiction. Many other photographers followed. The combination of constantly available material (provided you could jump the hurdle of self-exposure) and rebellion against disciplined photography makes this very attractive to photography students in particular.

> **Bibi, On Our Honeymoon, Chamonix, January 1920, by Jacques-Henri Lartigue**
A privileged upbringing and an indulgent father gave Lartigue the opportunity to develop a natural talent for photography. His own social and family world was his focus, and he felt unconstrained in his choice of subject matter. Anything that amused or interested him was fair game, including his own wife on the toilet.

INVENTION

In another direction, at an angle different from both capture and exploration, photography is used to record things and scenes that have been entirely constructed. This goes back to the basic division that we looked at in "How Shooting Happens" between unplanned and planned photography. Or, as the phrase goes, the difference between taking and making photographs. This is slightly tricky, and by no means clear-cut, because it suggests trying to draw a line between photography that purely observes and photography that controls what goes on, or at least intervenes. It's an impossible distinction if we get literal about it, because there are so many gray and pale-gray areas. With this in mind, I'm here taking the very obvious examples, in which either everyone knows that the image is invented, or they soon will after looking at it for a while because that is the photographer's intention. And most of it is not deceptive, but more like the theater—a kind of declared fiction. We'll leave the grayer area of invention that viewers don't realize until a little later, under "Deception" on page 118.

The single largest area of invented imagery is advertising, but as we saw earlier under "Genres" only a small fraction of this is sufficiently entertaining or unusual to be worth an extended look. Invention by definition has no place in photojournalism, but in contemporary art it does, particularly because concept, self-

▲ **Presidency II, 2008, by Thomas Demand**
A careful representation of the Oval Room in the White House, yet there is something not quite right, even at a glance. Closer inspection reveals that it is a model—scale unspecified—made principally of card. It is the use of a single material that creates the unease.

reference and irony are currently in vogue. Indeed, the two photographers used as examples here could well have been treated under "Concept" below.

The German Thomas Demand and the American James Casebere are the two best-known photographers who work in a conceptual way with model sets. Demand, who often takes notable interiors, such as the Oval Room of the White House on page 116, creates his models in a stylistic way, using paper, card, and Styrofoam, and then photographs them with the kind of lighting and depth of field that you would expect from the real thing. These materials give the game away to the viewer, but only after a while spent studying the image.

James Casebere's work bears close resemblance. His photographs are also of model interiors, like Demand's, but with two differences. One is that while Demand's have a distinct and mannered style of construction, Casebere's are more like perfect miniatures, with more detailed and accurate modeling, the sort that would be used for special effects in a feature film. They mimic reality more closely, so that they could be really taken for actual interiors—were it not for the second difference. This is that Casebere often adds a surreal element. His interiors are frequently abandoned or ruined for no obvious reason. In one, the interior is flooded. In the example here, of a Japanese minka (large old farmhouse), a landslide has apparently invaded it.

▲ **Minka with Dirt and Fog, 2003,
by James Casebere**
A minka is a traditional form of large Japanese farmhouse, sufficiently distant from many people's experience that this could seem real (Japanese interiors are expected, after all, to be neat and minimalist). The invasion of a landslide and wisps of fog rolling down it, however, does seem distinctly odd. The model photography (for this is essentially what this is, though in the service of art) is so good that there are no clues as to its scale—and therefore authenticity. Only knowing the work of the artist gives the game away.

DECEPTION

At a certain point, messing around with the situation and/or altering it digitally runs the risk of deceiving the audience, and raises the question of dishonesty. The problem is, few people can agree on what that point is. Extreme examples, as follow, are clear enough, but there is a shadowland between legitimate and illegitimate. Of course, any photographer caught out trying to fake a shot is going to attempt to fudge his or her way out of it, and even some of the most blatant examples have their apologists.

Deception scandals, which these days tend to focus on digital manipulation, have something of the fascination that bad restaurant reviews offer. Infractions are more common than was previously supposed, and what has made the difference has been investigation. Many more people are now actively interested in photography, doctoral candidates regularly analyze historical photographs, and the worldwide web offers unprecedented amounts of information, which can be shared widely. As we'll see below, under "Photographers' Skills," intervention of various kinds, usually fairly innocent, has always been widespread. Usually, it is in the interests of getting the shot, and stays within the bounds of acceptability. But over-enthusiastic and major intervention can cross the line.

Just as the way a picture is cropped or edited, in or out of the camera, can imply a different context, so the style of shooting can be suggestive. As a crude example, if the basic technique seems to be careless or hampered, the subtle inference could be that the photographer was working under pressure—in other words, that the situation was difficult and even dramatic. "Subjective camera" is a term more commonly used in cinematography—it is a combination of shooting techniques that puts the viewer in the place of the camera and emphasizes the presence of the photographer in the scene—but it has a definite place in photojournalism.

This type of "untruth" begins to matter considerably when the subject matter is as important as, say, war. During the desert campaign of World War II, one of the most active of the British army photographic units was known as "Chet's circus," led by one Sergeant Chetwyn, who was previously a Fleet Street photographer. He was responsible for the dramatic and frequently published picture, in which Allied soldiers are seen advancing into battle. Time-Life Books, for one, took the picture at face value, running it as a cover image and chapter-opener for a book on photography and captioning it as "Australian troops advancing on a German strongpoint at El Alamein, 1942." But Jorge Lewinski, in his book *The Camera at War*, provides a very different background. Partly because British official policy discouraged front-line journalism, and partly because inactive troops were frequently available for "exercises," reconstructed events were not uncommonly photographed. Lewinski quotes a British cameraman, Ian Grant, as saying that "Chet's circus" was "…bribing the support of some of the troops who were relaxing with bottles of whisky. Then they created their own little battle sequences. You got things like Chetwyn sitting on the top of a tank with maybe a couple of tanks riding out in echelon in front out of the frame of his camera. They would charge forward. In front he would have a box of hand grenades and he would lob the grenades in front of him while he was filming. This was approved by the War Office, but a lot of photographers did not like it." Understandably, Chetwyn himself does not agree with this interpretation, but Lewinski, who has interviewed other photographers, has no doubts: his caption to this photograph in his book reads "Desert war photograph, staged 1941."

One of many high-profile examples is the affair of *The Kiss* (*Le Baiser*), by the late Robert Doisneau, who made his name in street photography, capturing ironic and amusing moments on the fly. As he himself said, "The marvels of daily life are so exciting; no movie director can arrange the unexpected that you find in the street." As it turns out, not exactly "no movie director," because that is just what he did for his most famous image, *Le Baiser,* taken in Paris in 1950. For many years, this was generally thought of as a great reportage photograph. Then, in the 1990s along came a number of people claiming they were the ones in the picture and that under French law their privacy had been violated. In order to disprove the claim, Doisneau produced the real couple, who turned out to have done it on request. As the Wikipedia article has it, they were, "lovers whom he had just seen kissing but had not initially photographed because of his natural reserve, but he approached them and asked if they would repeat le baiser." For her part, the woman, who later went on to be an actress (cue a hint of suspicion), said "He told us we were charming, and asked if we could kiss again for the camera. We didn't mind. We were used to kissing. We were doing it all the time then, it was delicious. Monsieur Doisneau was adorable, very low key, very relaxed." Well, not quite, because when the contact sheet of the roll of film was published in 2009, it was seen to show the two lovers kissing not just in front of the café but all over the place, even on a bus (clearly having got to a visible point on the open back). According to the author of the book *The Contact Sheet*, Steve Crist, "The two models…were spotted by Doisneau near the school they were attending, and were hired for the series."

Now, in case you think this is a kind of disaster for the estate of Robert Doisneau, however much it may have dented his reputation for candid photography, it has actually increased the popularity of his images. And the response of the estate to this publicity? Well, we were going to show the image and contact sheet here, even though it is sufficiently well known. However, in the few months of our book's production, the price went up from an already substantial £1,500 to £3,783. We declined. Actually Doisneau appears to have had a good sense of humor. He wrote that "pictures have a life and a character of their own…Lots of them behave like good little girls and give me a nice smile whenever I walk

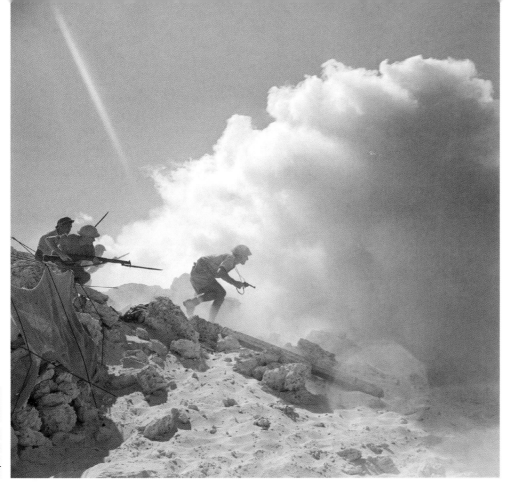

◄ **Australians storm a strongpoint, 1942, by Len Chetwin**
In a theater of war noted for its lack of battle photography coverage (British War Office policy did not encourage freely interpretative journalism during World War II), Sergeant Len Chetwyn's vital and atmospheric series of photographs of Allied troops attacking through a smokescreen is probably the most well known and well used from the Western Desert. It does, however, have a suspect pedigree, for Chetwyn's photographic unit was known to recreate battlefield situations.

past, but others are real bitches and never miss any opportunity to ruin my life. I handle them with kid gloves."

Then there's the "whose fault was it" situation, when the photographer's intention is called into question. In 1981, the German magazine *GEO* published in its national and American issues a series of photographs of giant pandas—claimed by the publishers to be a journalistic scoop and billed as "Pandas in the Wild." The American issue went on to say that "for the first time ever" a Western journalist had been allowed to photograph the animals in their wild, natural setting, in Sichuan Province. Giant pandas being rare, attractive, and the symbol of the World Wildlife Fund have a public importance, hence the fanfare for the pictures, at a time when access to China was restricted for foreign photographers. Hence also, however, the attention that the article drew from a number of naturalists familiar with the actual conditions—a secure enclosure of about two

acres that is part of the breeding center in the Wolong nature reserve. Natural setting certainly, but wild certainly not. The photographer, Timm Rautert, had access to this enclosure, where he took pictures of captive pandas that were part of the breeding program, carefully not showing any fences or other evidence of captivity. There was nothing wrong with that, but somewhere between perfectly legitimate photography and publication something went very wrong editorially. Exactly what is not clear, for in the nature of such embarrassing matters there was a certain amount of self-justification and recrimination. After the earlier trumpet-blowing, in which *GEO* claimed that these were "some of the most extraordinary wildlife photographs ever taken" (they would have been—giant pandas are hardly ever seen in their natural habitat, let alone photographed), later issues carried a correction and the photographer was dismissed. Where and from whom the misrepresentation came is any outsider's guess. The text and captions that

accompanied these pictures clearly made all the difference to their significance, yet this copy was added after the photographs had been taken. *The American* editor considered that the heading "Pandas in the Wild" made only a "technical difference." Yes, well…

Bringing deception up to date, an archetypical 2009 tale of Photoshopping concerned a story that appeared in the *New York Times*, and featured an architectural assignment called "Ruins of the Second Gilded Age" given to fine-art photographer Edgar Martins. The idea was to show unfinished grandiose building projects to illustrate the recent property collapse. It turned out that the published architectural interiors had been Photoshopped to make them more symmetrical, and this was spotted by amateur digital sleuths online (a new phenomenon). This came as a surprise to the *New York Times*, who withdrew the story. And worse, Martins had gone out of his way to declare earlier that he didn't do this kind of thing.

CONCEPT

The idea that concept should drive photography, which is largely behind much contemporary fine-art photography, has been divisive. Until this relatively recent view, most genres and motivations co-existed, more or less. Photojournalists, for example, may have little empathy with studio still-life photographers, but at least understand how they are all connected. Photography's entry into the high-concept world of art seems to have changed this, and the idea has grown that photography does not evolve from one form to another. Charlotte Cotton, in her 2009 review of contemporary art photography *The Photograph as Contemporary Art*, declines to include the work of earlier photographers partly on the grounds of what it "would suggest about contemporary art practice—that it is developmental—as emerging out of a continuous history of photography." But that, of course, is exactly what most of us would expect—that photography, like art and most other things, does evolve. This counter-intuitive view of Cotton is nothing new. When artists and critics think they have come to a break-point in art, it usually helps their arguments to claim that "as of now it's all going to be completely different." History is dead. Unfortunately for this brave-new-vision approach, history so far has managed to accommodate all of them.

Concept in art is a funny thing. In many ways it's the hidden background to what is on display. It's the idea behind a photograph, but an idea that has been well worked out and developed. It works by the audience knowing about it without having the label thrust in their face, and so is always in some way elitist. If you saw a Jeff Wall photograph for the very first time, and had never come across him before, you might wonder why it was there. Something seems to be happening, but you don't know what. And because a typical Jeff Wall image is not particularly dynamic or colorful, you might not give it a second glance. But if someone told you that this particular shot took weeks to create, you might stop for a minute and examine it more closely. Wall is a photographer who is happy to talk at length about the concept and execution of his images, so there turns out to be plenty to consider.

With conceptual photography, the idea tends to be more important than what appears on the surface of the image. It's very rare that conceptual photography shows off the kind of shooting skills that give so much pleasure in, say, a Cartier-Bresson image, or the exquisite compositional refinement of an Irving Penn, or the emotional power of a W. Eugene Smith reportage shot. To make up for this, the idea—the concept—has to be really good. What tends to happen is that someone has an original idea and makes something of it, and is then copied or followed by many others who do a mediocre job. Slim ideas make pretty poor photographs. Re-worked ideas do little better.

Not surprisingly, conceptual photography tends to be self-referential. It is photography about photography, or at least knowingly self-aware photography. This is tricky ground, because originality tends to be forfeited, and post-modernism is not going to last forever. Generally speaking, critics and curators who are post-modernist by inclination tend to be defensive on this topic. Cotton, mentioned above, goes on to say, "The idea that contemporary art photography is ultimately self-referential and in dialogue only with the history of art photography is simply not the case," but she provides no argument for this.

Not that photography before the 1970s was totally concept-free. Even Ansel Adams, whose work was fairly straightforward in celebrating the natural American West, wrote, "A photograph is not an accident—it is a concept." For the most part, however, concepts such as Adams' "positive assessment of the world" simply set the scene for the work itself. The acid test for conceptual photography is that the image does not work fully without the concept. Adams' pictures do work without. So does Frederick Evans' image of the cathedral steps on page 45, and in that case the concept seems to have come to Evans from the scene, rather than the concept inspiring the shot. Alfred Stieglitz' *Equivalents* series and Minor White's versions of these, however, make sense only when you know what lay behind them. Stieglitz, the American photographer most directly responsible for making photography acceptable as art, made a series of over 200 photographs between 1925 and 1934 that he called *Equivalents*. Most were of sky and clouds without horizon or other features. At an early show, in 1924, he exhibited a series of these that he titled *Songs of the Sky*, and wrote in the catalog notes, "Songs of the Sky—Secrets of the Skies as revealed by my Camera are tiny photographs, direct revelations of a man's world in the sky—documents of eternal relationship—perhaps even a philosophy."

Minor White, photographer and teacher, learned directly from Stieglitz, and created his own *Equivalents*, not confining himself to clouds but choosing mundane details and in particular looking for the unusual play of light on them. In an essay "Equivalence," he articulated the concept more precisely even than Stieglitz: "…an object or series of forms that, when photographed, would yield an image with specific suggestive powers that can direct the viewer into a specific and known feeling, state, or place within himself." This was abstract photography not for the motive of graphic exploration, but as metaphor for state of mind and emotion.

> ➤ **Warehouse Area, San Francisco, 1949, by Minor White**
> Much of White's "equivalence" photography centered on "found" images. Many of these involved the transitory play of light, but some, as in this ambiguous shot of a man in the warehouse district trailing a large piece of cloth that is blurred through movement, took chance and accident as their inspiration. He learned to be open to the unpredictable "in order to put myself in the path of accidents. But more than that, to put my act of photographing at the service of an outside power. So that when I photograph an outside (or inside) power may leave its thumbprint."

UNDERSTANDING PURPOSE

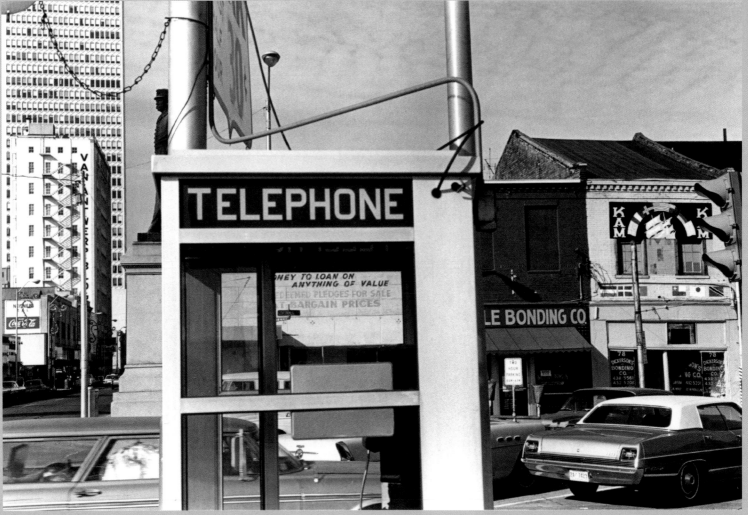

▲ **Pittsburg, PA, ca. 1979–1980,**
by Lee Friedlander.
A direct descendant of Marcel Duchamp's urinal-become-fountain, the functional street furniture and fragments of the United States, slapped down with no thought for what they might look like, became a subject for photography as soon as a few photographers, like Lee Friedlander, determined that they were. A blind spot in the American landscape became a new focus.

A borderline case of concept was Walker Evans' idea of photographing through open windows and looking along a sequence of openings. His biographer, Belinda Rathbone, wrote in *Walker Evans: A Biography*, "in drawing a distinction between the sentimental photography of the preceding generation and the pure documentary style that would soon overtake it, Evans made notable use of the metaphor of an open window and evoked a penetrating vista down through a 'stack of decades.' The receding vista, common to many of Atget's photographs, was becoming a particular interest of his." And, "That his photographs saw through windows and porches and around corners gave them a new dimension and power and even an aura of revelation."

Concept arrived with full force in the late 1960s and early 1970s, and has been with art photography ever since. The tradition of a cool, uninflected treatment of impassive subject matter, which in their various ways Eugène Atget (page 44), August Sander (page 47) and Walker Evans (page 106) pursued, had a major revival in the 1970s. It began with the American artist Edward Ruscha, who in the 1960s self-published *26 Gasoline Stations* (1962) and *34 Parking Lots* (1967). They showed just what they said, like a catalog. And as Andy Warhol was making a soup can a worthy subject, Ruscha was saying that the overlooked vernacular of the United States' semi-urban landscape (far from picturesque) was a subject fit for art. At approximately the same time, Bernd and Hilla Becher were photographing old and unlovely industrial structures. Ruscha inspired a number of young photographers, including Robert Adams and Stephen Shore. Banality was in. Not only was the subject matter fresh and controversial for photography, but the way they treated it was in the spirit of the banal and mundane—a flat, often head-on, pointedly undramatic style.

The important thing was that this largely deadpan approach was conceptualized. John Szarkowski, in particular, was in a powerful position to be able to articulate a new formal aesthetic. It promoted the unexpected, the overlooked subject matter, strict but unusual formalism, and the self-referential. There was a knowingness that depended on familiarity with photography itself. It was post-modern. The Ruscha-inspired imagery of American semi-urban landscape came together in a landmark show. *New Topographics: Photographs of a Man-Altered Landscape* was mounted in 1975 by the International Museum of Photography at the George Eastman House in Rochester, New York. The concept had a name.

It was meant to be provocative and it succeeded. It directly challenged the socially aware and committed work of photojournalists like those at Magnum. It also challenged anything that smacked of visual drama and energy: dynamic compositions, exciting color, evocative lighting. Other photographers joined the search for the unspecial that was a part of many people's lives, including Lee Friedlander, Gary Winogrand and the colorist William Eggleston. Their formalism was rather different from the large-camera-on-tripod variety of Robert Adams and others. It was 35mm formalism, which was more through-the-viewfinder exploratory. Friedlander specialized in showing the landscape in compositions that emphasized fragments of street furniture (street signs, phone boxes) that were often disoriented by shop window reflections. It was the everyday experience of walking and driving through unplanned American sprawl. Winogrand, though heavily championed by Szarkowski, shambled through his brief photographic career, never actually mastering the technicalities of the camera but always game for snapping away at anything in the street (if that seems unnecessarily cutting, consider all the thousands of rolls of film he never bothered to develop, let alone look at—see page 146 below).

William Eggleston's version of an epiphany occurred in the 1960s when he was wandering with his camera around Oxford, Mississippi. He wrote, "it was one of those occasions when there was no picture there. It seemed like nothing, but of course there was something for someone out there." He aimed the camera at the ground and began "taking some pretty good pictures." Later, over dinner, a friend asked him what he had been doing all day and he replied, "Well, I've been photographing democratically." More on Eggleston later, because he brought to the banal a missing component, that of color. At the time, color photography as it was practiced did not sit well with the MoMA-promoted concept. It was just too expressive, but then color itself, even without photography, has a tendency to be expressive.

These photographers did not think of themselves as a school, although in the minds of curators like Szarkowski and the trustees of art grants they cohered. But what they did have in common was a deliberate absence of rhetoric and an avoidance of social issues and context. One of them, Lewis Baltz, wrote, "I hope that these photographs are sterile, that there's no emotional content." They were highly influential for later photographers, principally in the fine-art market, on both sides of the Atlantic. The Bechers taught in Düsseldorf, and their students included Andreas Gursky, Thomas Struth, Thomas Ruff and Candida Höfer. None of these followed the Bechers or the New Topographics exactly, but developed different aspects of the concept. Gursky, for example, looked for subjects that were on a startlingly large scale, especially if they contained masses of components (page 73), and then produced huge prints of them. Struth did some of the same things as Gursky (they have often been seen as competitors), but later added to this an exploratory portraiture. At times, the large-scale subjects and grand treatments of them have brought Gursky's and Struth's works close to the visual drama that was originally being rejected at the beginning of this conceptual movement back in the late 1960s. In the words of a reviewer for the *Village Voice*, "They verge on *National Geographic* pics for the privileged."

One of the most conceptual of all contemporary art photographers is the Canadian Jeff Wall, most of whose work is in the form of heavily staged tableaux that explore issues from the history of photography, of art in general, and the philosophy of representation. Wall began as an art historian, and uses this training and knowledge extensively in his photographs. It also accounts for his unusual (among photographers) willingness to discuss and expand on his work in writing.

Each image is conceived as a dense and multi-layered story, and while the immediate surface impression is usually of a quite simply, even slightly thoughtlessly-taken photograph, what lies underneath is another world. In fact, Wall's apparently casual technique (note the power lines in the image here, which most people would expect a photographer to avoid by re-positioning the camera) is a part of the concept. It sets up a contradiction, because we know from everything else that it is not casual. At the same time, the almost-snapshot approach is an ordinary use of a camera such as someone competent but not a skilled professional would take, and it provides us, the viewers, with familiar territory. We all know pictures like this. They do not shout drama, high skill or photographic cleverness, so that we can easily believe them. There is the apparent absence of contrivance. Yet they are totally constructed.

To see the conceptual point that Wall is making in each case, we need to go into a lot of detail. Contrary to many images in this book, there is much to be said, and each image makes its point the more that is said. The image here, titled *The Storyteller,* depicts an ancient tradition of oral storytelling among native Canadians brought up to date (1986). A small group is seated by a freeway, with one woman telling a story. There is a dejected air to the image, and this is a comment on loss of tradition and the current status of native Canadians within society. Wall writes, "The figure of the storyteller is an archaism, social type which has lost its function as a result of the technological transformations of literacy." But, while it is "a relic of the imagination, a nostalgic archetype, an anthropological specimen, apparently dead," Wall invokes the critic Walter Benjamin to explain that "such ruined figures embody essential elements of historical memory…This memory recovers its potential in moments of crisis. The crisis is the present." The interpretation is that there is a process of recovery going on, "creating openings for a newer concept of modernist culture."

He sees the native peoples of Canada as "a typical case of this dispossession. The traditions of oral history and mutual aid survive with them, although in weakened forms. So the image of the storyteller can express their historical crisis." So, while the treatment of the subject looks drab and somewhat depressing (note the signs of marginalization, including the sleeping bag as presumably they will be sleeping rough tonight), Wall presents this on a note of optimism: "rediscovery of cultural identity…reinvention of archaic figures like the storyteller…could maybe provide a new figure within modernism."

Wall takes this explanatory approach further than most people, because he likes to re-visit the image and its making, and begin new discussions about things he had not seen at the time. Ten years later, Wall said in an interview, "I had a chance to study *The Storyteller* a bit last year because I saw it in a traveling exhibition," and went on to explain that when he shot the image, the significance of the actual story was important, but on re-visiting it he saw that the expressions on the faces of the couple listening (his frowning and skeptical, hers "Mona Lisa-like") showed something else. "The interesting thing about the 'cinematographic model' is what happens during the process of performance…the performers give you things you don't know to ask for, or don't know you are asking for." He discovered a countercurrent of doubt running through the situation. "The storyteller might be mistaken, or failing, or confused, or disingenuous." The very nature of conceptual photography—and this is a very good example—opens it to interpretation and discussion. It is meant to.

Tableau photography—there is sufficient of it for it to be a category—was a natural for the emerging art movement in contemporary China. Individual comment of any kind had been suppressed for so long, and because some areas still remain taboo, the role of art takes on a special importance because statements can be made in an oblique way. Wang Qingsong, whose image *Competition* is on page 70, works in this form. Much of his photography questions the changing value systems of Chinese society. In this image, he sees advertising as the crass successor to political and armed struggle, and writes, "In terms of visual form and content, this outdoor advertising onslaught is not unlike the big character posters ('Da zi bao') posted by competing factions and littering city streets in China during the Cultural Revolution. In the past, the streets were hung with posters in fights over political beliefs. Now the struggle is over financial power and business gain. Ads for items are like a rash growing out of control everywhere on our city streets." Obviously, conceptual photography appeals more to viewers who enjoy taking an intellectual approach rather than a visceral one.

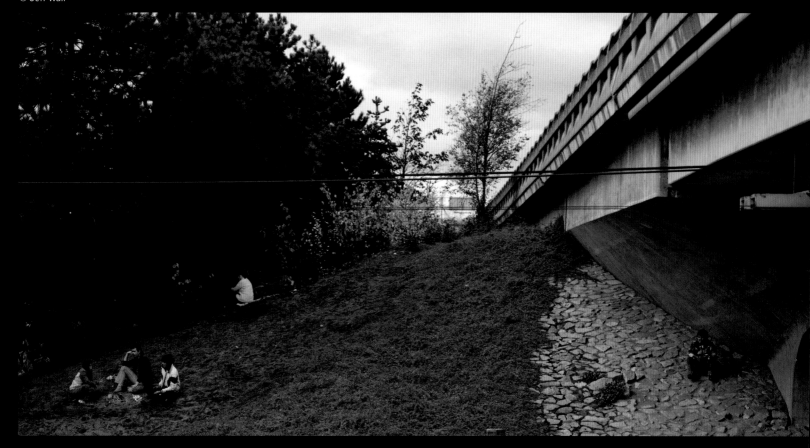

⋏ The Storyteller, 1986, by Jeff Wall
Large Cibachrome transparency on an aluminum
light box, 90 3/16" x 172 1/16' (229 x 437cm). One
of the artist's self-termed "cinematographic"
photographs, it has been conceived, planned and
shot as a still frame from a movie, with actors who
have been carefully briefed and assigned roles.
Wall's basic description (he has several) is "*The
Storyteller* depicts a group of native Canadians who
are dispersed on a bank underneath a freeway.
They could be and, sociologically, would be sleeping
around in the woods and around this freeway and if
you notice, the characters above have sleeping bags
that they are lying on, so they might be homeless or
they might not. They are relating in different ways
to the tale being told by the figure on the left." The
discussion continues in the text.

PART 3
PHOTOGRAPHERS'
SKILLS

The English photographer David Bailey, who did much to define the look of fashion and portraiture in Britain in the 1960s and early 1970s, said, "It takes a lot of imagination to be a good photographer. You need less imagination to be a painter, because you can invent things. But in photography everything is so ordinary; it takes a lot of looking before you learn to see the ordinary." Not only does it have to work with so much ordinary subject matter, but we all see a great deal of photography all the time. If the picture is about something we are already interested in, we don't give any of this a second thought, but for any other photograph to catch our attention, it has to have something that makes it stand out from the endless mass of imagery.

What makes photography more special than other art in this respect is output. Just on the numbers being produced, photography is way out in front, by orders of magnitude. That most of it is not art matters less than the fact that with so much camera imagery in front of our eyes all the time, we are all very familiar with the way photographs can look. The audience for photography takes photographs itself, as never before, so for any one image to be considered worth a closer look, it has to be different. It has to be interestingly different. Imaginatively different.

This is what makes photography so competitive. Anyone interested in photography and looking is constantly making judgments and comparisons. On a new image: this is good, better than that, but maybe not quite as good as that other one. Photographers are even worse, and if an image is within their area, they can't help but bring in the personal. This jostling of images for attention is unique to photography. On a daily level, for instance, there is editing—what photographers do at the end of a shoot when there may be anything from several to hundreds of images, needing to be whittled down to one or two for processing and possibly printing. Better or worse? Other art forms don't have this. Even writing and editing comes from the world of words, has a much slower and more detailed selection process. Photographs can be edited at a glance, and they often are in professional practice. Not necessarily edited well at speed, but they can be nevertheless.

SURPRISE ME

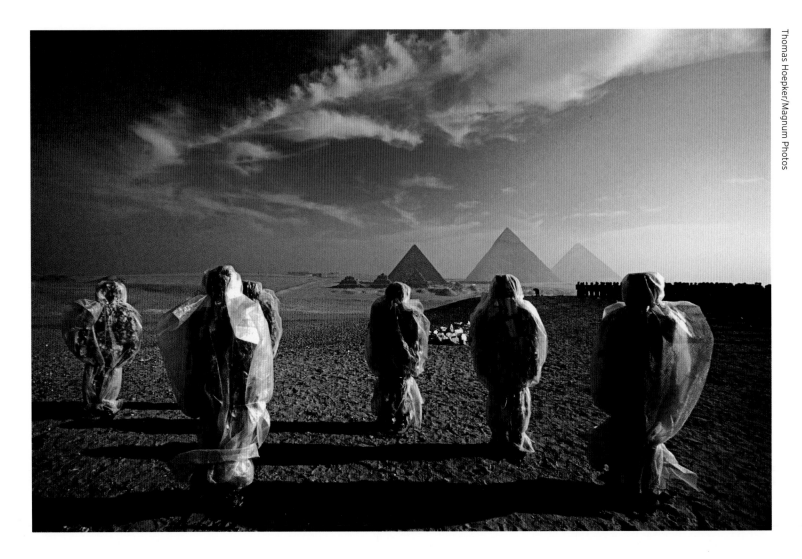

Thomas Hoepker/Magnum Photos

One way out of this is to take care of David Bailey's "ordinary." Find a striking subject and there is less other work to do. Or rather, being more committed, creative imagination applied to a special subject stands a chance of being even more effective than when applied to an ordinary subject. This is at the heart of a great deal of photojournalism—digging out the special subject. Unusual always works. There are distinct, out-there striking subjects, especially things that almost no one has ever seen. The exotic from travel has served photography faithfully since the nineteenth century, but now shows signs of coming to an end. There are certainly places and events, even entire societies, that remain to be found and photographed, and the energy of exploring photojournalists has never been stronger (it needs to be to keep pace with the increasing familiarity of the audience with distance and strangeness). But the worst sign is that the entire idea of exploration has become familiar. Most people expect that you can, if you really want, simply sign up for a trip to the ends of the earth, and it will all be taken care of. If you can, then to an extent you've embraced it already. In any case, travel is by no means the only way of finding surprising content. Society throws up daily all kinds of strange subjects, as does science, and art.

▲ **Giza pyramids with army of "trash people" by artist H.A. Schult, Egypt, 2002, by Thomas Hoepker** Unpacking of sculptures that arrived from Germany. From the very first look, it is obvious that something strange is going on here. Content is everything in this shot, and the surprise is in what is happening (which very much needs explanation in a caption). Hoepker went further, however, and made sure that he photographed the installation before it had been properly unpacked. The wrappings look even odder than the sculptures.

SEEING DIFFERENTLY

Surprising subject matter or not, one of the first tenets of professional photography is that you have to try harder, always and all the time. There's almost too much said about this, so I'll restrict myself to one only, from American photographer William Albert Allard: "You've got to push yourself harder. You've got to start looking for pictures nobody else could take. You've got to take the tools you have and probe deeper." Well, maybe I'll allow one more, as it's from Alexey Brodovitch, the influential and always quotable art director of *Harper's Bazaar* in the 1940s and 1950s: "Look at thousands of photographs and store them in memory. Later when you see in the viewfinder something reminding you of a familiar picture, don't click shutter." Trying harder and searching for different ways of seeing don't in themselves count as specific photographer's skills, but they are very much in evidence in all good photography.

The case history of Cary Wolinsky's image of a half-shorn sheep illustrates what it sometimes takes to create a special image from an otherwise unsurprising situation. Wolinsky first had to pitch the story—about wool—to the *National Geographic* editors. He had already done one story on silk (and had four rejections before it was accepted), which went on to be a successful, big feature for the magazine, running 52 pages. That made it easier, but even so, Editor Bill Garrett was not immediately swept away. "I pitched my ideas before a room full of editors from every department. Bill interrupted me at one point to declare that he didn't like sheep and ask if I could do the wool story without sheep pictures. I had to think about that for a moment. I told him I didn't think I could, but I would promise that any sheep pictures I took would floor him. That set the bar high from the start." The quote is long but worth it; Wolinsky tells it well.

▼ **Half-shorn sheep, New Zealand, by Cary Wolinsky**
"It seemed easy enough," said Wolinsky of the idea, "to show how much wool a sheep grows in a season, just shear off half the wool and have the sheep stand sideways. Knowing nothing about sheep I figured I'd have this picture done in an afternoon. The shearing season had started early in New Zealand. But I was determined to find a few sheep that hadn't been fleeced. We drove and drove. It seemed we had landed on an island populated by nearly naked sheep."

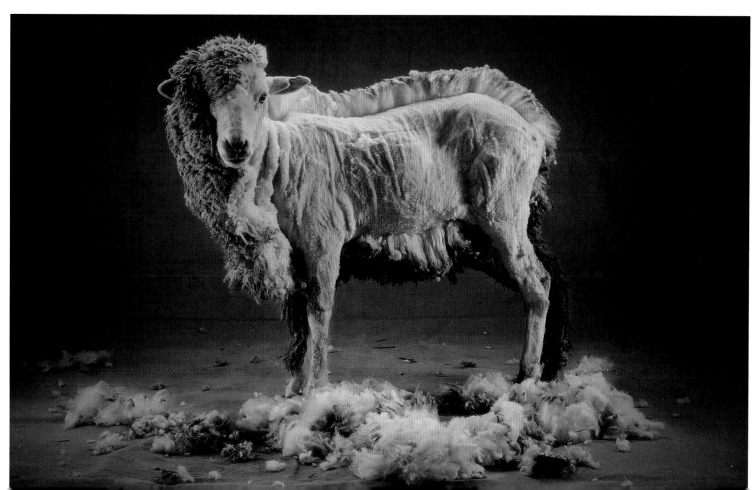

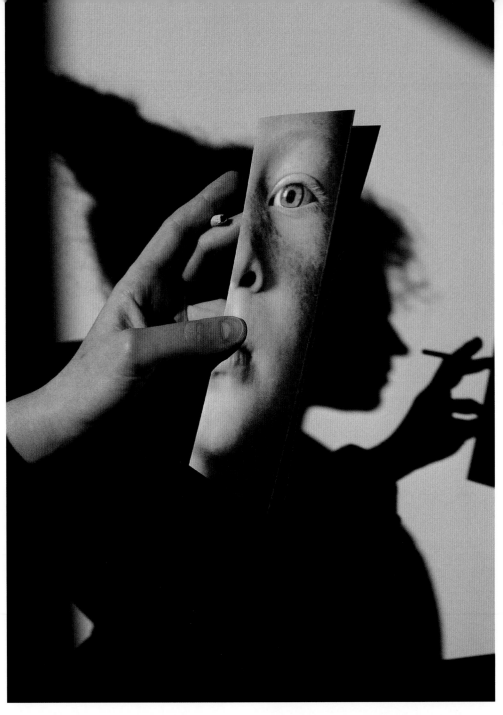

Wolinsky had with him a "gun" (top) shearer, Robin Kidd: "The shed was quiet. The five sheep huddled in the corner of the shearing pen looking like they would very much like to leave. Robin pulled one of them upright so that it was sitting on its rump. The sheep slumped into a catatonic state. Robin grasped the shears then hesitated. He had removed so many sheep jackets as whole fleeces he couldn't figure out the moves he needed to do just half. He pecked away with the shears. Dirty wool fell all around. Done. He released the sheep. It bounded to its feet, swayed a bit, then toppled toward the still woolly side. The now unbalanced sheep lay helpless on its side, feet bicycling in the air.

"The next try was better planned. A grazier (Australian for sheep farmer) near Melbourne agreed to hold, unshorn, 100 'hogs' (one-year olds) until I arrived. We converted the sheep shed to a studio. I had painted a huge canvas with waterproof paint (easier to clean up) to use as a seamless background. Ninety-nine young Merinos tried to hide behind the one in front as I went about the task of choosing which would become famous that day.

"Shearing sheds are hot, dusty, and, if the truth be known, a bit bloody. Electric shears are similar to those that barbers use but a lot coarser. Under all that wool Merino sheep have loose, wrinkled, ever so soft, and sensitive skin. When shearing a mob of several thousand sheep, shearers don't waste much time avoiding wrinkles. Otherwise clean, white, nearly naked sheep are spotted with little red shaving nicks. As a result the first sheep never achieved stardom. Nor did the second, the 19th or the 27th. We tried shearing them front to back as well as side to side. The well planned, half-day photo shoot was trying the patience of not only the generous grazier but of the 12 motorcycle shepherds who locked arms to create a human fence around each sheep while I attempted to make a picture.

"In the end it was sheep number 30 that became a star. Remembering how my dad temporarily patched his shaving nicks with a bit of tissue (I now use an electric shaver), I took a wad of wool, patched the nick on number 30's neck and got set up to make a picture. The motorcycle shepherds locked arms. The camera shutter clattered and 72,000 watt-seconds of flash bathed number 30 in light with a happy popping sound." The picture ran as the lead shot in the magazine.

▲ Portrait of designer, Paris, 1995, by Gueorgui Pinkhassov

Portraiture has its standard forms, as we saw earlier under *The Genres of Photography,* but the rules are fixed by no one. Pinkhassov's portrait of a designer plays multiple games with representation and with graphic form. He believes that creativity expresses itself "less in the fear of doing the same thing over again than in the desire not to go where one has already been."

Alex Webb/Magnum Photos

UNEXPECTED CONTRAST

Contrast plays a key role in photography. Not just the contrast of tone that most people think of, but of other image qualities, and of the subjects themselves. It's even possible to think of composition, in its broadest sense, as depending on contrast—playing one image element off another. This certainly was the idea of the Swiss teacher Johannes Itten, who from 1919 devised and ran the Basic Course at the Bauhaus, and was succeeded by the Hungarian photographer László Moholy-Nagy. One of his self-appointed tasks was "to present the principles of creative composition to the students for their future careers as artists," and one of the key exercises was to find and present contrasting pairs. "The basis of my theory of composition," he wrote, "was the general theory of contrast." This approach includes image qualities like brightness and color, and also specifically photographic image qualities such as focus and motion blur. Alex Webb's photograph above is typical of this photographer's handling

of harsh tropical shadow and light, while Trent Parke, whose images are on pages 15 and 182, takes contrast of light in another direction, letting the lit parts explode beyond the constraints of normal exposure.

De-focus is one of the optical qualities specific to photography, which is to say we don't experience it in the same way with our eyes. Combining sharp with unsharp focus in one image is not only easy, but in many situations inevitable. It can, however, be made more interesting as a contrast by reversing the expected planes of focus. William Klein does this with his image on page 19. Another quality that comes from photography itself is the way in which the camera records motion and passing time, from the unexpected frozen moment (unexpected because our visual system doesn't catch images quite like that at high speed) to motion streaking. This latter offers opportunities to contrast still and moving in one frame, and Liu Weiqiang's image of a sandstorm on page 21 exploits just this contrast.

▲ In the Arid Northwest of the Island, Haiti, Monded Blanc, 1987, by Alex Webb
The harsh light from an overhead sun, particularly common in the tropics, tends not to be the preferred lighting for most photographers, who generally congregate around the ends of the day when possible. Webb, however, specialized in techniques for using this high contrast, including the graphic silhouette in complex arrangements.

Contrast in this broad sense extends to the "surface" qualities of the subject, such as texture, transparency, solidity. On solidity, for example, it is essentially between hard and soft, massive and delicate. Bill Brandt's *Stonehenge* on page 37 does this wonderfully (he waited a long time for the right weather opportunity). Jim Brandenburg's photograph of the eye of a dead deer on page 151 has a disturbing contrast of texture between the glassy eye and the wet pelt—disturbing because the eye reflects blue sky and life, even while it is quite dead.

Going deeper into the content than these images and physical qualities, we reach contrast of meaning and of the essentials of a scene and subject. With people, this can involve emotion and expectation. From this perspective, Nan Goldin's intimate self-portrait on page 113, *Self Portrait in Kimono with Brian* is about contrast of feeling, involving hurt and disappointment. Dennis Stock's image here takes its power from not just from scale, but from its unexpected appearance.

Contrast can be a general and fundamental way of of thinking about composition. This is not composition in the detailed sense of dividing the frame just so, or using eye-lines to direct the viewer's attention, but an underlying idea of setting one thing off against another. That thing may be concrete or abstract, but done deliberately and efficiently it communicates to the viewer the sense of that against this, and the fact that such a contrast is pointed out can add an extra dimension to the photograph.

▼ **Playa del Rey, Los Angeles, USA, 1968, by Dennis Stock**
From *The California Trip*. A scene, and image, just rife with symbolism waiting to be picked up. But even without this, the unexpected juxtaposition of both scale (extreme) and activity (fast and noisy to private and relaxed) give a jolt. Stock made the most of this contrast by using a long telephoto lens for foreshortening and to crop out the context of the surroundings.

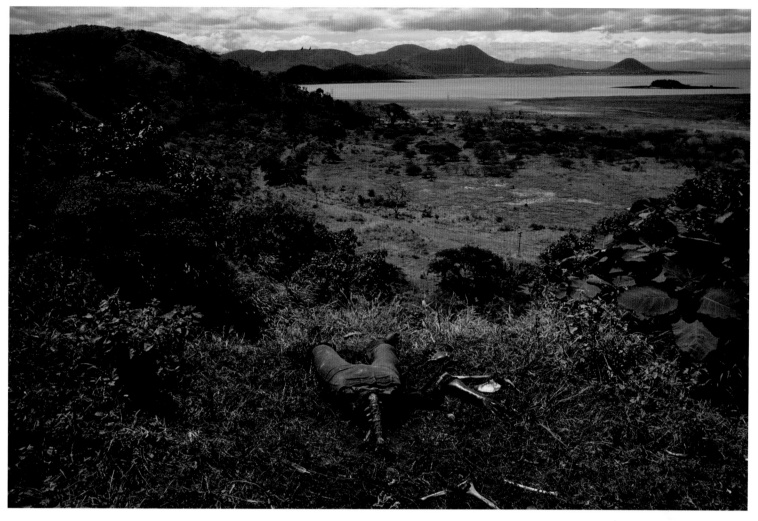

Susan Meiselas/Magnum Photos

HOLDING BACK

One of the less well-known distinctions in photography is between shooting to get the point across unequivocally, and shooting for a slow-burn effect on the viewer. Nailing the subject as clearly as possible is often (probably most often) the ideal, especially so in news and sports photography. Many photographers, however, prefer to ask questions in their images rather than try and give immediate answers. This is in contrast to the one-stop shot, which can be immensely powerful, as in Dorothea Lange's *Migrant Mother*, but which also carries the built-in disadvantage that the viewer tends to move on quickly. Shown here are images that do the opposite. The risk is that with an audience accustomed to getting the point in one glance, it may not hold the attention long enough for

its effect to work, but if it can, that effect can be strangely powerful, as in Susan Meiselas' shocking image from Nicaragua in the '70s (above).

Another way of holding back is deliberate ambiguity, in an image that asks the viewer to stay for a while and question. As an example, Icelandic artist/photographer Rebekka Guòleifsdóttir uses herself as a model in a series of tableau photographs, usually relating to the landscape around her. The scenes are intentionally not obvious; she writes, "I want the viewer to bring their own perspective into the image. It's not always imperative that the exact meaning I have in mind comes across, I encourage an open interpretation of my work, if that makes sense." Many have surrealist overtones: "I've been fascinated with surrealism since I was a child, and wanted to incorporate that into my photography from the start."

▲ **Cuesta del Plomo, Managua, Nicaragua, 1978, by Susan Meiselas**
American photographer Meiselas made her name with her coverage of civil conflict in Nicaragua and El Salvador. One of her most shocking images is this, of a place outside Managua that became well known as an assassination site used by the National Guard. Meiselas covered street fighting and other action, but was also interested in different approaches, "particularly the focus on a more distanced 'aftermath' rather than 'decisive' moments of engagement. The peculiar horror of this image comes from the scenic location—almost a beauty spot, with lake and hills in the distance—and from Meiselas' cool and undramatic treatment. The corpse is not the first thing the viewer sees, and its delayed arrival on the attention makes it all the more unforgettable. Meiselas said, "The American public could not relate their reality to this image. They simply could not account for what they saw."

▲ Out of the blue, 2005, by Rebekka Guòleifsdóttir.
For this composite image, the photographer says, "I'd been experimenting a great deal with high shutter speeds and suspending objects, water or myself in mid-air, inspired in part by Philippe Halsman's famous portrait of Salvador Dali, *Dali Atomicus*. Creating the picture presented a slight challenge in that I wanted to do so without any assistance, being a very stubborn do-it-yourself type. Obviously getting myself and the splash into the same frame simultaneously was physically impossible, so I resorted to shooting two frames and combining them in Photoshop, the same method I'd used to create double self-portraits. This photo exemplifies a simple rule I set myself from that point on: Never fake anything in Photoshop unless absolutely necessary, and only combine elements that were in fact present in front of the camera during the same photoshoot. This is my way of rebelling a little bit against the extreme use of digital manipulation to create an illusion of photography; the technology has advanced so far in the past few years that it's become damn near impossible in some cases to tell if a photo is at all real any more, and in many cases they aren't. This is so far removed from what photography essentially is about, it just doesn't interest me."

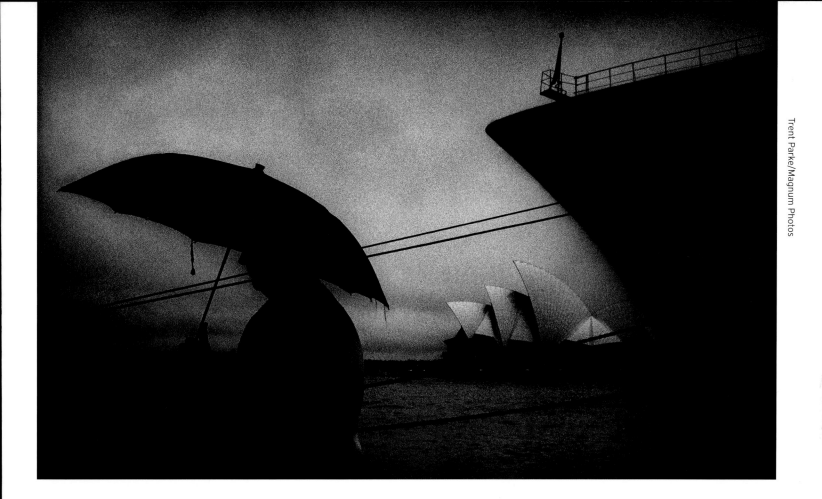

Trent Parke/Magnum Photos

MAKING CONNECTIONS

Seamus Murphy's photograph of the one-legged Afghan at the beginning of the book (page 18), contains one of those correspondences that add an extra layer to a photograph. This is a very specific form of what Cartier-Bresson referred to when he said, "What reinforces the content of a photograph is the sense of rhythm—the relationship between shapes and values." There are all kinds of possible graphic relationships, such as elements that are, in fact, far apart but appear touching, or neat frames within frames as in David Alan Harvey's picture on page 99, but the most special are such unexpected coincidences. The extra layer is often one of nuance, a sensitivity to graphic details. Ernst Haas wrote, "The best pictures differentiate themselves by nuances…a tiny relationship—either a harmony or a disharmony—that creates a picture."

The connection in the case of Murphy's image is purely graphic, yet at the same time draws attention to the missing Buddha statues. Seamus Murphy, who shot it, realized it consciously only later. As he said, it was "that thing in photography which is seldom talked about—luck! How we end up being at a particular place that turns out to be the perfect or decisive place is often down to intuition and serendipity, and then one's abilities are put to the test. But in this case it wasn't until I saw it as a negative image on the roll of film that I saw the rhyme of man and rock face shadow. In fact, even after I had seen this image I had chosen another Bamiyan rock face picture in my edit for the book. But after umpteen re-edits plumped for the one that's in now. So it was luck that made the shot and later reflection on the merits of both pictures, coupled probably with my mood at the time that made me choose the one I did." In a way, I wanted Murphy to say that it might have been a subliminal recognition, but while he wouldn't deny that outright, he stuck to luck.

Here are two more graphic connections, from Australian photographer Trent Parke and Italian

▲ From his Dream/Life series, 1999, by Trent Parke
A man stands in the rain at the overseas passenger terminal on Sydney harbor, which overlooks the Sydney Opera house. The umbrella passing through the frame echoes the shapes of Sidney's famous Opera House, and also the silhouette of the ship at right. None of the three have anything significant to do with each other, which is why the purely graphic correspondence works in a light-hearted way.

Romano Cagnoni. Neither need diagrams to point out the structure, although Parke's umbrella and ship's bow against the Sydney Opera House come across more obviously that the two curves in Cagnoni's shot. Also, look back at Raghu Rai's image of a wrestling school on page 31, and see how the coincidence of the painted arm at the top of the right door with the real arm belonging to the boy on the right adds a pleasing nuance to the shot. It extends the *trompe l'oeuil* effect, and is obviously both deliberate and skillful.

▲ New Guinea, 1962, by Romano Cagnoni
Shot on the small pacific island of Biak, this image owes much of its appeal (and later use) to a correspondence that was barely subliminal as Cagnoni shot it—the repetition of the curve of the pregnant woman's outline in the bamboo supports and their reflections. The way that the shot happened was that to begin with he thought that the succession of slim bamboo bridges might make a picture of some sort, and he walked out onto the middle of one of them. The boy splashing in the water in the distance gave the scene some life, but then Cagnoni saw that a woman was about to cross from the left. He had time to take three or four frames as she crossed, and this was the successful one. The strangely elegant curve of the woman's form is a strong ingredient, a second is that she is framed neatly in a clear space on the bridge, and a third is the correspondence mentioned—which Cagnoni realized later during the edit.

THE SKILL TO CAPTURE

Purpose and imagination apart, the sharp end of photography is the moment of capture, with all the actions that go into it. Because capture involves some very different activities, all running together at the same time, it gets interpreted differently by the people who are interested in understanding it. The photography critic's view is rarely the same as that of a camera enthusiast. Indeed, they often have completely opposed interests. The standard critical view of capture is to subordinate it altogether to postmodern interpretations, and the ways in which the equipment was used are usually ignored completely. The majority of camera enthusiasts are much more interested in equipment and its handling than in anything else, because they usually translate this information into their own photography. Comments in camera forums on Larry Burrows' helicopter photo essay, for example, concentrate on the cameras he used and especially on the special remote-control rig that he devised.

Between these two groups, critics and amateurs, the part of capture that tends to get lost is what goes on in the mind and eye of the photographer. Timing, anticipation, and composition are, of course, techniques in their own right, every bit as much as focus, selecting the shutter speed, and choosing the ISO, but they are less discussed. Critics and camera enthusiasts are not the only audience, however. Professional photographers looking at the photographs of others are likely to have yet another view. The equipment tends to be "taken as read," unless it makes some special and important contribution, such as the concealed lighting that Philip-Lorca diCorcia installed for his distinctive style of street photography, or indeed, Burrows' helicopter camera rig. In any case, there's a sense of it being unseemly among professionals to dwell too much on the gear. What motivates most professionals looking at photographs is working out how and why the capture happened, and it is normal to try and put themselves mentally in the place of whoever shot it. How would I have done that? Would I have done that?

Often passed over in art-crit commentaries is what, to many photographers, is the real core and fascination—the moments leading up to shooting. This is when all the creative and reactive skills have to mesh. There are exceptions, of course, notably in heavily planned and conceptual photography, but for most shooting, success or failure takes place here. Most photography happens on the spot, so it makes sense to look here for the answers. Yet this information is often conspicuous by its absence in shows and in publications. That may seem natural, because not all photographers supply that information. In fact, many photographers actively prefer not to give it. Robert Doisneau probably spoke for many when he wrote, "If you take photographs, don't speak, don't write, don't analyze yourself, and don't answer any questions." Andrè Kertesz, talking about composition, took another well-subscribed position when he said, "There is no explanation, I was born with these instincts." Well, of course there are explanations; it's just that Kertesz preferred to stay aloof.

But really, that's not a good enough reason, because if you think like a photographer, and can imagine yourself in the situation, it's often possible to reconstruct what happened. By no means always, but if we're seriously trying to appreciate an image, it's worth a stab. Commonsense will often point the way, and suggest whether or not there's enough information to make it possible. In the case of the photographs of a young Vietnamese boy grieving over his dead sister lying in a truck, there is most of the information available in the image to be able to have a photographer's understanding of the situation. Without a caption, there is a lot we don't know, but this does not necessarily influence the way the pictures were shot. We don't know that this is his sister, for example, although the pain and emotion on his face says that it's someone he loved. But the photographer would not necessarily have known this either, and it would have made no difference to the photography. In fact, these two images, discussed at length later under "Compositional Skills" were chosen precisely because they show two very different photographers reaching the same conclusion about shooting.

HANDS ON

However much we try and elevate photography as an art form, and photographers usually love this as much as anyone else (as long as it includes their pictures), quite a lot of it is manual labor. There's a strong blue-collar element, at least during shooting itself, and many photographers acknowledge some kinship with other practical professionals like engineers and mechanics.

But professionals don't generally like talking about cameras and equipment, unless they are teaching, or discussing it among themselves. The general agreement is that what makes a good photographer is skill and creativity, and for reasons of self-esteem most of us want to be thought of in this way rather than as camera operators. By contrast, most amateurs enjoy equipment discussions. Guides to using specific camera models are always high on the photography best-seller lists.

All of this makes for a rather confused situation. Equipment matters, and handling it skillfully is essential, but for different reasons many people downplay it as a subject. Common professional refrains are "It's just a camera," and "It's only a tool," implying that what really matters is that the photographer is a special and gifted individual. Cartier-Bresson perfected a technique of unassuming near-invisibility, and refused, often angrily, to be photographed himself. His style of candid, unnoticed shooting partly depended, he believed, on not being recognized. Joel Meyerowitz, doing street photography one day in New York, was surprised to see Cartier-Bresson at work: "It was astonishing. We stood back a few paces, and we watched him. He was a thrilling, balletic figure, moving in and out of the crowd, thrusting himself forward, pulling back, turning away. He was so full of a kind of a mime quality. We learned instantaneously that it's possible to efface yourself in the crowd, that you could turn over your shoulder like a bullfighter doing a *paso doble*."

Richard Avedon used an 8x10 inch Deardorff view camera for his *In the American West* portraits. It was manned by two assistants, and shooting with this kind of camera meant that, once the image had been framed and focused, and the darkslide with its film inserted, there was no reason to stand behind the camera. One assistant loaded film, a sheet at a time, at the back; the second stood by the lens, adjusting aperture and bounced light from a reflector as required, while Avedon stood to one side, talking to his subjects, exercising his famous control. The formality of such large, slow equipment communicated a sense of seriousness to everyone, including the subjects, as noted by the biographer of the project, Laura Wilson. This formality and Avedon's firm control give the portraits their sense of presence and gravity.

These are just three examples of why equipment, and the way the photographer uses it, can matter very much. Did I mention that Burrows used a Nikon F1? Is it important which brand? In that particular case it was, because in the 1960s Nikon led the way in rugged SLR cameras. Remote-control triggering was just one of the new possibilities from Nikon in 1965, and its use on a helicopter gunship was a first (Burrows also persuaded the reluctant military to let him use the rig on a night flight in an AC47 gunship, and shot it in color, the barrel flash from the 7.62mm miniguns creating a dramatic and strangely beautiful image.)

The mechanics and electronics of photography make a difficult layer of appreciation when it comes to looking at photographs. The information is usually suppressed, first of all by the photographer, and it may indeed have little to tell us about why we like a particular image. The photographer may be right to hold this back. On the other hand it is always a part of the process, and sometimes it is important. Most photography forums, however, will give you a very different impression, where members are cheerfully enthusiastic and inquisitive about equipment. It is partly because of this popular interest that many professionals censor the information, and a sure way to irritate most of them is to ask what camera they use. Even worse, what camera they used for a particular prized image. Apparently, Irving Penn's reply to that question from Ernest Hemingway was "Your novels are excellent. What typewriter do you use?"

With mechanically complex equipment such as a camera—or a typewriter—dexterous handling is the ideal, and was even more important in earlier years, before electronic automation of everything. Fast focusing or pre-focusing meant getting the shot sharp even when there was hardly any time to react, and some people could do it better than others. And how critical was this to the success of the image? How damaging was mistyping or slipped focus? Read on.

➤ **Juan Patricio Lobato, Carney, Rocky Ford, Colorado, August 23, 1980**
Photograph by Richard Avedon
In his huge project In the American West, Avedon's choice of subjects for portraiture homed in on the unusual and striking in faces and posture. As described in the text, the choice of large camera and a team of people invested each session with a sense of seriousness and significance.

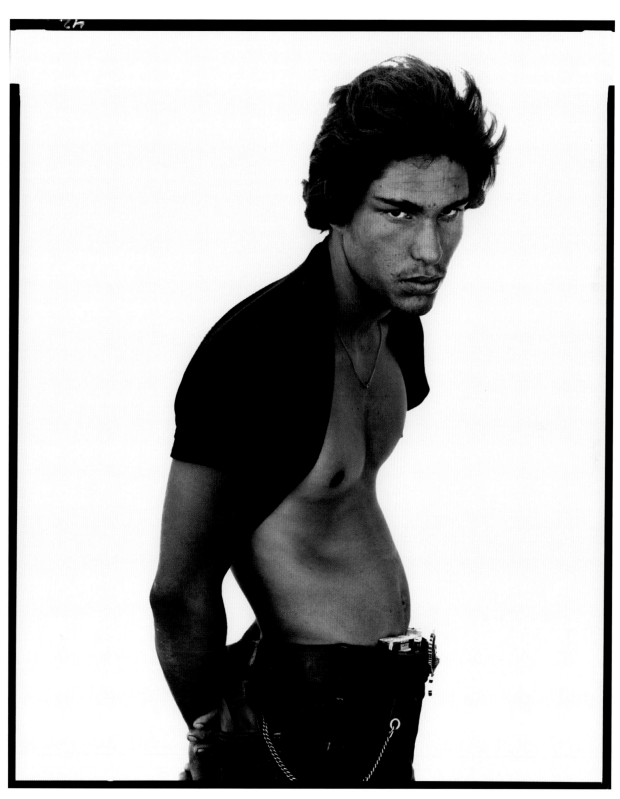

PERFECT IMPERFECT

Life photographer Alfred Eisenstaedt considered that a good picture "must have quality, drama, and it must, in addition, be as good technically as you can possibly make it." All true for the practicing professional, but circumstances sometimes conspire against technical perfection, and sometimes photographers simply get it wrong. But does it matter? When Robert Capa shot American paratroopers jumping in the invasion of Sicily in July 1943, there was just such a technical imperfection. He wrote, "They were slightly out of focus, a bit underexposed, and the composition was no work of art. But they were the only pictures to come out of the invasion of Sicily so far..."

In photojournalism, through the early decades when cameras and film were not so capable of recording images in extreme conditions of light and movement, imperfections such as these became a convention of authenticity. Readers of magazines and newspapers came to believe that focus problems, underexposure, graininess and awkward composition were the hallmarks of authenticity. Conditions were so bad that even the professional photographer was challenged. Surely no publication would run such imperfect images unless they were important and true. This began as the case, but with time, just the look alone became a badge of truth.

Something similar happened throughout photography in general. Technical mistakes were at first just unfortunate, but gradually came to be accepted in some circumstances, and even admired. Photographers' attitudes towards these imperfections went through a kind of evolution. Leaving aside the downright unusable, there were, first, mistakes that were tolerated because what was being shown in the image was important enough to override them. Then, there were mistakes that, on reflection, seemed to add something. This in turn led some photographers to a philosophy of preferring imperfections over what they saw as a "cold" technical perfection that had no spirit. And finally, a minority of photographers began deliberately making imperfections as a way of exploring the graphics of an image.

All of this taps into one of photography's unique properties as an art form, which is that even when purposeless and robotic, cameras still produce fully formed images. Unlike painting, or writing, there is no such thing as an unfinished photograph. When things go wrong, like camera shake, there is still an image. The photographer may have lost some of the control, but it doesn't necessarily invalidate the picture. In fact, there are occasions when the result may even be stronger. Well-known examples are not hard to find.

One of the most powerful images of World War II was taken by Robert Capa at the start of the D-Day invasion of France in June 1944. The picture is blurred, and only the crucial elements can be made out with any certainty—an American soldier sprawls in the surf to take cover; behind him in the distance are the angular shapes of German obstacles to prevent landing craft from making it all the way to the beach. Capa wrote in his autobiography *Slightly Out of Focus,* "The water was cold, and the beach still more than a hundred yards away. The bullets tore holes in the water around me, and I made for the nearest steel obstacle." A soldier was already there, and there was hardly enough room for the two of them. The soldier picked up the nerve to move forward, "and he left the obstacle to me. It was a foot larger now, and I felt safe enough to take pictures of the other guys hiding just like I was."

But consider what went into its making. In extreme danger, there was no time to compose and make all the careful adjustments that photographs are commonly supposed to need. Capa snapped it, rapidly. Under fire himself, he prudently lay flat, working from an awkward position, and did not even manage to hold the camera quite steady. *Life* magazine, when they published the picture, wrote that the "immense excitement of [the] moment made photographer Capa move his camera and blur [his] picture." Capa disputed this, and in fact the light was hardly sufficient for handheld shooting. "It was still very early and very gray for good pictures," Capa wrote, "but the gray water and the gray sky made the little men, dodging under the surrealistic designs of Hitler's anti-invasion brain trust, very effective."

▲ Omaha Beach. The first wave of American troops lands at dawn, June 6th, 1944, Normandy, by Robert Capa
One of the historic images of World War II, this photograph was taken by Capa just after he landed on a Normandy beach with the first wave of U.S. infantry troops spearheading the liberation of Europe. By "normal" photographic standards, the quality of the picture is poor, showing motion blur from camera shake. While this was certainly the result of difficult, dangerous conditions, it conveys the urgency of the moment perfectly.

Werner Bischof/Magnum Photos

▲ **Watch Tower, Koje Do Island, Korea, 1952, by Werner Bischof**
A U.N. re-education camp for Chinese and North Korean prisoners, during the Korean War, 1950–53. Motion blur speeds a Korean woman carrying a bundle on her head past a backlit line of prisoners and the watchtower overseeing them. This softness of the figure, combined with flared sunlight as Bischof positioned himself so that the tower cut into the sun, gives an expressive atmosphere to the picture, while the over-tight framing as the woman moves into view gives a sense of a shot hurriedly taken.

Technically, the picture is a mess, but its very imperfections are a large part of what make it so good; it is obvious that here is a picture taken in the heat of battle. Capa was an experienced and skilled photographer; he knew the value of such immediacy in photographs and is quoted as saying: "If your pictures aren't good enough, you're not close enough." Grain and blur reinforce the coarse reality of battle action. As it turned out, these, the first photographs of the invasion of Europe, were largely ruined by accident. After they were rushed to the *Life* lab in London on the same day, a technician closed the door of the drying cabinet under orders to rush, and of four rolls of 35mm, all but 11 negatives were melted beyond recovery. Before and after this image are some frames apparently shot from the same position, as Capa sheltered behind the anti-landing craft obstacle, and these are steadier, without motion blur. They have none of the urgency that this one does. On this occasion the technicalities prevailed, to the benefit of the photograph. And as we just saw, blur and similar "mishaps" became a convention that reinforced urgency and authenticity. John Morris was the *Life* picture editor in London at the time: "I held up the four rolls, one at a time. Three were hopeless; nothing to see. But on the fourth roll there were eleven frames with distinct images. They were probably representative of the entire 35-millimeter take, but their grainy imperfection—perhaps enhanced by the lab accident—contributed to making them among the most dramatic battlefield photos ever taken."

The role of photography in reporting World War II, as published in weekly illustrated magazines like *Picture Post*, *Collier's* and *Life*, gave photojournalism a big boost. Many would-be photojournalists wanted to follow in the footsteps of people like Capa and Cartier-Bresson, and the format of choice was 35mm black and white, shot with rangefinder cameras like the Leica and Contax, which were small and silent. Technically, this allowed much more freedom than the earlier, bulkier rollfilm and sheet cameras. You could shoot away and be reasonably confident of getting something, particularly with tolerant black-and-white negative film. And that is exactly what began to happen, with some photographers simply trusting the camera to deliver an image without worrying too much about shutter speed and aperture, even focus and precise framing. The Swiss photographer Robert Frank became well known for his experimental, loose approach, which at first was not at all well received. In picture after picture, particularly in his seminal book *The Americans*, Frank's extremely casual technique—the blur, imprecise composition and skewed framing—give a spur-of-the-moment, unplanned edge to the shot. In fact the anti-technique meshed perfectly well with what was, at the time, an ignored subject—the barrenness of everyday American life. In this case, although the exact effects of such a rough-and-ready camera technique could not be predicted, the principle was deliberate. Photographer Elliott Erwitt, an admirer, wrote, "The pictures of Robert Frank might strike someone as being sloppy—the tone range isn't right and things like that—but they're far superior to the pictures of Ansel Adams with regard to quality, because the quality of Ansel Adams, if I may say so, is essentially the quality of a postcard. But the quality of Robert Frank is a quality that has something to do with what he's doing, what his mind is. It's not balancing out the sky to the sand and so forth. It's got to do with intention."

This developed into an appreciation of imperfection among a number of photographers. This was often small imperfections, not as extreme as major motion blur, but such as the fall-off in illumination, the evidence of chance. Richard Avedon thought that "there is something about a perfectly lit photograph that I find offensive," while Cartier-Bresson took the patrician view that "sharpness is a bourgeois concept." The philosophy of admirable imperfection goes far beyond photography, and is one way of challenging the importance of getting everything ordered and precise. This is a vein that runs especially through Japanese aesthetics, where the elusive concept of wabi-sabi—an appreciation of the imperfect, impoverished and ascetic—is applied to a wide range of art, from the tea ceremony to photography.

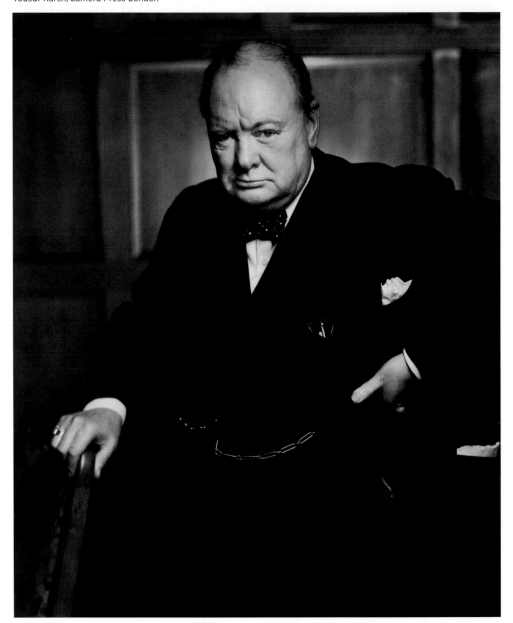

REACTION

For photographers, one of the major distinctions is between shooting what happens unplanned in front of you, and arranging things to photograph. They're both valid (under the right circumstances) but very much at odds with each other. This distinction lurks at all levels. It even defines whole genres of photography: photojournalism by definition should be "pure" in the sense of not arranged, while studio photography cannot help but be planned. But…dig deeper and we find that the possibility of doing one or the other exists almost everywhere. In documentary reportage, which covers a broader range than photojournalism, arrangement can be as simple a matter as asking someone to stop what they're doing so that they can be photographed (or continue with what they were doing before they stopped to look at the photographer!). In photojournalism itself, it's widely regarded as a sin if the viewer is led to believe that the shot was just as it happened. On the other side of the planning frontier, in the studio, many photographers like to play with chance—in a limited way, of course. Having set up the lighting and the scene, they can explore and react to what happens within it, and this is often when there is a person in front of the camera. Yousuf Karsh's famous photograph of Winston Churchill during World War II, shot for a *Life* cover, is accompanied by an equally famous story of how he captured the "British bulldog" demeanor of his gruff subject.

This was in the Ottawa parliament after Churchill had given an address and, according to Karsh writing in *Faces of Our Time*, "He was in no mood for portraiture and two minutes were all that he would allow me as he passed from the House of Commons chamber to an anteroom. Two niggardly minutes in which I must try to put on film a man who had already written or inspired a library of books, baffled all his biographers, filled the world with his fame, and me, on this occasion, with dread." Churchill entered and struck a pose, with a cigar clamped between his teeth. "Instinctively, I removed the cigar. At this the Churchillian scowl deepened, the head was thrust forward belligerently, and the hand placed on the hip in an attitude of anger." A second exposure showed Churchill in a more amiable mood, and this, for some reason, was Karsh's preferred version.

When an equally famous portrait photographer of the same generation, Philippe Halsman, also photographed Churchill, he took a less impertinent approach, and was rewarded with…a cigar!

⌃ Winston Churchill, 1941, by Yousuf Karsh
An iconic image that depends for its strength as much on Karsh's impertinence as on his signature lighting that emphasized contrast, as the text explains.

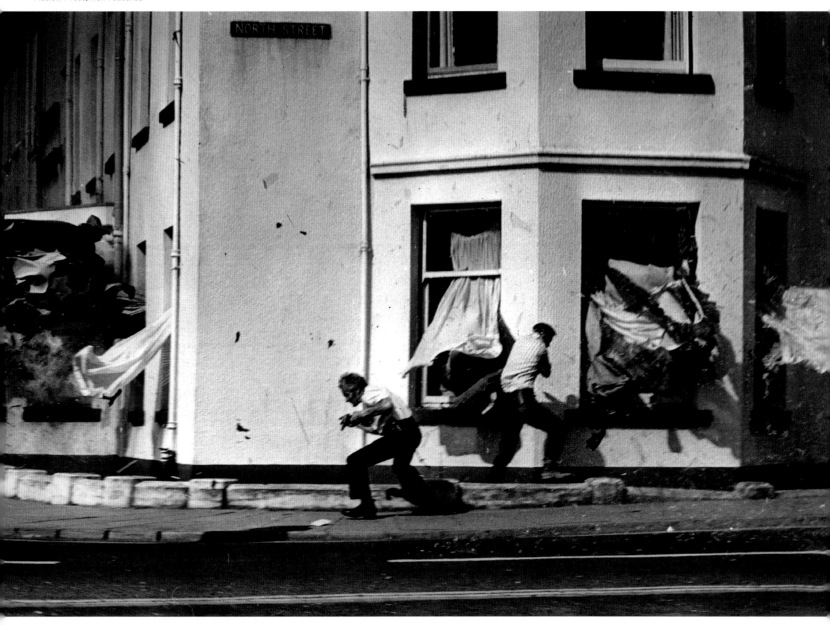

In a very different way, but one that is still essentially photographic, frozen action is another part of the camera's visual vocabulary. The macabre fascination of Brigitte Dahm's amazingly timed photograph of a bomb explosion in Northern Ireland comes largely from the new evidence it gives us of what actually happens in such extreme events; such information is outside our own experience, and it derived from the high shutter speeds and sensitive film of modern photographic technology.

Few of us see such a thing, fortunately, and even when a sudden event like this happens, people may be looking in another direction, or they blink and duck. This photograph is a rarity, and more than that, it reveals a frozen world that is quite terrible. In a way similar to Eadweard Muybridge's pioneering photography of animal and human locomotion with his zoopraxiscope, it shows us what our eyes would never register even if we were looking.

▲ **Ulster: Moment of Terror—Explosion at the Marine Hotel, Ballycastle, Northern Ireland, 1979, by Brigitte Dahm**
In the presence of fast action, eyes and brain fail to register all the details; if the action is violent as well, shock and other nervous reactions make it even more difficult to appreciate what has happened. This near-invisibility of such events gives this type of photograph an extra fascination. Here we can actually see the bizarre details of flying fragments and the power of the blast...and wonder what happened to the two men.

TIMING

Reaction is very much to do with timing, but there are more deliberate ways of deciding when the moment is right. Some of them even rely on editing the take later, which is a way of deferring the decision. All of them center on choosing the instant of exposure that will give what the photographer considers the best image.

Probably too much has been written about Cartier-Bresson's "decisive moment." There is certainly not much that hasn't been said about the idea that in an event, a situation, a piece of action, there is one instant, a fraction of a second, in which everything comes together elegantly in the frame. Cartier-Bresson, whose best work exemplifies just this principle, which he took, incidentally from the writing of Cardinal de Retz, the seventeenth-century Archbishop of Paris, explained: "Inside movement there is one moment at which the elements in motion are in balance. Photography must seize upon this moment and hold immobile the equilibrium of it." It is very much a concept embedded in photojournalism, or at least in photography as capture, and has pretty much nothing to do with planned photography like studio work or any situation in which the photographer can arrange things or say "do that again."

It places great importance on the ability of a photographer to read a situation, both physically and visually, and to have the skills of anticipation, composition and speed to be able to catch it. The "it," however, is not some perfect, pre-ordained moment. It is whatever each photographer chooses it to be. Most photographers who write have at some time or another felt compelled to comment on it, and I'm afraid I'm doing just that myself. Seen as a kind of commonsense universal truth, which it is, there is not much to be said other than agree, but many people have challenged it as not being relevant to their way of shooting. In the case of, say, Gary Winogrand, who coined the inevitable "indecisive moment," or Arnold Newman, who called it a simplistic catchphrase, adding that "there are many moments," these are true also. Winogrand shot street photography haphazardly and in great quantity, and would later go through the contacts to see what he had (it's telling that he left behind on his death over 8,000 unprocessed rolls of film waiting for this selection process). What do exist, however, are good moments, not-so-good moments and downright missed moments.

▶ **Liberia, 1931, by Martin Munkácsi**
Alternatively and misleadingly also titled Boys Running into the Surf at Lake Tanganyika and Three Boys at Lake Tanganyika. As well as being a spectacular example of timing and composition, this image has the distinction of having inspired Henri Cartier-Bresson to take up photography. He wrote, "In 1932 I saw a photograph by Martin Munkácsi of three black children running into the sea, and I must say that it is that very photograph which was for me the spark that set fire to the fireworks... It is only that one photograph which influenced me. There is in that image such spontaneity, such a joy of life, such a prodigy, that I am still dazzled by it even today." There is little doubt, incidentally, that this was shot in Liberia, some 2000 miles from Lake Tanganyika. Munkácsi was on assignment in Liberia, and of course there is no surf like this in the East African lake. Cartier-Bresson, who abhorred cropping, may not have realized that this image, sometimes presented as a 2:3 format which would suggest a 35mm camera, was in fact shot with a 9 x 12cm camera. The crop is principally at left, to take out the hand of a fourth boy, with a fraction off from the right.

For a detailed look at a concentrated photographic moment of unusual importance, here is what happened on August 9, 1974, in Washington, D.C. Twenty-seven-year-old Pulitzer-Prize-winner David Hume Kennerly, who to date has photographed every US president since Richard Nixon, (and had unprecedented access to the White House under the Ford tenure as his official photographer), was present at the most telling moment of Nixon's resignation—his departure from the White House.

"I was scrunched among dozens of other photographers 100 feet away on a photo stand waiting for President Nixon to make that long last walk from the White House. You could feel unfolding. I had a clear line of view of the door of the waiting military helicopter that would carry Nixon to Andrews AFB where he would board Air Force One for his trip to San Clemente, California, and exile.

"We had no idea what he would do when he boarded. If Nixon just walked onto the chopper without turning around there would have been no dramatic moment, no photo, just the back of his head. Fortunately that didn't happen.

"The President and First Lady Patricia Nixon said goodbye to vice president, and soon-to-become chief executive, Gerald Ford, at the bottom of the steps. Nixon then ascended the helicopter steps, paused midway, turned, and looked back, (wistfully, I think), at the executive mansion he was vacating. With one brusque flip of his right arm, his lips tightly pursed, Nixon waved goodbye to the White House and the crowd of staffers who had come to see him off.

"What followed was bizarre. The dozens of staffers started applauding him, and broke into cheers. Nixon responded with his trademark 'V' sign as he waved both arms around, like at one of his campaign rallies of the past. But it wasn't a rally, rather it was one of the darkest days in presidential history, outside of the assassinations, of course.

"That one-armed, tight-lipped wave was 'the money shot' and it ran in *Time Magazine*, where I was a contract photographer. That

David Hume Kennerly/Getty Images

photo was picked by the editors at *Time* as the 'decisive moment.' I had no say in its selection, photographers rarely did. Similar photos from other photographers ran on the wires, in the *New York Times*, and in other publications. I thought it was the right picture at the time, and it still holds up well to this day. My only reservation is that the preceding frame #11 is a bit more subtle, and makes you wonder what was going through his mind as he looked up there for the last time as president. When it comes down to it, all these years later, I would still go with #12 if I had to pick just one.

"I do believe that the sequence in the contact sheet tells the story of his departure the best.

From Ford's saying goodbye, to Nixon's awkward farewell waves, and then Ford's walking off in the last frame, it is almost like a mini-movie. The contact sheet, taken as a whole in this case, is a more important historical document."

Photographers tend to favor either shooting in quantity or limiting themselves to a few exposures, and there is little sympathy between the two approaches. Heavy shooting in the professional world is not because of uncertainty and indecision, but for security (in case anything goes technically wrong) and also to get the best out of the subject and situation.

By contrast, a few photographers have, for near-philosophical reasons, challenged themselves creatively by limiting their opportunities to shoot. American landscape photographer Thomas Joshua Cooper has spent two decades traveling to the most extreme locations on the planet, such as Prime Head, the furthest extremity of Antarctica, which has had fewer human visitors than the moon. He photographs in black and white with a nineteenth-century view camera and plates. But perhaps the most notable feature is that Cooper chose to take just one picture at each of the difficult locations he had chosen. Now, whatever else you think about when you go to a great deal of effort to get to somewhere special for a photograph, you do think about safety. I don't mean your own physical safety, but the matter of securing the images. Whether on film or a memory card, you take precious care of it, and you'd normally take a number of pictures and explore the visual possibilities. In fact, the more remote, the more exceptional and unrepeatable the occasion and place, the more trouble you might take to make the most of it. Yet here, in the most extreme of situations, the photographer is doing the opposite.

When the *Financial Times* reviewed Cooper's 2009 show, the reviewer saw this as a limitation to the body of work, as a flaw in an otherwise fine enterprise, with perhaps even a hint of pretension: "It is an arbitrary restriction and one that profoundly affects the quality of the whole. Cooper's genius is his own but the result of setting such artificial 'rules' is that he jeopardizes his quality control. It results in an awkward mixing of quality that does no favors to the best pictures in the show." But the argument for this way of working is compelling. By forcing himself to choose just one moment, one composition from all the possibilities, Cooper intensifies the creative experience. A great deal is being invested in a single image.

In 1997, wildlife and nature photographer Jim Brandenburg conceived an assignment for the *National Geographic* in which he would, over the course of 90 days, take one, just one frame per day in snow-bound northern Minnesota. No second chances. If he shot a scene early in the day then came across something stunning and unmissable later, too bad. If he fluffed it technically, too bad.

To most people the idea of self-imposed austerity seems at first thought perverse. Why would you do that? What would it feel like to do that? Would you even dare to do that? It was discussed at length on one of the many Internet photo forums. One member, typical of many, wrote that "Every one of us knows that if you have such an encounter like this [a gray wolf chasing ravens] we stick our finger like glue to the button and we may only stop when the roll is finished, and this is because we have the fear of not taking that perfect picture…"

Exactly, fear. But not so exactly, bolstered by the belief that by not taking a decision and just shooting like a robot, all will come fine in the end, That is the choice between trying for everything and choosing later, or holding your breath and going for just one moment. However, if a photographer shoots a burst of exposures with the camera set on continuous at, say, five frames a second, the odds of getting the perfect (for that photographer) moment actually get worse. The reason is this: a continuous sequence like that gives regularly spaced frames over a second or so, but the detail of the action may be much faster than that. Shooting at 1/100 second at five frames a second captures only one twentieth of the possible moments in that second—and worse, they are arbitrarily spaced by the camera, not by the photographer. Brandenburg's reasoning is clear. He wrote, "When you smother something with repeated shots, in a certain way it's demeaning. But when you value something enough to take just one picture, you're paying it homage."

Comparisons with movies and video fade in and out of discussions on photography. Right now, the relatively new ability of DSLRs to capture video makes them more pertinent, because the same camera in the same hands can be switched instantly to do one or the other. Eddie Adams, whose most famous image is of the Saigon police chief executing a Vietcong prisoner in the street in 1968, had a forthright view: "A still photographer has to show the whole fucking movie in one picture. A still picture is going to be there forever." Wim Wenders, who shoots still photographs as well as making movies (including *Paris, Texas* and *Wings of Desire*), believes that "Every photo is the first frame of a movie." This suggests another way of thinking about timing. Movies and video carve time up into distinct sequences, and for many kinds of photography, too, it's practical to think like this. It works for much photojournalism, and very well for sports and wildlife. The units are typically from between a few seconds to several minutes. And the still image needs to be located, according to this way of looking at things, somewhere significant within it. Wenders thought at the start, Adams thought at the point that seemed best to sum up everything. Kennerly thought that a sequence snipped from throughout the sequence worked best. It depends on defining the beginning and end of a sequence, which is itself a construct, of course. The moment could be at the very end, or it could be halfway through. The latter influenced Martin Scorsese in his filmmaking, using quick cuts to jump straight into the middle of a scene. Carravagio's paintings influenced him in this. He said in an interview, "I was instantly taken by the power of [his] pictures. Initially I related to them because of the moment that he chose to illuminate in the story. *The Conversion of St Paul, Judith Beheading Holofernes*: he was choosing a moment that was not the absolute moment of the beginning of the action. You come upon the scene midway and you're immersed in it. It was different from the composition of the paintings that preceded it. It was like modern staging in film: it was so powerful and direct…I thought, I can use this too…So then he was there. He sort of pervaded the entirety of the bar sequences in *Mean Streets*."

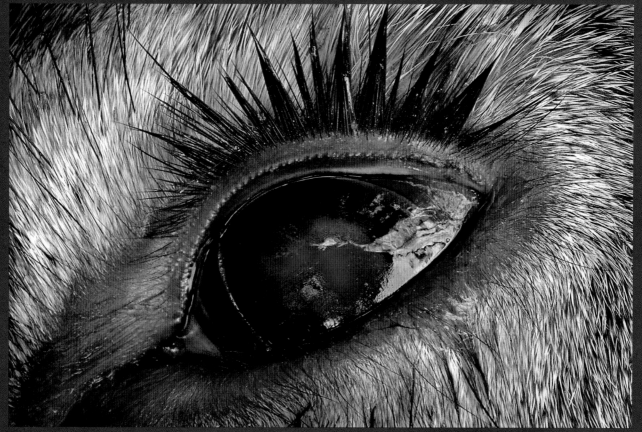

⋏ ➤ Chased by the Light, contact sheet, 1994, by Jim Brandenburg

Having spent 25 years working for *National Geographic*, with its culture of heavy shooting— thousands of images from which a handful were culled—Brandenburg proposed the opposite: taking just one photograph a day between the fall equinox and the winter solstice.

INTERVENTION

All shooting involves some kind of choice, however hard the photographer may try to stay a pure, hands-off observer. Even the simplest act of framing leaves some things out and pushes other things in. This much is no surprise to anyone, but there is another kind of control when the photographer in person interacts with the scene, the situation. Nothing unusual, you might think, in asking a subject to stand over there, look at the camera, look away. But it gets a little complicated if the viewer assumes at the start that the shot is snatched in passing from a slice of life. These are exactly the kind of philosophical games that Jeff Wall plays with many of his tableau photographs (see "Concept," page 120).

As it happens, and though it's impossible to measure this, probably more intervention goes on than most people expect. The only evidence for this is the kind of public reaction whenever some intervention is uncovered concerning a well known image. Some of it borders on the deception mentioned above ("Deception," page 118), but most of it is just a way of making the shot happen, but done so well that the viewer does not think about it. One typical example is a key shot from Brian Brake's "Monsoon" story shown on pages 86–87. This is the picture of a girl's face upturned to the arrival of the rains, quite elegiac in its way.

The shot was organized—very much so—and this would not surprise most photographers. The girl, Aparna Sen, was the daughter of a Bengali filmmaker, and went on to have a career as an actress. "He took me up to the terrace, had me wear a red sari in the way a village girl does, and asked me to wear a green stud in my nose," she said in an interview much later. "To be helpful, I said let me wear a red one to match, and he said no—he was so decisive, rather brusque—I think a green one. It was stuck to my nose with glue, because my nose wasn't pierced. Someone had a large watering can, and they poured water over me. It was really a very simple affair. It took maybe half an hour."

While Sen was not happy with the picture ("I looked more 28, than 14, and I was all teeth. I didn't like myself at all."), at age 14 it was none of her business. "I felt I was just a model, a prop. I did what I was asked to do. Nothing more, or less." Nevertheless, later she admired the result professionally. "This photograph, it's amazing the way it conveys a great deal more than went into it. In a way, it's so like [Satyajit] Ray; Ray is the master of the close-up. In one close shot, there would be so much information, emotional and physical."

Alfred Eisenstaedt, one of *Life* magazine's most famous and respected photographers, wrote, "It's important to understand it's OK to control the subject. If most editorial stories were photographed just as they are, editors would end up throwing most in the waste basket. You have to work hard at making an editorial picture. You need to re-stage things, rearrange things so that they work for the story, with truth and without lying." *Life*, of course, was famous in its day for pushing its photographers to get the shot. One such "managed" shot is instructive in showing how the culture of assignment photography has changed. John Dominis, one of *Life*'s better known staff photographers, spent months in Africa in 1966 shooting "The Great Cats of Africa" story. In fact, he spent three months just on leopards (not atypical of the luxurious time and expense allowances of those days). The most famous image to come out of this story was of a leopard attacking and catching a baboon—very dramatic. The image is displayed now on the *Life* web site with the caption "In 1966 Botswana, *Life* photographer John Dominis captured this photo of an encounter between a big cat and an ape. As you can imagine, things did not turn out so great for the baboon." So, what is implied here, even by omission? That this was life in the wild?

In fact, the magazine wanted a kill from this long assignment, and that was what Dominis provided. In the book *The Great Life Photographers*, by the editors of *Life*, the explanation is that "even though he orchestrated his famous baboon-leopard encounter (the feline was a rental dropped in among the simians), Dominis had never

suggested otherwise. 'Frankly, it was set up,' he said, 'In those days we were not against setting up some pictures that were impossible to get any other way.'" For several reasons these days this would not be acceptable, but in the 1960s practice and expectations were different.

In the 1860s, John Thomson set out to record scenes from the life and landscapes of China, riding on the wave of interest in exotic travel. The role of the traveling photographer was not complicated: to show what exotic places looked like. Thomson visited China for a total of five years in the 1860s, with the intention of producing a photographic record that would be as informative as possible. He was not outwardly concerned with self-expression or "art." The photographic historian Beaumont Newhall considered that the work contained "that sense of immediacy and authenticity of documentation, which a photograph can impart so forcibly." This was true only up to a point. Authenticity, for a Victorian photographer, often involved compromises to overcome technical limitations. If Thomson had had access to camera and films that allowed rapid shooting, we might indeed have seen a good deal of the candid depiction of Chinese life that he wanted. But, given the materials of the day, the only way of showing people in close-up was to pose them, which Thomson had to do regularly. He did this conscientiously, but he did it inevitably with his own eye for the way things should be. In other scenes individuals pose "naturally" beside monuments. A Victorian reader might be forgiven for thinking that picturesque Chinese were forever meditating in impressive landscapes.

The danger for the viewer, obvious in principle but hidden in specific images, is that photographs which may seem to be essentially documentary, whether they are records for public or private consumption, are often influenced by other attitudes—both towards the subjects of the pictures and towards the photographs themselves as objects.

There is another meaning for intervention, applied to the photograph once taken rather than

**A Monks eating at Fang-guang-yuan Monastery,
Fuzhou, Fujian, 1870–71, by John Thomson**

to the situation being shot. The term now used since photography turned digital is manipulation, and for most people this is a completely separate issue. While it's true that the processes involved are all on the computer at a later date, much of this digital manipulation can also be thought of as continuing the work of a photographer's on-the-spot management of a scene. Like physical intervention, it still carries a whiff of impurity for many people, even though there are many situations in which it can be justified.

Post-production intervention (or manipulation) has a different aspect depending on which side of the process you sit: the photographer's or that of the audience. To photographers who do it, adjustments, alterations, removals and so on are as much a part of creating the image as what went on at the time of shooting. One flows into the other. For the audience, not generally privileged to know all the production details, the two activities look quite separate—if, indeed, either can be spotted. From this point of view, and it has claims to being commonsense also, the content of the original photograph was locked at the moment of shooting into the film, or nowadays the raw image file. Anything done later looks like another image, or another version.

Usually, of course, the audience does not know whether, how or how much a photographer

intervened in either taking a shot or playing with it afterwards. If and when they do find out, which happens more and more as notable photographs get investigated by everyone from amateurs to PhD candidates, they tend to react differently to digital manipulation. A look at online photography forums where it was discussed suggests that the setting-up of Brian Brake's "Monsoon" portrait came as a surprise to people who knew the shot and created a mild disappointment. The typical reaction is "Oh, I thought she was standing in the rain," then followed by "but it's a great shot anyway, and it was in the photographer's mind." The underlying sentiment for most people is that whatever happened, it was still caught on film, and therefore a true record. It's worth asking whether the image would seem less "natural" if it had been taken in a studio rather than outdoors.

Most people react to the surprise uncovering of digital manipulation as being quite different in type, and with more evident hostility. Except for cases when the photographer is actively playing with the idea of manipulation, as in Thomas Ruff's *Blue Eyes*, and when it is obviously all part of a game, as in much of advertising, this kind of digital intervention is usually seen as deception, which takes us back to "Deception" and in particular to the Edgar Martins case on page 119.

But rather than show one of the very many contemporary digital examples of this, we can look at just these issues in a black-and-white negative image shot in 1954 by W. Eugene Smith. This was the lead shot for Smith's famous photo essay on Albert Schweitzer, who ran a hospital in Lambarene, French Equatorial Africa. Smith made the prints himself, including the powerful

lead shot, deeply printed for a heroic effect, with the pith helmet and highlights on Schweitzer's face bleached for an intentional halo-like, saintly rendering. In the lower-right corner, we see the silhouette of a saw and a hand, but these came from a second, entirely different negative. Glenn Willumsun (see his analysis of "Country Doctor" on page 81 above), interprets this added element as reinforcing the presentation of Schweitzer as carpenter himself, and especially for its Christlike connotations. This is by no means fanciful, given Smith's obsessive commitment to layered interpretations, and given the accompanying headline and text: "Man of Mercy," and the first-paragraph description "humanitarian, warm and saintlike."

Now, the tonal adjustments in the printing are one thing—the result of Smith's expertise and dedication—but stripping in part of another negative might strike most people as being serious manipulation. Smith himself did not see it like that. He considered it "rearranging for the truth of actuality." This print, claimed Smith, was the result of a non-stop darkroom marathon of five days and nights. Smith followed the argument of the "higher truth" as objectivity is an illusion on photography, it is more honest to aim for fundamental truths and use any photographer's skill to that "honest" end. He wrote, "This is the way I see it...that photography has very little of reality in it, and then only on the lower level of simple recognition. Beyond that, in the transmission of inner feeling, I feel that everything that is honest to the situation is honest to the photograph."

COMPOSITIONAL SKILLS

Inextricably linked to the creative imagination that goes into a shot is how the photographer chooses to frame and compose. This is very much an individual matter, some photographers paying more attention to it than others. It may be entirely intuitive, and the faster and more reactive the kind of shooting, the more likely this is, as with Werner Bischof's shot on page 142. Intuitive shooting, however, can mean years of practice in order to do instantly what other people might need to take time over. But composition can also be utterly deliberate, considered and adjusted over minutes, or longer. The photography of Gursky (page 73) and Burtynsky (page 108), for example, is thoroughly planned well in advance, and the compositions decided long before the image is committed to film or sensor.

I use the two terms frame and compose because sometimes they are two actions, or are two segments of the process. Framing is how the boundaries are set; the shape of the camera frame is the given, and often the first decision is how this is going to be applied to the scene in front of the photographer. How much of the scene is going to fit in it, and from what angle? The viewpoint and the lens focal length are the two main variables, followed by decisions on what will be included and what left out. Composition may, just may, lag behind basic framing, meaning the organization of elements inside the frame; this of course means further adjustments to angle and scale and so on. But for some photographers this all happens together.

Other terms that people use are design, geometry, placement, formal structure and spatial organization. From now on I'll use the word composition to mean the entire business of not only arranging the graphic structure, but what it means to the subjects in the image and how this is going to influence the way someone else will look at it. It would be wrong to think of composition as an exercise in arranging abstract shapes and lines. They all belong to real-life subjects, and composition is a skill that most photographers put to work to get their ideas across better. As usual, Henri Cartier-Bresson had something useful to say about it: "A photo seen in its totality in one single moment, like a painting, its composition is a melting together, an organic coordination of visual elements. You can't compose gratuitously; there must be a necessity, and you can't separate form from substance." Not all photographers, however, are entirely candid about their involvement in composition, and there is a fair amount of denial or refusal to discuss it. Sometimes this is because composing can be difficult to describe. A lot goes on quite quickly at the time, and it's not always obvious even to the photographers themselves why they organized the image in a certain way. Another reason is that many people think that this part of photography, at least, should be alchemical, a little magical, and that to dissect it is to kill its power.

Here we look at some of the pressures that subjects and situations apply, because often, once these have been chosen, they push to be framed in a certain way. Photographers react to this differently, many acquiescing and looking for the reasonable solution, fewer fighting it and working to impose their own ideas of arrangement on the scene. We also look at some of the many styles of composition. These sometimes follow fashion, sometimes are rebellions against the usual, and sometimes are chosen because they suit a particular subject or an idea that the photographer wants to get across.

➤ **Kandilli, teens jumping into Bosphorus, Istanbul, Turkey, by Bruno Barbey**
In terms of composition, the pale naked torsos function as units within the frame. Barbey positions himself so that three nearer figures span the frame left to right, and the gaps between them are filled with the more distant figures. The graffiti happily undulates to enclose all of these.

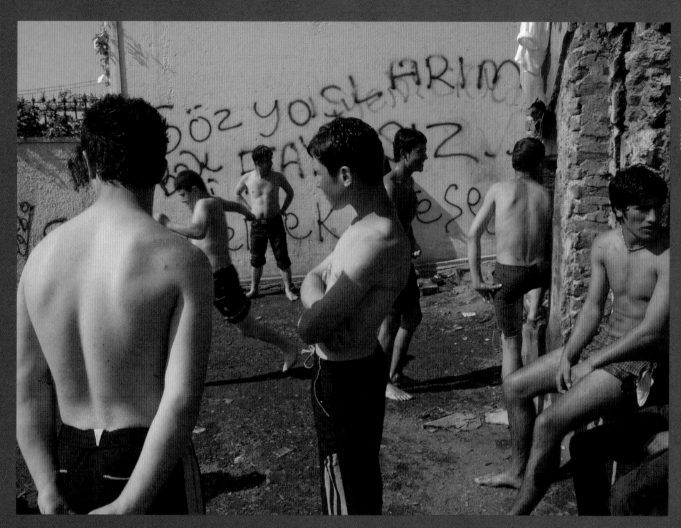

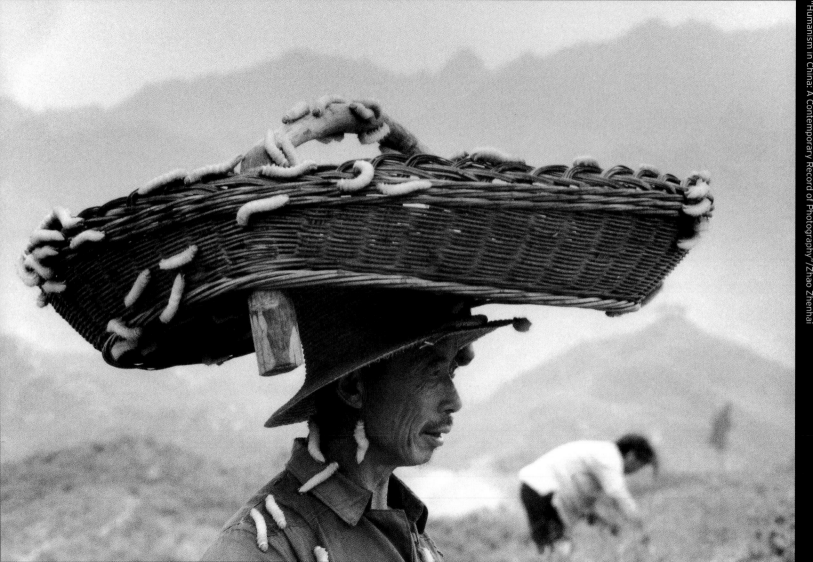

◄ **Farmers who specialize in breeding silkworms, Lushan, Henan, 1987, by Zhao Zhenhai**
The subject is striking and unusual, needing no help from imaginative composition. This, indeed, is a natural, and effective, way of framing the shot. We need to see no more of the man, but we do need his face and neck crawling with silkworms. The shape of the basket plus head neatly fits the frame. Additional touches are a camera angle that includes the hill skyline just above the basket (they correspond), and for context another farmer at work in the middle distance.

ASSERTIVE SUBJECTS

Some subjects seem to want to be framed in a particular way. It depends on the format of the camera, and how they appear from the starting viewpoint, but subjects that have shapes that in some way correspond or interact with the frame encourage a certain composition. The jade horse on page 29, for example, left little choice for framing or viewpoint if the idea was to reveal its intended qualities. In particular, the exquisitely sculpted curve from the nape of the neck up and round the muzzle could be seen only from this angle, give or take a fraction of a degree. Any higher and the muzzle would have broken the line of the back. There is also from this angle a correspondence between the negative space under the throat—a looping curve—and the similar looping curve of the muzzle; any more to the left or to the right would have destroyed this. Still life, in particular, is susceptible to this kind of minutia, because there is plenty of time to consider and position, and because the photographer has a duty to make things interesting.

Of course this is fanciful. The subjects have no will to make images, and what we're looking at here is our typical eye–brain reaction, but still, this is the way it often feels to the photographer. In a way, Martin Munkácsi's shot of the three boys running into the sea, the one that so entranced Cartier-Bresson, is a natural for the frame held vertically. Naturally also, it didn't start that way, but at that moment, when they came together as they ran, and the photographer was behind them, they made a fit for the frame. (Although see the caption on page 146 for the way that cropping altered the image). Would someone else have framed them differently (by choice, that is)? If you were there, and could slow time so that you could think, and there was just that couple of seconds of action, would you have? It's a useful question, because it has to do with not just choice, but with whether you accept that some images just fall together in the frame.

Not everyone does, and this has a lot to do with personality. Subjects may not be literally assertive, but photographers certainly can be. If "surprise me" is the call, some photographers respond by working on a subject in a way that is deliberately, and usually assertively, individual. This is where style comes into composition, which we look at in a moment, below.

KNOWING WHAT WORKS

Taking this matter of the "natural fit" of a subject further, there are situations and scenes that tend to provoke a similar response. In a way, this comes from professional training. Over time, most photographers learn to deal with certain subjects in their chosen area in a certain way. This is especially true in fast reactive shooting, when the most important thing is to get the shot for the client, and predictable composition is an aid— one less thing to worry about. This happens quite a lot when content rules.

The example here is a striking illustration of what can happen, and not without irony. The two pictures of a boy, crying in anguish over the body of his dead sister lying blood-soaked in the back of a truck, have been mistaken for each other, and are the work of two photographers whose contrasting reputations were made in Vietnam: Philip Jones Griffiths and Tim Page. At this instant, Griffiths and Page were together in a situation that provoked the same journalistic response, but the body of work of each of these photographers is actually quite different. Page

▼ **Vietnam, 1968, by Philip Jones Griffiths** from the story "The battle for Saigon." The caption reads, "The Saigon fire department had the job of collecting the dead from the streets during the Tet offensive. They had just placed this young girl, killed by U.S. helicopter fire, in the back of their truck, where her distraught brother found her. When *The New York Times* published this photograph, it implied there was no proof that she was killed by American firepower."

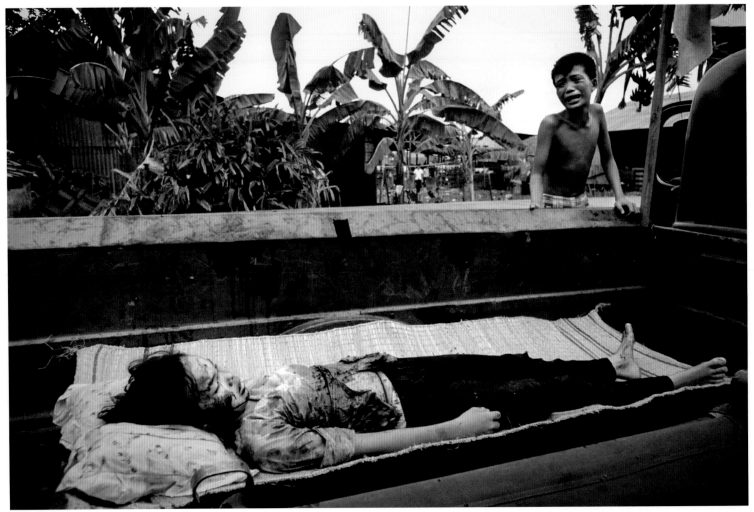

Philip Jones Griffiths/Magnum Photos

is probably best known for his part in one particular mythology of Vietnam, mainly through Michael Herr's book *Dispatches* and through a characterization of him in the film *Apocalypse Now*. He became, as William Shawcross put it, a "war groupie," fascinated with the mixture of high technology, savagery, and military bungling. Many of Page's images capture the cowboys-and-indians glamour of military hardware, and the excitement of young GIs playing with deadly toys.

Griffiths' attitude to the same war could hardly have been more different. The anger in his book *Vietnam Inc.* is unconcealed, and he was eventually banned from returning to the war. Page's coverage is less coherent, but shows another side of Vietnam—and echoes the feelings held by a large number of the participating American forces. Photography's peculiar relationship with reality meant here that two photographers with very different views of the same issue can at times come up with the same image.

▼ **Shot girl, Vietnam War, 1968, by Tim Page**
The same scene, about a foot and a second or so away. The caption reads "A young boy cries over the body of his 12-year-old sister shot by U.S. helicopters during the mini-Tet offensive near Y-bridge, Saigon, in 1968."

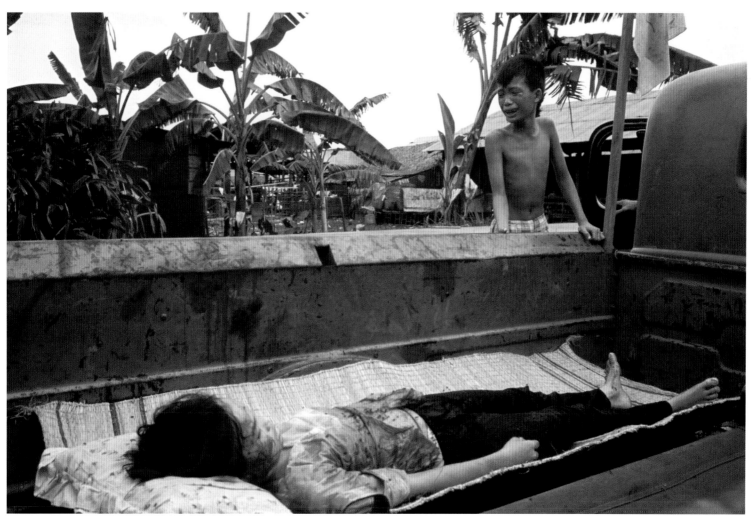

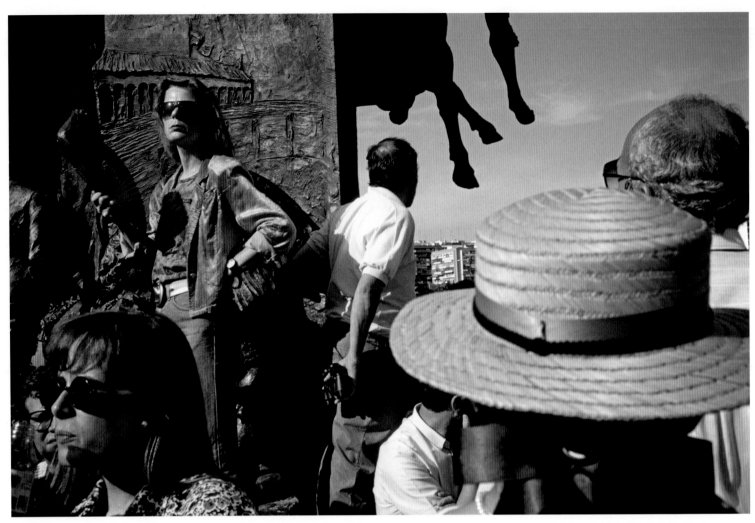

Alex Webb/Magnum Photos

STYLES OF COMPOSITION

The traditional view of composition is something on the lines of creating order out of chaos, and getting the untidy world into some sort of attractive or functional arrangement inside the image frame. Edward Weston's early rejection of landscape as a manageable subject for photography because it was too crude and lacking in arrangement (page 42) fits this view. The argument is that good composition makes things clearer. This sounds good, and works most of the time, but it is not the whole story. Composition, as much as any other aspect of photography, or art for that matter, can be challenged. We just looked at assertive subjects; now let's see what assertive photographers do.

Ground zero for conventional composition is a level horizon. Departures from this are often

mistakes, but with one major qualifier, which is this: only if it was meant to be straight. If the photographer just doesn't care, then it's another matter. And if the horizon or any other obviously level surface is treated as just another line in the image to be used graphically, then it's the photographer's judgment up for criticism, not the technique. The bulk of the American reviews of the Robert Frank's book *The Americans* were highly critical of many things, including his method. The influential-among-amateurs *Popular Photography* magazine was particularly scathing. Seven of the magazine's editors expressed their displeasure, including the following on Frank's technique, which was considered to be part and parcel of a dyspeptic view of America: "meaningless blur, grain, muddy exposures, drunken horizons and general sloppiness."

⋀ Outside bullfight stadium, Madrid, Spain, by Alex Webb
Geometric frame division is nothing new, but here Webb uses it to interesting effect by drawing attention to the strange apparition of the silhouetted legs of a bull. The vertical edge of the sculpted wall, the woman in orange and the straw boater combine to divide the frame into four, which makes the upper-left quarter appear as a frame in its own right.

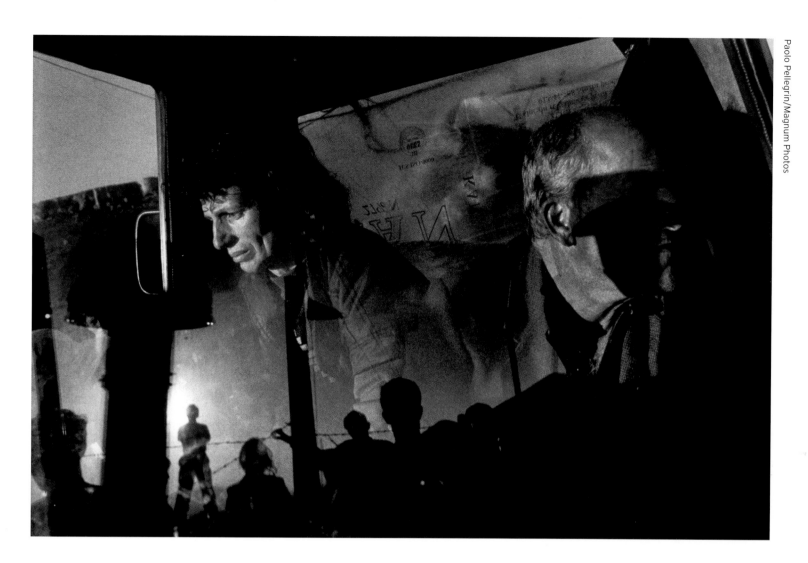

Paolo Pellegrin/Magnum Photos

In many ways, though, this set the ball rolling, and Frank's work influenced a number of recent styles. One is unexpected and strong frame division that appears at first to disjoint the image.

Related to this, and sometimes used in addition in the same image, is an illusionary layering, often through reflections and refractions, and shooting through screens of various kinds. Paolo Pellegrin's shot of refugees here does this, as does Laura El-Tantawy's highly identifiable style. El-Tantawy's comes from a desire to explore composition and light: "One thing is that personally I find it very boring to repeat myself, so I always try and do something different—for me, by the way, not different from other photographers. It varies between night pictures and daylight situations. The camera movement is something I can more easily work

with in low light, but in daylight I'm more intrigued by harsh light. I like the difference between harsh light and sudden shadow, like the way a band of hard light falls across just part of someone's face. I think it makes for very interesting compositions and it makes pictures intriguing."

▲ **Kosovar refugees who have just crossed the border into Albania at Morina on their tractor, Kosovo, Albania, 1999, by Paolo Pellegrin**
Reflection shots, with their built-in capacity for layering an image, do not work automatically. The superimposition of scenes is often a recipe for confusion, and it takes skill to find the viewpoint at which the scenes (usually two) combine comfortably. This means, for instance, using counter-shading and aligning lit parts of one image with dark areas in the other, as here. The face on the left, positioned over the silhouetted figures, is the focus.

Laura El-Tantawy

In the same family, as it were, is the disruptive foreground, deliberately positioning the camera so that something near obstructs the view of what claims to be the main subject. One way of doing this is to reverse the usual expectation of focus, as already mentioned under "Unexpected." William Klein's New York picture (right) does just this, with the obvious foreground subject de-focused. What then becomes the subject? Where should the viewer look? This uncertainty and dual presence is exactly what the image is about. Robert Frank did exactly the same in *The Americans*.

▲ From the series *Smile Me Hello*, by Laura El-Tantawy
Following hours of intricate make-up application and costume preparation, a variety dance group takes to the stage during the annual Sukhothai festival and sound and light show at the Sukhothai Historical Park. The swirl of color and shapes as Thai dancers perform on-stage uses the first of two of the photographer's preferred techniques. She explains: "It varies between night pictures and daylight situations. The camera movement is something I can more easily work with in low light, but in daylight I'm more intrigued by harsh light. I like the difference between harsh light and sudden shadow, like the way a band of hard light falls across just part of

someone's face. I think it makes for very interesting compositions and it makes pictures intriguing." For El-Tantawy, its purpose reaches further than surface design: "A large part of it has to do with the element of mystery, which psychologically I'm drawn to. With my kind of photography I don't want to answer a lot of questions. I want to engage the people who look at the picture and provoke them into saying, 'What is she trying to do? What am I really looking at ?' I like to engage viewers into thinking beyond what they're seeing."

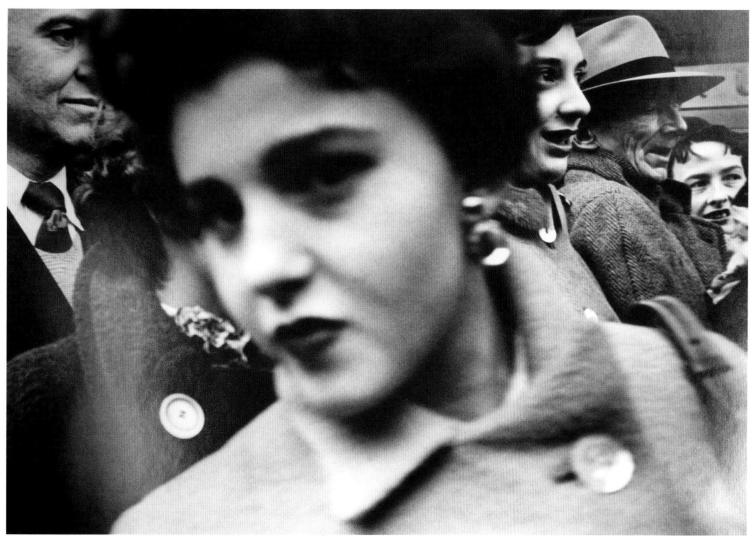

All of the above is graphic composition being worn on the sleeve, so to speak. The complete opposite is also current: an uninflected, deadpan style that apparently avoids both classical principles and contemporary high-graphic style. Robert Adams' image of tract housing in Colorado on page 43 is one example.

Achieving this effect, however, takes a lot more than simply ignoring the techniques of composition. It has to be worked on, and because of this such anti-design ends up being more design-conscious than much of the photography it sets itself up against.

And then there is the snapshot aesthetic, which has been around for longer than many imagine. One of the first to promote it was the Austrian-born American photographer Lisette Model, who began her career in the 1930s. "I am a passionate lover of the snapshot," she wrote, "because of all photographic images, it comes closest to the truth…the snapshooter['s] pictures have an apparent disorder and imperfection which is exactly their appeal and their style." In 1937 Lisette and her husband Evsa Model came to the United States to visit his parents. Compared to Europe the newness of New York and its fantastically different visual aspect was at first an overwhelming experience. "For a year and a half I took no pictures. I was blind because it was all too different."

▲ St. Patrick's Day, Fifth Avenue, 1954–55, by William Klein
Shallow depth of field, with part of the image soft in focus, is one of photography's unique qualities. By convention and expectation, the defocused elements are less important than the sharp, but here the photographer confounds that expectation. The eye is drawn to the background faces because they are sharply focused, but equally to the unfocused woman's face because of her prominence.

▲ Demonstration in favor of the leading opposition figure Ayatollah Kazem Shariatmadari, Tabriz, Iran, 1980, by Gilles Peress
A geometric division of the frame similar to that by Alex Webb above, but even stronger graphically. The alignment of the foreground poster and the wall behind, held together by strong depth of field from a small aperture, is entirely a decision of the photographer to position himself just so. The partial faces add to the strength of the image, particularly as the cut-offs top left and lower right complement each other.

SUSPICIONS ABOUT COMPOSITION

With all the above effort being put into composition, there is the inevitable question of whether style is always appropriate. It matters particularly in photojournalism—inevitable because any kind of mannerism can easily look out of place in an image that pretends to be scrupulous in its reporting accuracy. Stephen Mayes, New York head of VII Photo Agency, commented in 2010 that "The overwhelming impression from the vast volume of images is that photojournalism (as a format for interpreting the world) is trying to be relevant by copying itself rather than by observing the world. Nowhere is this more obvious than at World Press Photo where every year the winners stimulate a slew of copyists (in style and content)." Preoccupation with composition and graphic style is seen by many as being unseemly in a "concerned" photojournalistic shot, although others would argue that it is a sign of high professionalism and sensitivity. Cornell Capa's *Concerned Photographer* was someone making "images in which genuine human feeling predominates over commercial cynicism or disinterested formalism." The argument continues. Photojournalist Stuart Freedman expressed one firmly held point of view, "that two styles have come to dominate the modern photo documentary. The first, a cold, bastard child of formalism, seeks to show people dehumanized—as stationary butterflies under glass. Static, bored, disengaged. The other, which has come to dominate contemporary reportage, shows photographers recording in a sub-Gilles Peress pastiche of abstracted shadows and blurs." Making strong compositional statements was not a preoccupation of Peress (an influential photojournalist whose work goes back to Northern Ireland in the '70s), and this is the point Freedman is making as he criticizes stylistic imitation. Peress writes, "I work much more like a forensic photographer in a certain way, collecting evidence. The work is much more factual and much less about good photography. I don't care that much anymore about 'good photography.' I'm gathering evidence for history, so that we remember."

There's some irony in the recent trend to co-opt photojournalism into the realm of collectable, fine-art photography. In 2007, indeed, it was Gilles Peress' work that was being displayed on the Cartier stand at Art Basel. It's just possible, and only my opinion, that the sense of tough, conflict photojournalism having failed to motivate the public has in a sense made it more available as art. In other words, war continues, and the photography of war continues, yet changes nothing. As a result, there is this range of images, from one war to another. The very fact that they persist gives a kind of comforting desolation that seems to work well in the contemporary art scene. This re-purposing of photography has gone on for a long time, and has a special importance in understanding what photography is about. Photojournalism happens to be the most significant contemporary example.

▲ **Running Legs, 42nd Street, New York,
c. 1940–41, by Lisette Model**
New York inspired her, as it has inspired many
photographers, through its energy. This encouraged
her to experiment, seeing what the camera could
deliver, almost by chance. She used a Rolleiflex, a
twin-lens reflex design that is now obsolete but
was very popular. There were two matching lenses,
one above the other. The lower lens exposed the
film; the upper lens projected a view upwards onto
a ground-glass screen, and photographers used the
camera by looking down into it. Normally this was
at waist-level, but it lent itself to easy ground-level
photography also. And that in turn led to discovery,
of unaccustomed views, as Model learned.

COLOR AND NOT

Only recently have the lines begun to blur between color and black-and-white, and this is because of the way that digital cameras work (shooting in black-and-white, with a color interpolation that can be removed easily later). The lines that have long been drawn have been an odd mixture of practical, aesthetic, and philosophical. Photographers and other interested parties who sat full square on one side of the line generally had no sympathy or feeling for the other side. It's a story of commitment and antipathy, but also of sheer pragmatic effects.

It's of little surprise that technically color came late to photography, and is only mildly interesting. The effect this had on the way photography was thought about, however, was something else. Woefully but regularly ignored in photography is the importance of how it is presented. In the case of color, it meant that, strangely, shooting in color was possible much earlier than was useful. The richly hued portrait here of Alim Khan, Emir of Bukhara, was, perhaps surprisingly, taken in 1911. This early color was achieved by the inconvenient method of taking three separate black-and-white negatives, each filtered with a different color— obviously as quickly as possible with the subject holding his breath. This was not even the first color photograph; that was in 1861, but with an imperfect result. Autochrome came on the market in 1907, and, in 1936, 35mm Kodachrome for still cameras.

But the initial problem for color was how to show it. The remarkably modern-looking portrait of the Emir looks remarkably modern for two good reasons. One is that the digital composite made from this century-old photograph is modern, the other is that the page you are looking at is printed with the latest twenty-first century printing technology. This latter has come a long way from even the 1960s, which were when color half-tone printing really took off. For any photographer or picture editor who worked with color transparency film (it was this, not color negative, that was the main staple of magazines), the way to look at the image and understand its unadulterated color and density was by viewing the slide on a lightbox with a loupe.

The first widely used color film was Kodachrome, a transparency film, and one of its remarkable properties was the stability of the color dyes (they were added later, during processing). Kodachromes shot half a century ago still look good, but then the ideal way of looking at a Kodachrome is on a lightbox. By transmitted light, its rich density comes alive, but when reproduced on a printed page, it depended, like any other color original, on the state of printing technology.

Color printing was possible pre-war, but expensive, and the quality pales by comparison with modern reproduction. *Time* magazine's first color cover was a portrait of Emperor Hirohito in 1928, and the first color photograph printed in a British newspaper was in the *Times* in 1931, but it was the 1960s before color became normal for magazines rather than exceptional.

Library of Congress, Washington D.C.

➤ Minab, red masked woman, Iran, by Mike Yamashita
A *National Geographic* cover shot, which combines two powerful ingredients needed for the purpose: intense, contrasting color, and an intriguing subject. For competitive reasons, magazine covers have to be striking, attract attention quickly, and encourage the reader to open.

Michael Yamashita

◄ The Emir of Bukhara, Alim Khan (1880–1944), 1911, by Sergei Mikhailovich Prokudin-Gorski
By shooting three black-and-white negatives in quick succession, each through a different filter (red, blue, and green), the photographer essentially made an in-camera color separation, the basic technique for magazine and book color repro. The three negatives were exposed side by side on a glass plate, and could be viewed in a special projector, but it took many decades before this, and the hundreds of other images in Prokudin-Gorski's ambitious survey of the Russian Empire, could be reproduced properly in print.

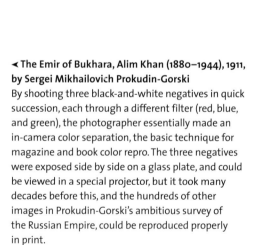

▲ **Untitled (Mississippi), circa 1982–86,**
by William Eggleston
Dye-transfer print, 16 x 19 3/4 inches,
40.6 x 50.2 cm

THE ART-CRIT PROBLEM WITH COLOR

Part of John Szarkowski's influence as curator of photography at MoMA, beginning in 1976, was to make color photography an acceptable form of fine art. It was already being practiced widely, of course, and boomed during the 1960s as we just saw. But the fine-art market resisted it. Photography itself was not taken very seriously by galleries and museums, and color was definitely a step too far. In the collective mind of that market, color meant advertising, postcards and snapshots, none of which could possibly be taken seriously.

In reality, there was already very good, very serious color work being done by, among others, Irving Penn, Eliot Porter, Magnum photographers Ernst Haas and Brian Brake, and advertising photographers Pete Turner and Art Kane. The deeper problem for curators and critics, apart from its perceived crass associations, was that these photographers worked with the sensual, expressive qualities of color. Some of them enjoyed rich color, which was quite beyond the pale for fine-art photography, because far too populist.

As part of Szarkowski's self-appointed task of redirecting photography, he wanted a color version of the postmodern ethic, and he found it, apparently by chance, in William Eggleston. Szarkowski discovered an artist to champion,

one who already fitted in to his post-modern aesthetic. Eggleston, both loved and disliked, did two things that were important. One was to photograph anything that caught his eye from his immediate surroundings (most of his photographs are taken in his native state of Mississippi), especially if it seemed not to be a conventional subject. He called this "democratic photography." The second was to have them printed by the dye-transfer process for striking richness. The first fits into the then fashion for banal subject matter and a seemingly naïve response to it well enough not to need much extra explanation. He followed the Ed Ruscha principle of elevating the American vernacular. The printing, however, does merit a closer look, because most people have never actually seen a dye-transfer print, so can only imagine what it might look like. It was a Kodak process, quite unlike normal wet darkroom printing, and Kodak discontinued it in 1994. Let's examine it, beginning with Eggleston's discovery.

He came across it in a Chicago photo lab in Chicago, which advertised services, he recalled, "from the cheapest to the ultimate print. The ultimate print was a dye-transfer. I went straight up there to look and everything I saw was commercial work like pictures of cigarette packs or perfume bottles, but the color saturation

and the quality of the ink was overwhelming. I couldn't wait to see what a plain Eggleston picture would look like with the same process." The dye-transfer process was more like traditional printing, but very exacting. Three monochrome separation negatives were made from the original, each exposed through a different filter (red, blue, and green). These were, in turn, each projected onto a gelatin relief film at the size of the final print. When this special film had been processed and washed, the image was in relief, with the thickness of the gelatin in proportion to the amount of light to which it was exposed. The rest of the process took place in normal lighting. Each gelatin relief film was bathed in a photographic dye—one cyan, one magenta, and one yellow— and, one by one, laid down onto the receiving paper. The registration had to be perfect, and used a steel register punch and pins; the rolling down had to be done on a perfectly flat surface, such as machined from granite. In the hands of the expert lab technicians who specialized in this, the results were technically outstanding. Everything could be controlled, in a darkroom era when normal color work offered almost no control, and the colors could be intense. For advertising, the main reason for using the process was that the work could be retouched to perfection, by painting with the very same dyes.

> ➤ **A 35mm Kodachrome transparency.**
> As it looks when handled, viewed against a lightbox, which was once the normal workplace for picture editors and photographers editing their shoot.

▲ Route 66, Albuquerque, New Mexico, 1969, by Ernst Haas

Traffic in the streets of Albuquerque, New Mexico, after a heavy downpour. Before digital processing made exaggeration commonplace, the richness of Kodachrome and a thunderstorm retreating into the distance close to sunset combined in Haas's color-attuned vision to make one of his most identifiable images. The Swiss-born photographer re-vitalized color photography (with the help of his preferred Kodachrome) to the extent that Edward Steichen credited him with launching "a new epoch in photography." Nevertheless, this was inconvenient for the Szarkowski-inspired argument that color photography "began with William Eggleston," and his reputation languished temporarily during the 1970s and 1980s for entirely artificial reasons.

The ad agencies used dye-transfers for the very reasons that they now rely on Photoshop. Skin retouching and packshot retouching were the main beneficiaries. This did not interest Eggleston as much as the intense color possibilities. One of his best known images is the 1973 *The Red Ceiling*, the print of which he said "is so powerful, that in fact I've never seen it reproduced on the page to my satisfaction. When you look at the dye it is like red blood that's wet on the wall…A little red is usually enough, but to work with an entire red surface was a challenge." As a result, about half of his work is lost in reproduction, as in this book. The essence of Eggleston's work, therefore, was a marriage of what he called democratic (the subject matter) and a very elitist process. And, the irony of color photography's acceptance into fine art depending partly on the very richness that disqualified photographers like Ernst Haas ought not, perhaps, to be lost.

The result, in any case, was a MoMA exhibition in 1976 of 75 works by Eggleston, and the simultaneous catalog *William Eggleston's Guide*. The initial reaction was not favorable. Hilton Kramer, the respected art critic of the New York Times, took Szarkowski's catalog claim that Eggleston's photographs were "perfect," and wrote, "Perfect? Perfectly banal, perhaps. Perfectly boring, certainly." There were other MoMA-sponsored photographers who took a postmodern approach, the common ingredients being fairly banal subject matter and restrained color. A significant number, including Stephen Shore, Joel Sternfeld, Mitch Epstein, and Joel

Meyerowitz, used mainly large-format cameras, with a correspondingly careful, formal style of composition. Eggleston, after all, had already commandeered the self-aware snapshot slot. The European equivalents came from the Dusseldorf school, in particular Thomas Struth, Thomas Ruff and Andreas Gursky, sometimes know collectively as Struffsky.

The price for color photography's acceptance in fine art, however, was a curious blind spot that has persisted for the color that went before 1976. Philip Gefter, writing for *Art & Auction*, is fairly typical in saying "Stephen Shore and William Eggleston, pioneers of color photography in the early 1970s." What, no Eliot Porter then? Or Penn or Haas? And Paul Outerbridge from the 1930s? Unfortunately, these earlier masters tend to spoil the argument, so better not mentioned. As for influence, the "New Color Photography," as it was sometimes called, had great impact, although more on the fine-art market than elsewhere. The Victoria and Albert Museum's entry on Eggleston states that he "set the precedent for color documentary and art photography of the last twenty years." True enough for art photography but sweeping for documentary work. A great deal of editorial color photography, possibly even most, has followed an older tradition influenced by Haas.

Things have moved on considerably in the color department technically since the '70s, and every advance has made color more democratic in a way that Eggleston may not have envisaged when he began. Color reproduction everywhere,

from printed page to screen, has never been more wonderful, and this has leveled the field in one sense. Fantastic color reproduction is no longer a privilege, and no longer something for which you would need to visit a gallery in order to experience. Color inkjet printers, with many inks, are now capable of producing results that greatly reduce the specialness of the dye-transfer, and they can be used with an impressive variety of paper—from such traditional paper manufacturers as Hahnem hle, who have been making paper since 1584.

However, while color is by now almost fully accepted in the art market, digital prints still have a way to go. This has little to do with the technical aspects (contemporary inkjet prints have had the edge for some years), but much to do with market conservatism. People are accustomed to wet darkroom prints, and as prices rise, buyers want more than ever to be reassured about things like traditional values, archival qualities, and craftsmanship. For collectors, the more that goes into making a print, and the more exclusive it is, the better.

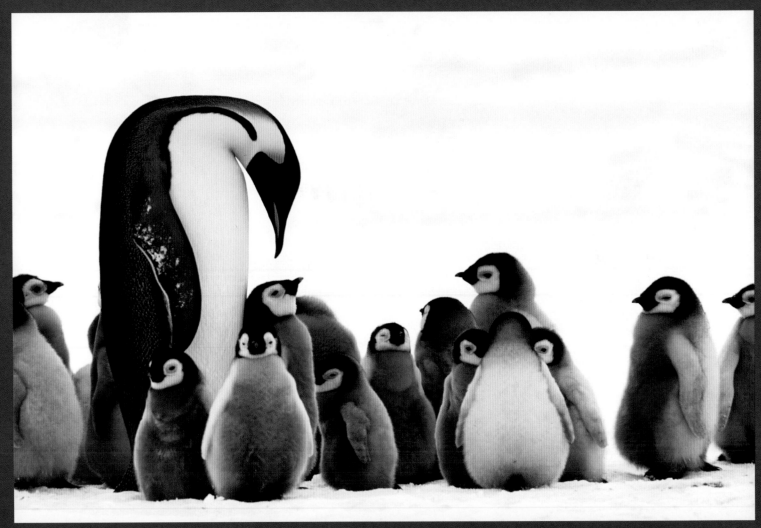

▲ **Emperor penguin parent looking for its chick in creche, Aptenodytes forsteri, Weddell Sea, Antarctica, by Frans Lanting**
The monochromatic (for the most part) penguins and surroundings make the color all the more striking, and the effect is of both color and black-and-white imagery combined in a single frame.

◄ **Images de Deauville, c. 1936, by Paul Outerbridge. Carbro print, 35.6 x 50.8cm**
In the late 1930s, Outerbridge, who made his reputation with commercial advertising work, pressed to elevate color photography as an art form. He wrote, "One very important difference between color and monochromatic photography is this: in black and white you suggest; in color you state. Much can be implied by suggestion, but statement demands certainty…absolute certainty." He perfected the use of the expensive and time-consuming three-color carbro transfer-printing process, which he used here for a still life that shows the influence that the Surrealists and Dadaists had on him. The unusual sense of perspective, partly from the constructed set and partly from the use of movements on the large-format camera, recall de Chirico's paintings, and the reflecting ball M. C. Escher.

THE DYNAMICS OF BLACK AND WHITE

For a while, it looked as if black and white, once the norm of photography, was going to all but disappear into a niche. The time was the 1980s and color was truly in the ascendant. For casual amateurs, color films were better than ever, and printing services were fast and inexpensive. For more serious amateurs, and professionals, color-transparency films were also highly evolved, notably Fuji's Velvia. Even the small fine-art market had embraced color. Black and white seemed set to become specialized—for fine-art and old-school photojournalists.

That this did not happen is because of digital. It changed the rules. In film photography, you choose first between color and black and white, when you load the film. In digital photography you can choose later, and this has made a huge difference to the fortunes of black and white. As it happens, digital sensors record in monochrome, with the color being interpolated (predicted) from a grid of colored filters. Not only is it extremely simple to process a digital image from the camera in black and white, but the choice of tonal control is far greater than is possible in film.

In a second way, digital has promoted black and white by reviving interest in film. There's no paradox in this. In every sphere, some people will always value what progress replaces, and in the case of film it has certain unique aesthetic appeals, including grain, the sloping characteristic curve that handles shadows and highlights in a way that is quite different from digital, and the sense of object—the image on film is a physical thing. For decades, the basic unit of photography was the silver gelatin print, and this is not going to disappear any time soon. Just as wet darkroom prints are still preferred in the fine-art market for color, so they are for black and white.

Without flogging an old theme to death, it's worth mentioning the two key qualities of black and white. One is that, being a step removed from a complete visual record, it can lay claim to being more of an interpretation than color. You could take this as far as you liked. Robert Frank, for example, believed that "Black and white are the colors of photography. To me they symbolize the alternatives of hope and despair to which mankind is forever subjected."

The second key quality, related to this, is that, aesthetically, black-and-white images can be printed (and in the case of digital files, processed) to greater extremes than can color. This needs a little explanation. If the aim is for the image to stay looking photographic and naturalistic (it usually is), then the hues in a color photograph can be adjusted only by a small amount. One of the notable things about the psychology of color is how sensitive we are to what seems "right." Skin tones, for example, need to be only a small percentage out on qualities like hues, saturation and brightness to look "wrong." In black and white, all this expressive, subjective information is absent anyway. Moreover, with only a single range to modulate—white through gray to black—tones in different areas of the scene can be pushed higher or lower without offending anyone's sense of how they should be. The pair of prints opposite from W. Eugene Smith's story on a mental asylum in Haiti illustrate the power of this. In another way, Mark Steinmetz's print of a girl at a balcony on page 178 runs through a delicate range of grays. There are other examples elsewhere in the book, including Eikoh Hosoe's stark, high-contrast portrait of Yukio Mishima on page 48, and Trent Parke's low-key image on page 135.

➤ **Patient in a mental hospital, Haiti, 1959, by W. Eugene Smith**
Top: straight print; Below: final print with the background pushed right down, and bleaching applied to highlights on the face. Smith took his printing very seriously indeed, to the point of taking it away from the *Life* darkroom, which had a good reputation, and doing it himself. He wrote, "Negatives are the notebooks, the jottings, the false starts, the whims, the poor drafts, and the good draft but never the completed version of the work… Negatives are private, as is my bedroom…" For this already powerful image of a patient staring wildly into the light, Smith knocked back the surroundings almost to extinction to concentrate all the attention on the face and its disturbed, and disturbing, expression. Doing this also allowed him to darken the tones of the face for a deeper psychological effect, while still holding the viewer's eye. Another printer might have kept the wild hair for dramatic effect, but Smith was single-minded. He continued, "I don't think that any really great writer would make his rough draft and then toss it to a secretary to put into final form… If I am trying to reach people, if I am trying to say something and if I am trying to say this as strongly as I can, why go to all of the other effort and then neglect one other way of reaching the reason that it all began."

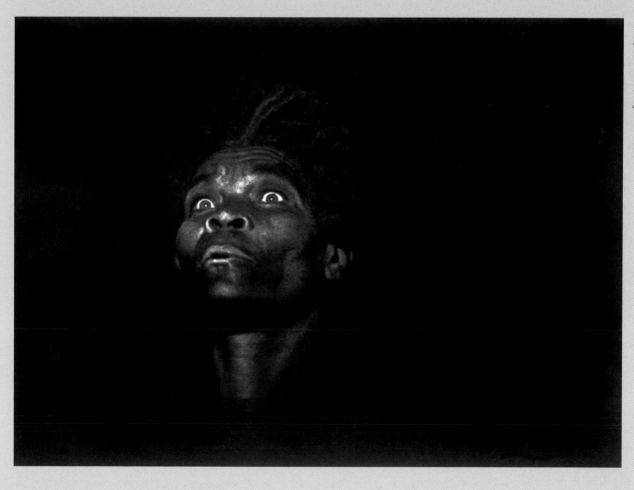

Reaching back further into photography's chemical history, older processes have become more highly valued, and are being revived. These include platinum printing, of which Emerson's 1886 photograph of life on the Norfolk Broads is an example, as are one-off Daguerrotypes. Wet darkroom processes are also being extended. One example is Lith Printing, of which Tim Rudman's Icelandic landscape on page 43 is an example. The element of craft, and even a sense of the alchemical, is illustrated by Rudman's description of the process: "The term Lith Printing is often misconstrued as being concerned with lith film and high contrast graphics. It couldn't be more different. It is a creative and very interpretative printing technique, using black and white negatives (or even color negatives) onto black-and-white paper, but processed in diluted lith developer instead of conventional paper developer. This can be used to give tones of extraordinary delicacy and color or quite graphic cold starkness—or an infinitely variable mixture of the two.

"Lith developer has a special property known as 'infectious development' and it is this that drives the lith printing process. In simple terms this means that an 'infectious' accelerator is released locally where a tone starts to develop faster. This causes faster development, releasing more accelerator, causing even faster development, and leading to a chain reaction giving an exponentially explosive acceleration in the dark tones. The light tones, meanwhile, are lagging way behind in the early stages of development. By "snatching" the print part way through development the printer can get a balance of fine grain lighter tones—which are warm in color, smooth and creamy in texture and low in contrast—and large grain darker tones—which are grainy, cold, gritty, and high in contrast.

"I love the clean tones of a classical West Coast school print and I find some (not all) of Adams' and Weston's prints deeply satisfying and inspiring. I came to them much later though. My first inspirational influences were very different.

The first was Sam Haskins and it was seeing a book of his black-and-white work in the early '60s that jumped me from charcoal, pencil, and pen and ink to photography. I knew the instant I saw his work and within two weeks I had found a darkroom and was trying to teach myself to print instead of draw. Both his *African Images* and *Cowboy Kate* books showed his use of grain, blown-out white space and featureless blacks that I had never seen and I saw for the first time that photography could be a personal expression and not simply a way of recording things."

As never happened before, color and black-and-white imagery sit together in an increasingly comfortable way. Either/or decisions are essentially a thing of the past. As just mentioned, the original capture is in black and white, but because the color comes from a processing step, it can be reversed easily. More than that, from the three color channels, red, green, and blue, the precise gray tone of anything in the image can be adjusted. Green grass can be white, any shade of gray, or black, as can blue sky, red fingernails, and so on.

The deferred decision about whether a photograph might look better in black and white than in color is beginning to change photographic practice, particularly for those who were never committed one way or another. The example here shows a situation in which the content was there and needed to be shot, but the midday sunlight was not to the photographer's liking. I could choose to join the black-and-white camp just for this image. The ability to flip backwards and forwards between color and black and white is beginning to show up in the way photographs are presented, and there appears to be a slowly growing acceptance of mixing the two, on web sites, in publications, and on gallery walls.

◄ **Athens, Georgia (from South East), 2001, by Mark Steinmetz**
Using a makeshift 6 x 9 cm camera assembled from old Mamiya Universal Press parts placed on a tripod, and shooting on negative film (Tri-X), Steinmetz created a print that stresses the subtlety of gray rather than the usual full black-to-white range. He writes, "When I took this photo I was working on an extensive project in the town where I live (Athens, Georgia, USA) that included photographing teenagers and people in their twenties. Sometimes I would make appointments to photograph them at their homes—these settings often turned out to be ramshackle but still rather elegant. The subject in this picture was the friend of a friend and she struck me as someone who might have been chosen by Leonardo.

◄▲ **Packtrain crossing the Yalong River, Sichuan, 2009, by Michael Freeman**
The smaller image, as shot and processed literally, was considered unsatisfactory because of the muddy and distracting combination of green and brown. Nevertheless, the event was there and then. By processing the digital file so that both green and yellow wavelengths were drastically reduced, the image was transformed. The graphics were enhanced, attention fixed on the bridge and animals, and the whitetops in the water highlighted.

LIGHTING

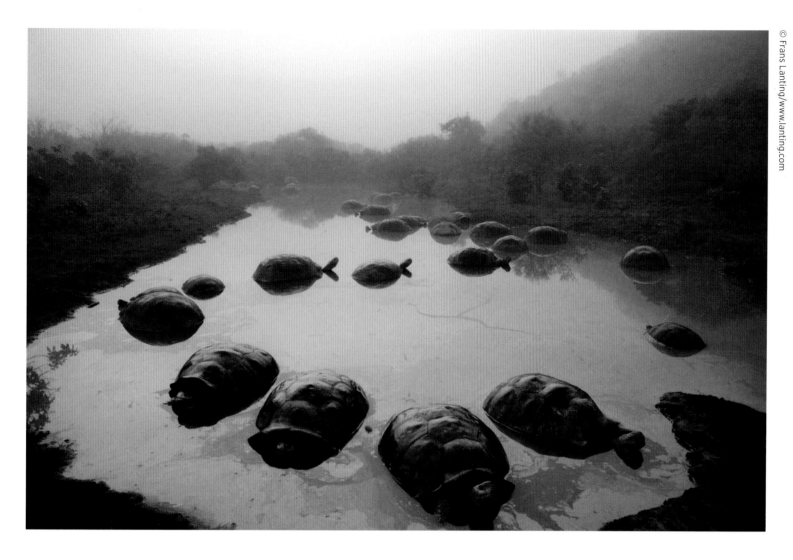

It's easy to come up with platitudes about light and photography, but the way it falls can have quite a mysterious effect on our minds. People regularly use a whole range of non-technical terms to describe it, such as hard, gentle, sweet, ugly, harsh, and this suggests a kind of visceral reaction to the way a scene is lit. Lighting can be as functional as in Roman Vishniac's photograph of *shtetl* life on page 77—no more than the means for making the exposure—and it can be as central to the image as in Trent Parke's image on page 182. Parke himself says, "I am forever chasing light. Light turns the ordinary into the magical." The role of light, whether natural or added, varies hugely, both in what it can do for the subject, and in how photographers feel about it.

As we've seen, there are many elements in a photograph that potentially fight for attention, and the quality of light is just one of them. There is, for instance, content (often prime in photojournalism), composition, sense of motion, color, idea, concept, among others. They make up the layers of experiencing an image described at the beginning of the book. But what I'm looking at here is light that is pre-eminent, at least in the mind of the photographer. The viewer might not have the same response, but it's usually not hard to tell when the photographer was thinking hard about light.

▲ **Giant tortoises in pond, Geochelone nigra, Alcedo Volcano, Galapagos Islands, by Frans Lanting**
The subject is exotic and challenging, but even so, Lanting has worked hard with the lighting (other shots from the series show a range of conditions, including moonlight). Arguably, the attractive low sunlight with rising mist shares the billing with the content.

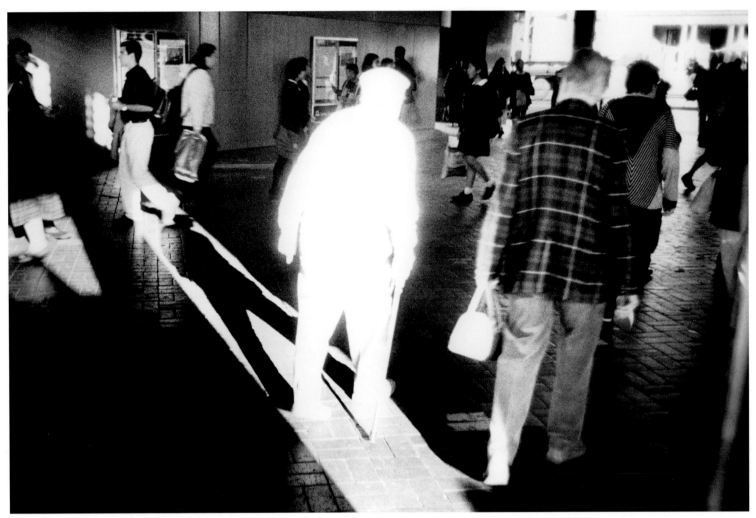

For photographers, light functions in some way as a commodity, and many treat it as almost tangible. Attention to lighting is not universal among professional photographers—for some, there are other more important things to deal with in the image—but I think it's fair to say that the majority of successful photographers take it seriously. Some images are almost entirely about light. Like composition as discussed above, lighting has encouraged many styles in photography, and they cycle through fashions. Clean, enveloping light is one example, hard light and chiaroscuro another.

Lighting can be found or constructed, just as subjects themselves. Actually lighting a set,

whether in a studio or on location, obviously calls for considerable knowledge and skill, even though working with natural light is not necessarily any less demanding. The great difference between the two is choice. When light is natural, or at least found (as in city streets at night), you react to it. In a studio, or a set on location, you build it. Robert Golden, one of whose studio shots is here, writes, "In a photograph, light is of course not only fundamental (as in writing with light) but as much a part of the image as the subject matter. It is a partner, a presence, a character which plays with all of that which it reveals and through its absence, all which it hides. Whenever I make a photograph the question

▲ From his *Dream/Life* series, 2001, by Trent Parke
An elderly man dressed in white walks into harsh sunlight in a tunnel under Circular Quay railway station. High-contrast light is often seen as a problem to be solved in photography, but Parke here uses it in an unexpected way to make a fresh kind of image. The standard treatment in a case like this would be to expose for the highlights so that they would not blow out, and then take care in the processing to restore shadows. Parke, however, encourages the lit central figure to burn through completely.

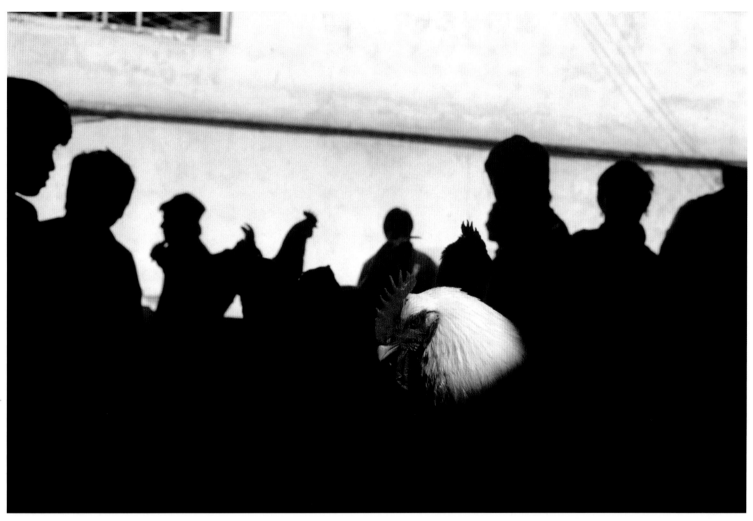

Gueorgui Pinkhassov/Magnum Photos

of feeling, mood, ambience, emotional sensation, the evocation of time of day and time of year are all answered by what I will ask the light to do."

One frequent concern for studio photographers is the degree of perfection and precision, and this tends to move in cycles. Horst P. Horst's fashion imagery of the 1930s and 1940s, for example, was exceptionally well crafted, with nothing left to chance…except, that as in the example here, he frequently arranged for the play of light and shadow to be in against expectation—the face in shadow, for example, when the audience might have anticipated it to be lit. The relationship between deliberation and chance can be complex,

especially as everything is nominally under the control of the photographer, so that discarding perfection becomes a definite decision. Richard Avedon wrote, "I've worked out of a series of 'no's. No to exquisite light, no to apparent compositions, no to the seduction of poses or narrative. And all these 'no's force me to the 'yes.' I have a white background. I have the person I'm interested in and the thing that happens between us." In a similar vein, Art Kane's opinion was "If the light happens to drop off, so be it. That might produce a certain mystery. I'm interested in withholding some information—in not spelling things out so clearly that they become dull and cold."

▲ **Market, Tashkent, Uzbekistan, 1992, by Gueorgui Pinkhassov**
With light as with composition, Pinkhassov is mainly interested in exploring and in seizing unplanned opportunities. Chiaroscuro, contrast and shadow provide more of these opportunities than does soft light. Here especially, in an Asian market, with a featureless white wall behind, luck adds concentrated color to the lighting.

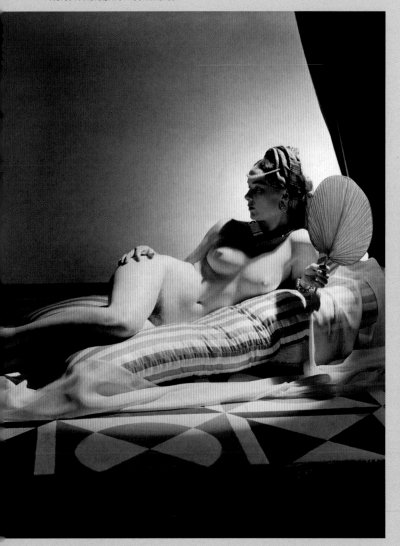

⌃ Odalisque, New York, 1943, by Horst P. Horst

Odalisques, with their connotation of a Turkish harem, became an emblem of Orientalism in the nineteenth century. The erotic theme inspired countless attempts by painters and photographers, of which the most famous were by Ingres, Lefebre and Matisse, though most qualify as kitsch. For Horst, who achieved fame with his fashion and portraiture for *Vogue* in the 1930s and 1940s, it was a theme well suited to his extravagant and sensual lighting style. His technique, which involved sophisticated studio lighting, used contrast to show off curves (which he liked), counter shading (evident here in the background's relationship with the figure), and the deliberately unexpected fall of light and shadow. Faces would, as here, be cast into shadow, while shaded spots lit patches and edges of the subject.

⌃ Wine Glass, Garlic and Shadow, 1980s, by Robert Golden

Golden, who maintains his studio work, generally food-related, separate from his documentary filmmaking, describes what he was setting out to do with this assertively lit still life: "In this photograph I was playing with the sense of lighting from films in the 1930s. It was not intended to be a pastiche but rather a starting point, a way of creeping into the visual assumptions being made back then to see what I could learn."

➤ German Industrialist Alfried Krupp, 1963, by Arnold Newman
This American photographer's reputation for portraits had been built very much on his method of showing his subjects in the context of their life or activities. Stravinsky with his piano, Andy Warhol as a collage, and Piet Mondrian with his easel in a Mondrian-segmented composition, are well-known examples, all in Newman's hallmark strong graphic style. In this case, he made a menacing portrait of the German industrialist Alfred Krupp, using the methods described in the text. Newman's deliberately unsympathetic treatment earned his subject's enmity.

I'll end this section—and the book—with a short but telling illustration of the power of technique. I don't mean *f*-stop or shutter speed or what many people think of as technique, but the technique of achieving a certain look that the photographer knows will have a certain effect on the audience. In 1963, Arnold Newman was asked by an American magazine to photograph the powerful German steel magnate Alfried Krupp. Newman was unwilling to perform the assignment, for he considered Krupp, who was a convicted war criminal because of his use of slave labor, to be nothing less than the devil. Eventually, when he was persuaded to go ahead by the editorial department, he decided to portray his subject as the criminal he felt him to be. One difficulty with this was that the man looked, as Newman described him, "like a nice, distinguished, gentlemanly human being." Undeterred, Newman chose to rely on a basic technique of using two low lights aimed upwards towards Krupp's face, something he acknowledged to be "the usual cliché." Even so, like many clichés, it did the job. What completed the diabolical effect was Krupp leaning forward towards the camera, which was fitted with a wide-angle lens, known among portraitists for its unflattering perspective. Newman hid the exposure-test Polaroids that he was taking, for Krupp naturally could not imagine the visual effect that the lights were having, and would have terminated the session had he known.

Arnold Newman/Getty Images

INDEX

A

A Day in the Life of Australia 88
Adams, Ansel
 landscapes revealed 42, 165
 peer review 24, 143
 work explained 34, 69, 72, 74, 120
Adams, Eddie 150
Adams, Robert 22, 42, 43, 123, 165
advertising 62, 64, 171, 173
Aldridge, Miles *65*
Allard, William Albert 129
amateurs 137, 138
America
 early pioneers 40, 42
 everyday life captured 24, *122*, 123, 143, 171
 life stories 106, *107*, 108
 market dominance 30, 32
architectural photography 44–45, 123
Atget, Eugène 44, *44*, 98, 102, 123
audience
 angles of view 69
 expectations of 17, 24–25, 30
 individual interpretation 133, 137, 164
 intervention, attitude to 155
 new subjects sort 103
 photo books 89
 as portrait sitter 46, 50
 viewing exhibition prints 71–72, 74
 viewing slideshows 95
Avedon, Richard
 "In the American West" 138, *139*
 portraiture 47, 50, 65
 working methods 143, 183

B

backlit transparency 74
Bailey, David 127
Baltz, Lewis 123
Barbey, Bruno *157*
Barnard, George 40
Beaton, Cecil 65
beautification 46
Becher, Bernd 45, 123
Becher, Hilla 45, 123
Bischof, Werner *142*, 156

B (second column)

black and white photography 176,
 177–78, 179
Bourdin, Guy 35, 66, *66*
Brake, Brian 88, 152, 155, 171
Brandenburg, Jim 132, 150, 151
Brandt, Bill *37*, 132
Brassaï *52*
Brodovitch, Alexey 129
Burrows, Larry 78, 83, *84*, 138
Burtynsky, Edward 74, 108, 156

C

Cagnoni, Romano 17, 50, 53, *54*,
 135, 136
camera types
 35mm 98, 103, 143
 drop-bed folding plate 53
 large-format 173, *175*
 SLR 138
 view 63, 69, 103, 150
candid photography *49*
Capa, Cornell 30, 50, 74
Capa, Robert 140, *141*, 143
capture 137–55
Cartier-Bresson, Henri
 composition 103, 135, 156
 'decisive moment' 75–76, 146
 dislike of captions 78
 moral purpose 50
 single print 69, 80
 techniques 138, 143
Casebere, James 117, *117*
Chetwyn, Len 118, *119*
China, in pictures
 culture 152, *153*, 158
 events *11*, *21*, 53, *90*, *91*
 everyday life *33*, *34*, 46, *46*, *104*
 exhibitions 32
 tableau photography *70*, 124
cinematography 150
color
 dye-transfer printing 171, 173
 early developments 168
 exclusivity of 173
 subject enhancement *172*, *174–75*

C (third column)

composition
 assertive subjects 159
 experimentation 162–63
 intent 160–61, 164–65
conceptual photography 120–21, *121–22*, *123–24*, *125*
contemporary photography
 conceptual imagery 120–21, *121–22*, *123–24*, *125*
 fine art prints 71–72, 98, 119, 171, 173, 176
 internet coverage, quality of 10, 25
 invented imagery 116–17
 large-print 74
 social conscience 166
context 35–36, 69
contrast, application of 131–32
Cooper, Joshua Thomas 150
Cotton, Charlotte 120
creative process 26–29, 35
creative purpose 98
Curtis, Edward *40*, 42

D

Dahm, Brigitte 145, *145*
Deardoff 138
deception scandals 118–19
'decisive moment' 146, 149
Demand, Thomas *116*, 117
Derges, Susan 114
digital photography
 altering the truth 98
 black and white imagery 176
 color printing 173
 enlargements 72
 finishing touches 27
 manipulation 155
 print size 69
documentary role 30–31, 50, 53, 103, *104–5*, 108
Doisneau, Robert 118–19, 137
Dominis, John 152
Du Camp, Maxime 40

E

Early pioneers 40
e-books 96, *97*
editorial photography 77–79, 80, 83
Eggleston, William 123, *170*, 171, 173

Eisenstaedt, Alfred 46, 78, 140, 152
El-Tantawy, Laura 12, 163, 164
Emerson, Peter Henry 51
emulsions, orthochromatic 40
Epstein, Mitch 173
Erwitt, Elliott 16, 57, 143
Evans, Frederick H 44, 45, 120
Evans, Harold 72, 78
Evans, Walker 13, 32, 89, 106, 108, 123
exhibitions
 curated show 75, 75–76
 fine art photography 71–72
 museums 33, 66, 93, 123, 171, 173
exotic locations 103
experimentation
 processing techniques 110, 111–12
 taboo subjects 113, 114, 115

F
Faas, Horst 54, 55
Farm Security Administration 32, 106
fashion photography 65–66
film types
 35mm film 143, 168, 171
 black and white 176
 color transparency 168, 171
 gelatine relief 171
 roll film 143
Financial Times 150
food photography 64, 184
framing 156, 159
Franks, Robert 24–25, 89, 106, 143,
 162, 176
Freeman, Michael 91, 180
Fresson process 75
Friedlander, Lee 122, 123
Frith, Frances 40
Fuchun, Wang 33

G
genres of photography 40–67
GEO (magazine) 103, 119
Golden, Robert 62, 64, 64, 182, 184
Goldin, Nan 113, 114, 132
"good" photograph

composition 14, 14–15, 27
cultural context 20
depth of image 17, 18
imitation unnecessary 22, 23
opinion on 13
provokes a reaction 16, 17
reason for image 20, 21
Graflex 106
graphic connections 135
Greenberg, Clement 17, 22
Guangdong Museum of Art 17
Guòleifsdóttir, Rebekka 134, 134
Gursky, Andreas 71, 73, 74, 123,
 156, 173

H
Haas, Ernst 135, 171, 172, 173
Haitao, Xie 11
Halász, Gyula see Brassaï
Halsman, Philippe 50, 144
Harris, Brian 109, 109
Hartmann, Christian 60
Harvey, David Alan 99, 135
Haskins, Sam 179
Hiro 62, 66
Hoepker, Thomas 79, 128
Horst, P. Horst 183, 184
Hosoe, Eikoh 23, 48, 89, 176
humanitarian photography 50, 53,
 103–8

I
imperfection and authenticity 140, 142
infrared photography 110, 111, 114
International Museum of Photography
 123
internet
 audience debate 25
 judging of quality, impaired by 10
 website slideshows 94–95
 websites and e-books 96–97
 worldwide talent showcased 32
intervention 152–55
iPad 96, 97
Itten, Johannes 131

J
Jackson, William Henry 40
Jianqiang, Ye 104
Jianxin, Feng 68
Jones Griffiths, Philip 35, 54, 160,
 160–61
juxtaposition 12, 23, 56, 80, 132

K
Kandar, Nadav 89, 90
Kane, Art 171, 183
Karsh, Yousuf 144, 144
Kennerly, David Hume 148, 149, 149
Kertesz, Andrè 137
Klein, William 19, 131, 164, 165
Kodachrome 168, 171
Koestler, Arthur 13
Koo, Bohnchang 62
Kramer, Hilton 173

L
landscape painting 40
landscape photography 40–43
Lange, Dorothea 27, 32, 106, 107
Lanting, Frans 58, 59, 174, 181
Lartigue, Jacques-Henri 114, 115
Le Gray, Gustave 41
Leica 98, 143
Lewinski, Jorge 118
Lichfield, Patrick 50
Life
 broad audience 30
 "Country Doctor" 79–80, 81
 "Monsoon" 86–87, 88, 152, 155
 "Omaha Beach" 140, 141, 143
 "One Ride with Yankee Papa 13" 83, 84
 photographic arrangement 78
 "Spanish Village" 80, 82
 "The Great Cats of Africa" 152
 "Winston Churchill" 144, 144
lighting 27, 29, 180–85
linear sequences 92, 94–95
lit screens, safe viewing 69
lith printing 179
luminogram 114

INDEX

M

Magnum 22, *31*, 50, 57, *79*, 96, 123
Martins, Edgar 119
Mayes, Stephen 166
McCabe, Eamonn 74
McCullin, Don 54
Meiselas, Susan 96, *133*, 133
Meyerowitz, Joel 138, 173
miniatures 69
Model, Lisette 10, 165, *167*
Modernism 61, 98, *100–101*
Moholy-Nagy, László 131
Munkácsi, Martin *147*, 159
Murphy, Seamus 17, 18, *18*, 135
museum exhibitions 66, *93*, 123,
 171, 173
Museum of Modern Art (MoMA) 32,
 171, 173

N

National Endowment for the Arts
 32
National Geographic 30, 103, 129,
 150, *169*
Newman, Arnold 47, 50, 146, *185*
news photographers 109
Nikon 138

O

O'Sullivan, Timothy 40, 42
Outerbridge, Paul *61*, 61, 62, *175*

P

Page, Tim 35, 53, 160–61, *161*
Paris-Match 30, 83, *85*
Parke, Trent
 composition 135, *135*, 176
 lighting *15*, 131, 180, *182*
Parkinson, Norman 57, 65
Pellegrin, Paolo 163, *163*
Penn, Irving 62, 64, 138, 171
Peress, Giles 166
perspective 69
photo book 89–91
photo essay 50, 68, 78–88, 103

photographers
 authenticity and imperfection 140, 143
 authenticity orchestrated 152, 155
 capture, peer review 137
 dislike of captions 72, 78
 documentary challenges 103
 endorsing new technology 96, 171, 173
 equipment as tools 138
 intent 36, 46–47, 68, 185
 personal development 62
 preserving techniques 176, 179
 professionalism questioned 57
 stretching the imagination 129
 style 35, 36, 74, 89, 160
 worldwide talent 32
photography
 attributes of 10, 12
 uniqueness of 9
photojournalism
 craftsmanship 24, 68
 documentary role 17, 50–57, 74, 103,
 106, 166
 imperfection and authenticity 140
 news photography 109
 street photography *19*, 118, 138
 striking subjects 128–29
Photoshopping 119
picture magazines 30, 32
 see also GEO, Life, National Geographic,
 Paris-Match
Picture Post 30, 37
picture story see photo essay
Pinkhassov, Gueorgui *15*, *130*, *183*
polemic photography 106, *106–7*, 108
Popular Photography 24, 106, 162
Porter, Eliot 171
portraiture 46–50
prints
 contact 69, 71, *71*
 giant 71
 size, question of 72
Prokudin-Gorski, Sergei Mikhailovich *168*

Q

Qingsong, Wang *70*, 124

R

Rai, Raghu *31*, *56*, 135
Rautert, Timm 119
reading of photographs 34–37, 78
real life, photographs of
 primary source 10
 recording of events *11*
 specific look 12
 varied perspective 35
Reeves, Martin 110, *111*
Rodchenko, Alexander 98, *100*
Rolleiflex *167*
Rudman, Tim *43*, 179
Ruff, Thomas 155, 173
Ruscha, Edward 123

S

Salgado, Sebastião 103, *105*
Salomon, Erich *49*
Sandbank, Henry 62, *62*
Sander, August 46, *47*, 123
scientific photography 67
Scorsese, Martin 150
Scully, Julia 54, 56
Shahn, Ben 32
Sherman, Cindy *25*
shooting
 'decisive moment' 146, 149
 intervention 152–55
 planned 28–29
 reaction to events 144
 unplanned 26–27
Shore, Stephen 123, 173
single print 69
slideshow 92–95
Smith, W. Eugene
 "Country Doctor" 79–80, *81*
 "Dr Albert Schweitzer" *154*, 155
 "Haiti mental hospital" 176, *177*
 Life photographer 17, 78
 "Spanish Village" 80, *82*
Smolan, Rick 88
sport 60
spot news photography 77–78
Steichen, Edward 30, 65, 66

Steiglitz, Alfred 120

Steinmetz, Mark 176, *178*

Sternfeld, Joel 173

Stewart, John 75–76

still life painting 61

still life photography 28–29, 61–64, 159

Stock, Dennis 132, *132*

Strand, Paul *101*

street photography *19*, 26–27, 118, 138

Struth, Thomas 123, 173

Stryker, Roy E. 106

subject matter
 assertive subjects 159
 banal and mundane 123, 173
 still life 61, 62, 64, 108
 story portrayed 53, 78, 80, 103, 114
 surroundings 40, 44

Sunday Times Magazine 88

Surrealism 61, 98

Szarkowski, John 57, 123, 171

T

tableau photography 124

The Kiss (Le Baiser) 118

The New York Times 119, 149, 160, 173

The Sunday Times 72, 88

The Times 168

Thompson, Ed 78, 80

Thompson, Florence Owens 106, *107*, 108

Thomson, John *46*, 103, 152, 153

Tillmans, Wolfgang 76, *76*, *112*, 114

Time (magazine) 149

Time-Life Books 118

timing 27, 60, 146–51

tossography 110

Turner, Peter 171

V

viewing angle 69, 74

Vishniac, Roman *77*, 180

visual arts, place in 10

Vogue 57, 62, 65

W

Wakabayashi, Yasuhiro see Hiro

Wall, Jeff 71, 72, 74, 120, 124, *125*

war photography
 Biafra *54*, 54
 Korean war *142*
 Nicaragua 133
 social conscience 166
 Vietnam 53–55, 83, *84–85*, *160–61*
 World War II 118, 140, *141*, 143

Watkins, Carleton 40

Webb, Alex 131, *131*, *162*

websites *94–95*, 96

Weiming, Hu *53*

Weiner, Dan 50

Weiqiang, Liu *21*, 131

Wenders, Wim 150

Weston, Edward
 composition 162
 contact prints 69
 landscapes 24, 42, *42*, 179
 peer review 24
 still life 61

White, Minor 110, 120, *121*

wildlife and nature photography 58–59, 150, 152, *174*, *181*

Willumsum, Glenn 80, 155

Winogrand, Gary 123, 146

Wintour, Anna 65

Wolinsky, Cary *129*, 129–30

Y

Yamashita, Mike *169*

Yiwei, Liu *34*

Z

Zhenhai, Zhao *158*

PICTURE CREDITS

p7 *Pittsburg, PA ca. 1979–1980*, by Lee Friedlander © Lee Friedlander, courtesy Fraenkel Gallery, San Francisco; pp8–9 Courtesy Michael Freeman; p11 *Scene of a building collapse, Xi'an, Shanxi, 2000*, by Xie Haitao "Humanism in China: A Contemporary Record of Photography" Xie Haitao/FOTOE/www.fotoe.com/image/10126149; p12 *From the series Four Seasons in One Day, 2007*, by Laura El-Tantawy; p14 *George Town, Penang, 1990*, Gueorgui Pinkhassov/Magnum Photos; p15 *From the Dream/Life series, Sydney, 1998*, Trent Parke/Magnum Photos; p16 *Felix, Gladys and Rover, New York, 1974*, Elliott Erwitt/Magnum Photos; p18 *Image from Darkness Visible series: Bamiyan, Bamiyan Province, June 2003*, Seamus Murphy/VII Network; p19 *Theater Tickets, New York, 1955*, by William Klein © William Klein, Courtesy Howard Greenberg Gallery, NYC; p21 *A village submerging in a sandstorm, Daqing, Heilongjiang, 2001–3*, "Humanism in China: A Contemporary Record of Photography"/Liu Weiqiang; p23 *Man and woman 24, 1960*, © Eikoh Hosoe, Courtesy Howard Greenberg Gallery, NYC; p24 *Pyrámide del Sol, Mexico, 1923*, by Edward Weston Collection Center for Creative Photography © 1981 Arizona Board of Regents; p25 *Untitled, 1984*, Color photograph, 67 x 47 inches (170.2 x 119.4 cm), Edition of 5, by Cindy Sherman, Courtesy of the Artist and Metro Pictures; p26–29 all pictures/diagrams courtesy Michael Freeman; p31 *Through the doors of a wrestling school, Delhi, 1989*, Raghu Rai/Magnum Photos; p33 *On the train from Wuhan to Changsha, 1995*, "Humanism in China: A Contemporary Record of Photography"/Wang Fuchun/FOTOE/www.fotoe.com/image/20156605; p34 *Worker on a viaduct, Beijing, 2002*, "Humanism in China: A Contemporary Record of Photography"/Liu Yiwei; p35 *Female lower half in seamed stockings, yellow background*, by Guy Bourdin © Estate of Guy Bourdin. Reproduced by permission of Art + Commerce; p37 *Stonehenge, 1940s*, by Bill Brandt; pp38–39 Courtesy Michael Freeman; p40 *Canyon de Chelly, Navajo, 1904*, by Edward Curtis, Library of Congress, Washington, D.C.; p41 *Grand Vague, Cette (Sète)*, albumen paper from two glass collodion negatives, 1857, 34.5 x 41.6 cm, by Gustave Le Gray Gift of John Goldsmith Phillips, 1976. © 2011. Image copyright The Metropolitan Museum of Art/Art Resource/Scala, Florence; p42 *Storm, Arizona, 1941*, by Edward Weston Collection Center for Creative Photography © 1981 Arizona Board of Regents; p43 (top) *Untitled, Denver, ca. 1970s*, by Robert Adams © Robert Adams, courtesy Fraenkel Gallery, San Francisco, and Matthew Marks Gallery, New York; p43 (bottom) *Kirkjufell, Iceland*, by Tim Rudman, Courtesy of Tim Rudman; p44 *Rue des Ursins, 1923*, by Eugène Atget ©

2011. Image copyright The Metropolitan Museum of Art/Art Resource/Scala, Florence; p45 *A Sea of Steps, Wells Cathedral, 1903*, by Frederick H. Evans, courtesy of George Eastman House, International Museum of Photography and Film; p46 *Shanghainese Woman wearing a Snood, Shanghai, 1869*, by John Thomson, Wellcome Library, London; p47 *Varnisher, 1930*, by August Sander © Die Photographische Sammlung/SK Stiftung Kultur – August Sander Archiv, Cologne; DACS, London, 2011; p48 *Ordeal by Roses (Bara-kei) #32, 1961*, by Eikoh Hosoe © Eikoh Hosoe, Courtesy Howard Greenberg Gallery, NYC; p49 *Garden party at the home of Joseph Avenol during a League of Nations session, Geneva, 1936*, by Erich Salomon, SSPL/Getty images; p51 *Ricking the Reed, Twixt Land and Water, 1886, from Life and Landscape on the Norfolk Broads*, by Peter Henry Emerson, SSPL/Getty Images; p52 *Bijou, 1932*, by Brassaï © Estate Brassai - RMN, George Pompidou Centre, Museum of Modern Art, Paris © Pompidou Centre Collection - RMN/Adam Rzepka; p53 *Dead fish in polluted pool, Wuhan, Hubei, May 1999*, by Hu Weiming "Humanism in China: A Contemporary Record of Photography"/Hu Weiming/FOTOE/www.fotoe.com/image/10203012; p54 *Biafra, 1968*, by Romano Cagnoni © Romano Cagnoni www.romanocagnoni.com; p55 *Vietnam War, U.S. Army/Vietnamese*, by Horst Faas, Horst Faas/AP/Press Association Images; p56 *Gangotri, the source of Ganga River, 2004*, by Raghu Rai, Raghu Rai/Magnum Photos; p58 *Polar bears sparring, Ursus maritimus, Hudson Bay, Canada*, by Frans Lanting © Frans Lanting/www.lanting.com; p60 *Crash on the Tour de Suisse, 2010*, by Christian Hartmann, Reuters/Christian Hartmann; p61 *Saltine Box*, platinum print, 1922, Paul Outerbridge, Jr. © 2011 G. Ray Hawkins Gallery, Beverley Hills, CA; p62 *Original Vessel, Horim Museum, Seoul, 2006*, by Bohnchang Koo; p63 *Untitled, c. 1970*, by Henry Sandbank; p64 *Smoked Fish, 1980s*, by Robert Golden; p65 *Lily Cole* by Miles Aldridge, trunkarchive.com; p66 *Image of feet under huge leaf*, by Guy Bourdin © Estate of Guy Bourdin. Reproduced by permission of Art + Commerce; p67 *A Superconducting Quantum Interference Device (SQUID)*, courtesy Michael Freeman; p68 *A soldier is saying goodbye to his wife and child who came to see him, Weichang, Hebei, 1987*, by Feng Jianxin "Humanism in China: A Contemporary Record of Photography"/Feng Jianxin; p70 *Competition, 2004*, 170 x 130cm, © Wang Qingsong/www.wangquigsong.com; p71 courtesy Michael Freeman; p73 *Andreas Gursky. Paris, Montparnasse, 1993*. c-print, Andreas Gursky / VG Bild-Kunst, Bonn / DACS 2011 / Courtesy Sprüth Magers Berlin London; p75 *John

Stewart exhibition at the Wilmotte Gallery, London, summer 2010*, courtesy Michael Freeman; p76 (top and bottom) *Wolfgang Tillmans' Installation View, Serpentine Gallery*, London, summer 2010, photograph by Gautier de Blonde; p77 *Talmud students, Mukacevo, c. 1935–38*, by Roman Vishniac © Mara Vishniac Kohn, courtesy International Center of Photography; p79 *A drill sergeant delivers a severe reprimand to a recruit*, Parris Island, South Carolina, 1970, Thomas Hoepker/Magnum Photos; p81 *"Country Doctor," with photographs by W. Eugene Smith, which ran in Life on September 20, 1948*, copyright 1948 Picture Collection Inc. Reprinted with permission. All rights reserved; p82 *The "Spanish Village" story, with photographs by W. Eugene Smith, which ran in Life on April 9, 1951*, copyright 1951 Picture Collection Inc. Reprinted with permission. All rights reserved; p84 *"One Ride with Yankee Papa 13," with photographs by Larry Burrows*, Copyright 1965 Picture Collection Inc. Reprinted with permission. All rights reserved; p85 *Paris-Match*, copyright 1965 Picture Collection Inc. Reprinted with permission. All rights reserved; pp86–87 *"Monsoon," September 8, 1961*, Copyright 1961 Picture Collection Inc. Reprinted with permission. All rights reserved/Images: Courtesy Brian Brake Estate; p89 *Sudan: The Land and the People*, courtesy Michael Freeman; p90 *Chongqing IV (Sunday Picnic), Chongqing Municipality, from the book Yangtze, The Long River, 2009*, by Nadav Kander; p91 *The Tea Horse Road, China's Ancient Trade Road to Tibet*, by Michael Freeman and Selena Ahmed, published by River Books; courtesy Michael Freeman; p92 *The Moody Blues in concert in 1975*, courtesy Michael Freeman; p93 *Shanghai Art Museum*, courtesy Michael Freeman; pp94–95 *Slideshow*, courtesy Michael Freeman; p97 *iPad display*, courtesy Michael Freeman; p99 *Nuestra Señora de la Candelaria de la Popa, the oldest church in Trinidad, Cuba, 1998*, David Alan Harvey/Magnum Photos; p100 *Stairway, 1930*, by Alexander Rodchenko © Rodchenko & Stepanova Archive, DACS 2011; p101 *Chair Abstract, Twin Lakes, Connecticut, 1916*, by Paul Strand © Aperture Foundation Inc., Paul Strand Archive; p102 *Avenue des Gobelins, 1925*, by Eugène Atget, Courtesy of George Eastman House, International Museum of Photography and Film; p104 *Crowds waiting to get into the toilet at the station, Guangzhou, Guangdong, 1991*, by Ye Jianqiang, "Humanism in China: A Contemporary Record of Photography"/Ye Jianqiang/FOTOE/www.fotoe.com/image/10129203; p105 *Fisherman resting, The Mattanza, traditional tuna fishing*, Trapani, Sicily, by Sebastião Salgado © Sebastião Salgado/Amazonas Images; p106 *The corner of the kitchen in the Home of Floyd Burroughs,*

cotton Sharecropper, Hale County, Alabama, 1936, by Walker Evans, Library of Congress, Washington D.C.; p107 all pictures *Migrant Mother*, California, 1936, by Dorothea Lange, Library of Congress, Washington D.C.; p108 *Shipbreaking No.49* Chittagong, Bangladesh, 2001, by Edward Burtynsky © Edward Burtynsky, Courtesy Flowers, London & Nicholas Metivier, Toronto; p109 *François Mitterand at an election rally*, Toulouse, by Brian Harris/*The Independent*; p111 *Resting Bull at Pagan, Burma*, by Martin Reeves © Martin Reeves www.martinreeves.com; p112 *Freischwimmer 26*, 2003, chromogenic print, 70 x 94 inches, by Wolfgang Tillmans, Courtesy Galerie Daniel Buchholz, Cologne/Berlin; p113 *Self Portrait in Kimono with Brian, NYC, 1983*, by Nan Goldin, Courtesy Nan Goldin Studio; p115 *Bibi, On Our Honeymoon, Chamonix, January 1920*, photograph by Jacques Henri Lartigue © Ministère de la Culture—France / AAJHL; p116 *Presidency II, 2008*, by Thomas Demand, © DACS 2011; p117 *Minka with Dirt and Fog*, 2003, by James Casebere, copyright James Casebere. Image courtesy James Casebere and Lisson Gallery, London www.jamescasebere.com; p119 *Australians storm a strongpoint, 1942*, by Len Chetwin, Imperial War Museum; p121 *Warehouse Area, San Francisco, 1949*, by Minor White, reproduced with permission of the Minor White Archive, Princeton University Art Museum. Copyright © Trustrees of Princeton University; p122 *Pittsburg, PA, ca. 1979–1980*, by Lee Friedlander © Lee Friedlander, courtesy Fraenkel Gallery, San Francisco; p125 *The Storyteller, 1986*, by Jeff Wall © Jeff Wall; pp126–127 Courtesy Michael Freeman; p128 *Giza pyramids with army of "trash people" by artist H.A. Schult, Egypt, 2002*, Thomas Hoepker/Magnum Photos; p129 *Half-shorn sheep, New Zealand*, by Cary Wolinsky, TrilliumStudios.com/www.trilliumstudios.com; p130 *Portrait of designer, Paris, 1995*, Gueorgui Pinkhassov/Magnum Photos; p131 *In the Arid Northwest of the Island, Haiti, Monded Blanc, 1987*, Alex Webb/Magnum Photos; p132 *Playa del Rey, Los Angeles, USA, 1968*, Dennis Stock/Magnum Photos; p133 *Cuesta del Plomo, Managua, Nicaragua, 1978*, Susan Meiselas/Magnum Photos; p134 *Out of the blue, 2005*, by Rebekka Guòleifsdóttir/ www.rebekkagudleifs.com; p135 *From his Dream/Life series, 1999*, Trent Parke/Magnum Photos; p136 *New Guinea, 1962*, by Romano Cagnoni © Romano Cagnoni www.romanocagnoni.com; p139 *Juan Patricio Lobato, Carney, Rocky Ford, Colorado, August 23, 1980*, photograph by Richard Avedon © The Richard Avedon Foundation; p141 *Omaha Beach. The first wave of American troops lands at dawn, June 6th, 1944, Normandy*, Robert Capa © International Center of

Photography/Magnum Photos; p142 *Watch Tower, Koje Do Island, Korea, 1952*, Werner Bischof/Magnum Photos; p144 *Winston Churchill, 1941*, by Yousuf Karsh, Yousuf Karsh/Camera Press London; p145 *Ulster: Moment of Terror—Explosion at the Marine Hotel, Ballycastle, Northern Ireland, 1979*, by Brigitte Dahm, Action Press/Rex Features; p147 *Liberia, 1931*, by Martin Munkácsi © Estate of Martin Munkácsi, Courtesy Howard Greenberg Gallery, NYC; pp148–149 *Richard Nixon leaving the White House, August 9, 1974*, David Hume Kennerly/Getty Images; p151 *Chased by the Light, contact sheet, 1994*, © Jim Brandenburg; p153 *Monks eating at Fang-guang-yuan Monastery, Fuzhou, Fujian, 1870–71*, by John Thomson, Wellcome Library, London; p154 *French Equatorial Africa, Gabon, Lambarene, Dr. Albert Schweitzer and a carpenter, watch the building of the Mission hospital, 1954*, W. Eugene Smith/Magnum Photos; p157 *Kandilli, teens jumping into Bosphorus, Istanbul, Turkey*, Bruno Barbey/Magnum Photos; p158 *Farmers who specialize in breeding silkworms, Lushan, Henan, 1987*, by Zhao Zhenhai, "Humanism in China: A Contemporary Record of Photography"/Zhao Zhenhai; p160 *Vietnam, 1968*, Philip Jones Griffiths/Magnum Photos; p161 *Shot girl, Vietnam War, 1968*, Tim Page/Corbis; p162 *Outside bullfight stadium, Madrid, Spain*, Alex Webb/Magnum Photos; p163 *Kosovar refugees who have just crossed the border into Albania at Morina on their tractor, Kosovo, Albania, 1999*, Paolo Pellegrin/Magnum Photos; p164 *From the series Smile Me Hello*, by Laura El-Tantawy; p165 *St. Patrick's Day, Fifth Avenue, 1954–55*, by William Klein © William Klein, Courtesy Howard Greenberg Gallery, NYC; p166 *Demonstration in favor of the leading opposition figure Ayatollah Kazem Shariatmadari, Tabriz, Iran, 1980*, Gilles Peress/Magnum Photos; p167 *Running Legs, 42nd Street, New York, c. 1940–41*, by Lisette Model, The Lisette Model Foundation, Inc. (1983). Used by permission; p168 *The Emir of Bukhara, Alim Khan (1880–1944), 1911*, by Sergei Mikhailovich Prokudin-Gorski, Library of Congress, Washington D.C.; p169 *Minab, red masked woman, Iran*, by Mike Yamashita; p170 *Untitled (Mississippi), circa 1982–86*, by William Eggleston © Eggleston Artistic Trust. Courtesy Cheim & Read, New York; p171 A 35mm Kodachrome transparency, courtesy Michael Freeman; p172 *Route 66, Albuquerque, New Mexico, 1969*, Ernst Haas/Getty Images; p174 *Emperor penguin parent looking for its chick in creche, Aptenodytes forsteri, Weddell Sea, Antarctica*, by Frans Lanting © Frans Lanting/www.lanting.com; p175 *Images de Deauville, c. 1936*, Paul Outerbridge, Jr. © 2011 G. Ray Hawkins Gallery, Beverley Hills, CA; p177 (top and bottom) *Patient in a*

mental hospital, Haiti, 1959*, W. Eugene Smith/Magnum Photos; p178 *Athens, Georgia (from South East), 2001*, courtesy Mark Steinmetz; p180 (left and right) *Packtrain crossing the Yalong River, Sichuan, 2009*, by Michael Freeman; p181 *Giant tortoises in pond, Geochelone nigra, Alcedo Volcano, Galapagos Islands*, by Frans Lanting © Frans Lanting/www.lanting.com; p182 *From his Dream/Life series, 2001*, Trent Parke/Magnum Photos; p183 *Market, Tashkent, Uzbekistan, 1992*, Gueorgui Pinkhassov/Magnum Photos; p184 (left) *Odalisque, New York, 1943*, Horst P. Horst/Art + Commerce; (right) *Wine Glass, Garlic and Shadow, 1980s*, by Robert Golden; p185 *German Industrialist Alfried Krupp, 1963*, Arnold Newman/Getty Images

BIBLIOGRAPHY

Arnheim, Rudolf. *Art and Visual Perception.* Berkeley, Los Angeles, London: University of California Press; 1954.

Berger, John. *About Looking.* London: Writers & Readers; 1980.

Berger, John. *Ways of Seeing.* London: BBC/Penguin; 1972.

Bouleau, Jacques. *The Painter's Secret Geometry.* New York: Hacker Art Books; 1980.

Cartier-Bresson, Henri. *The Mind's Eye.* New York: Aperture; 1982.

Dexter, Emma. Weski, Thomas. *Cruel and Tender.* London: Tate Publishing; 2003.

Eauclaire, Sally. *The New Color Photography.* New York: Abbeville Press; 1981.

Evans, Harold. *Pictures on a Page.* London: William Heinemann Ltd.; 1978.

Frank, Robert. *Peru.* Washington: Steidl / National Gallery of Art; 2008.

Freeman, Michael. *The Photographer's Eye.* Lewes: Ilex; 2007.

Garner, Gretchen. *Disappearing Witness: Change in Twentieth-Century American Photography.* Baltimore and London: The Johns Hopkins University Press; 2003.

Gombrich, E.H. *Art & Illusion: A Study in the Psychology of Pictorial Representation.* London: Phaidon; 2002.

Gombrich, E.H. *The Image and The Eye.* Oxford: Phaidon; 1982.

Gregory, Richard L. *Eye and Brain: The Psychology of Seeing.* Oxford: Oxford University Press; 1998.

Haas, Ernst. *In America.* London: Thames and Hudson; 1975.

Haas, Ernst. *The Creation.* Harmondsworth: Penguin Books; 1971.

Jacobs, Karen. *The Eye's Mind: Literary Modernism and Visual Culture.* Ithaca and London: Cornell University Press; 2001.

Kerouac, Jack. *The Americans.* Washington: Steidl/National Gallery of Art; 2008.

Koestler, Arthur. *The Act of Creation.* London: Hutchinson & Co. Ltd.; 1964.

Livingstone, Margaret. *Vision and Art: The Biology of Seeing.* New York: Abrams; 2002.

Loran, Erle. *Cézanne's Composition.* Berkeley: University of California Press; 2006.

Irving Penn. *Still Life.* London: Thames & Hudson; 2001.

Rothenstein, John. *The World of Camera.* London: Thomas Nelson and Sons Ltd. 1964.

Shaw, Philip. *The Sublime.* London and New York: Routledge; 2006.

Smith, W. Eugene. *The Camera as Conscience.* London: Thames and Hudson; 1998.

Sontag, Susan. *On Photography.* New York: Farrar, Straus & Giroux. 1973.

Hiroshi Sugimoto: *Time Exposed.* London: Edition Hansjörg Mayer; 1995.

Szarkowski, John. *Looking at Photographs.* New York: The Museum of Modern Art; 1973.